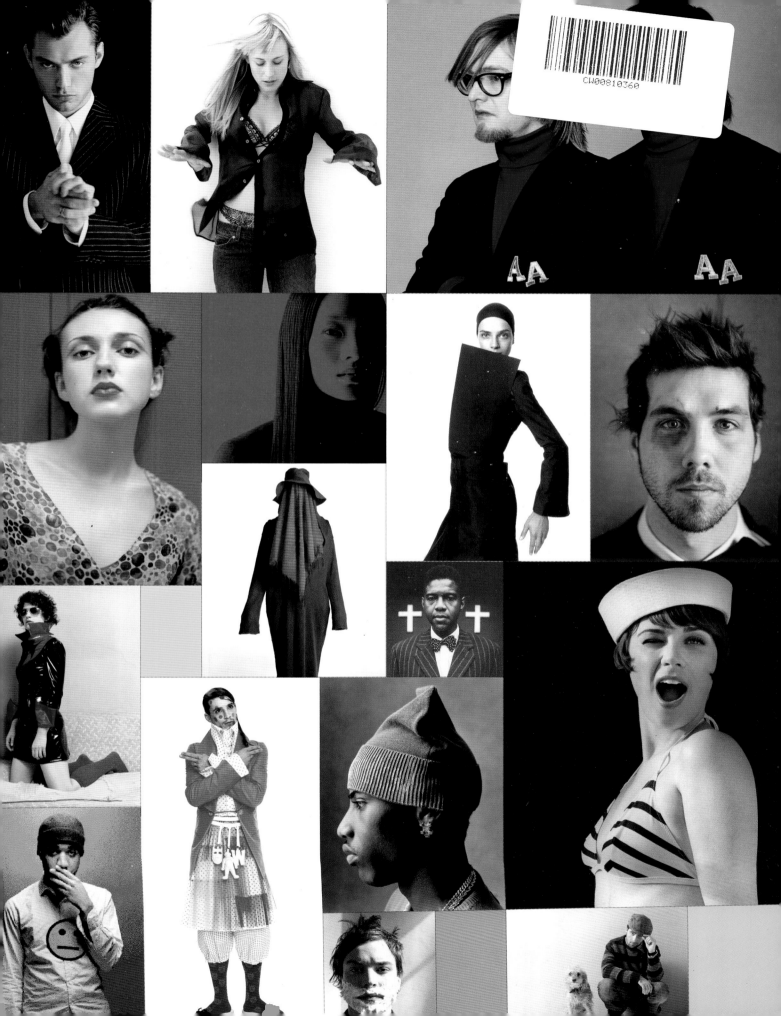

20
YEARS OF
STYLE

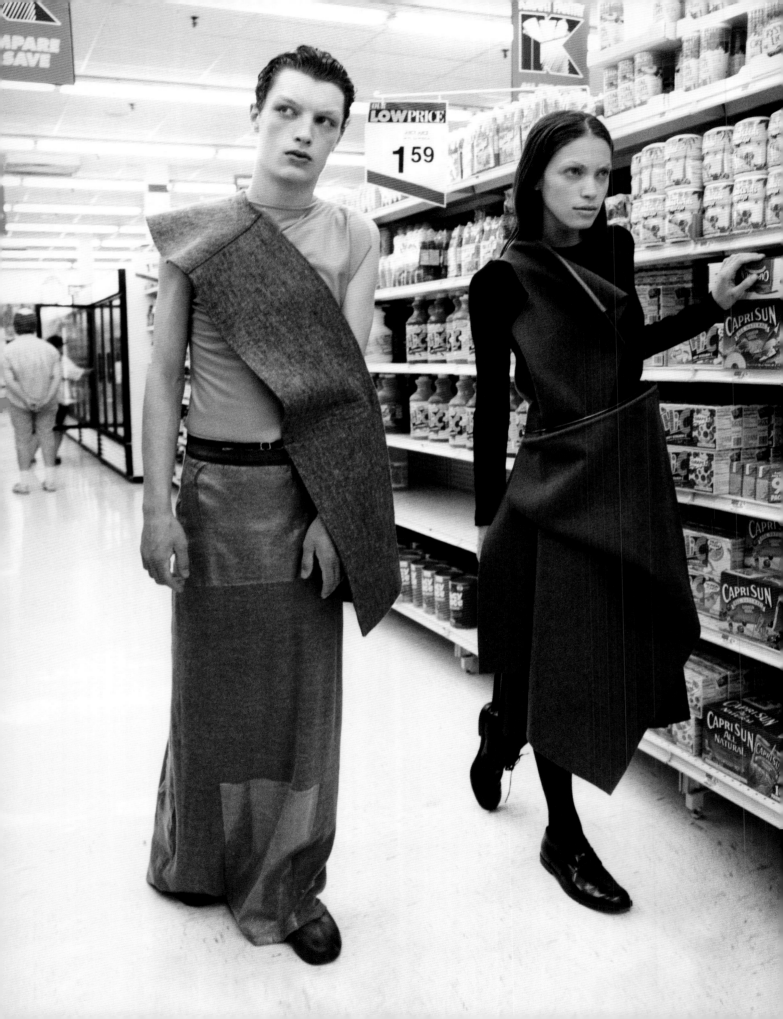

20

YEARS OF

STYLE

the world

according to

PAPER

EDITED BY KIM HASTREITER AND DAVID HERSHKOVITS

HDi

HARPER
DESIGN
international

An Imprint of HarperCollins*Publishers*

FIRST PUBLISHED IN 2004 BY
HARPER DESIGN INTERNATIONAL • AN IMPRINT OF HARPERCOLLINS*PUBLISHERS*
10 EAST 53RD STREET • NEW YORK, NY 10022 • TEL 212-207-7000 • FAX 212-207-7654
HARPERDESIGN@HARPERCOLLINS.COM • WWW.HARPERCOLLINS.COM

DISTRIBUTED THROUGHOUT THE WORLD BY
HARPERCOLLINS INTERNATIONAL
10 EAST 53RD STREET • NEW YORK, NY 10022 • FAX 212-207-7654

HARPERCOLLINS BOOKS MAY BE PURCHASED FOR EDUCATIONAL, BUSINESS, OR SALES PROMOTIONAL USE.
FOR INFORMATION, PLEASE WRITE SPECIAL MARKETS DEPARTMENT
HARPERCOLLINS*PUBLISHERS* INC. • 10 EAST 53RD STREET • NEW YORK, NY 10022

THE ART DIRECTION IN THIS BOOK IS BY BRIDGET DE SOCIO.

LIBRARY OF CONGRESS CATALOGING-IN-PUBLICATION DATA:

HASTREITER, KIM.
20 YEARS OF STYLE : THE WORLD ACCORDING TO PAPER / EDITED BY KIM HASTREITER AND DAVID HERSHKOVITS.
P. CM.
INCLUDES INDEX.
ISBN 0-06-072302-5 (PBK.)
1. UNITED STATES—CIVILIZATION—1970–2. POPULAR CULTURE—UNITED STATES. 3. CELEBRITIES—UNITED STATES. 4. STYLE
(PHILOSOPHY) 5. ARTS AND SOCIETY—UNITED STATES. 6. UNITED STATES—SOCIAL CONDITIONS—1980–7. POPULAR CULTURE—
NEW YORK (STATE)—NEW YORK. 8. PAPER (NEW YORK, N.Y.) I. TITLE: TWENTY YEARS OF STYLE. II. HERSHKOVITS, DAVID. III. PAPER
(NEW YORK, N.Y.) IV. TITLE.
E169.12.H385 2004
306'.0973'09045–DC22
2004004320

FIRST EDITION
PRINTED AND BOUND IN HONG KONG

1 2 3 4 5 6 7 8 9 10 / 09 08 07 06 05 04

THE WORLD ACCORDING TO PAPER • 20 YEARS OF STYLE

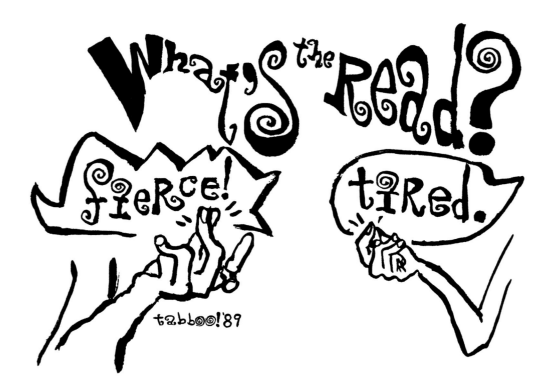

THIS BOOK IS DEDICATED TO ALL *PAPER* PEOPLE—FRIENDS AND PARTICIPANTS, SUPPORTERS AND TROUBLEMAKERS—WHO HAVE BUILT AND CONTRIBUTED TO OUR COMMUNITY AND MAGAZINE OVER THE YEARS. WE SALUTE THESE CREATIVE VISIONARIES FROM ALL MEDIUMS, WHO PUSH THE BOUNDARIES OF WHAT EXISTS AND BLOW OUR MINDS WITH THE EXCELLENCE OF THEIR IDEAS, TALENT, CRAFT AND AESTHETICS.

CONTENTS

PART THREE

20 YEARS OF STYLE

1984-1994

1995-2004

CONTENTS

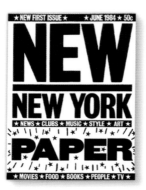

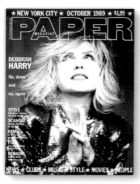
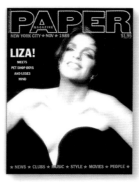
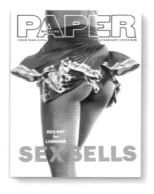
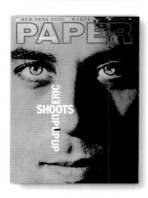

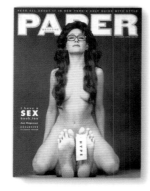
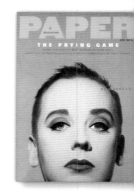
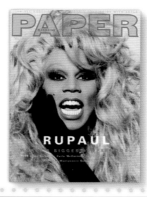
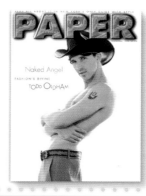
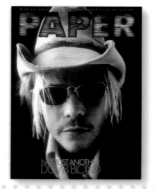
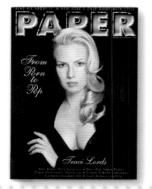

THE WORLD

PAPER'S MOM AND POP STARTED THEIR MAGAZINE WITH $4,000,
A TYPEWRITER AND A STYLE-SOAKED DREAM

WELCOME TO THE WONDERFUL WORLD OF *PAPER*, WHERE WE LIVE AND WORK IN A NEIGHBORHOOD CALLED "DOWNTOWN." DOWNTOWN IS LOCATED SOUTH OF 14TH STREET IN NEW YORK CITY, AND IT WAS HERE, 20 YEARS AGO IN A LOFT NEAR CANAL STREET, THAT WE COBBLED TOGETHER OUR BELOVED INDIE BROADSHEET FOR $4,000. AT THE TIME RENTS WERE CHEAP AND THE STREETS WERE A BIT SKETCHY, BUT THE COMMUNITY WAS OVERFLOWING WITH YOUNG MAVERICKS LIKE US WHO HAD COME TO NEW YORK FROM ALL CORNERS TO MAKE THEIR MARKS AND CREATE ARTISTIC CHAOS. OUR AREA OF THE CITY DANCED ON THE EDGE OF THE SUBVERSIVE, EXPLODING WITH NEW IDEAS ABOUT CULTURE. THE LANDSCAPE WAS MADE UP OF FILMMAKERS, ARTISTS, MUSICIANS, WRITERS, FASHION DESIGNERS, PERFORMERS, INTELLECTUALS AND FREAKS, BUT WHAT WE ALL HAD IN COMMON WAS THAT WE WANTED TO BE AT THE EPICENTER. IT WAS SIMPLE: EVERYTHING STARTED DOWNTOWN, SO DOWNTOWN WAS WHERE WE HAD TO BE.

ACCORDING TO PAPER

by david hershkovits + kim hastreiter

WE WANTED TO BE AT THE EPICENTER.
EVERYTHING STARTED DOWNTOWN, SO
DOWNTOWN WAS WHERE WE HAD TO BE.

AS YEARS PASSED, ALTERNATIVE AREAS OF THE CITY gentrified and rents rose, forcing the rebels who came to Manhattan to disperse to other boroughs and cities. As economics and geography evolved, downtown gradually came to mean what it does today: a state of mind that can be found anywhere unconventional scenes sprout up, whether in a basement on 145th Street or a skate ramp in the canals of Los Angeles.

As we continued to publish PAPER independently every month, we were forced to dig deeper to find the blurry edge of the vanguard. Meanwhile, we were occupying a space in the media that often took the shape of an alternative universe with its own galaxy of stars and interests. Our independence allowed us to roam freely, untethered by mainstream standards, accountable to no one but our own hearts and souls. We called it "our utopia," a place where drag queens mixed with rappers, who simultaneously mixed with skateboarders, fashion designers, club kids, models and artists. We cherry-picked the best and pointed our finger at what we found amusing or shocking. While the mass media was busy chronicling stories for the largest possible audience, PAPER was always looking elsewhere to find signs of creative life among the downtown tribes—those for whom style was the great signifier. Our journalism was a curious hybrid. We created a crossover magazine like no other: Borderlines grew hazy as music became video and dance, while art turned into photography, installation and fashion.

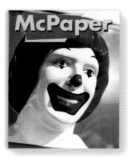

Created by pop enthusiasts with a wide range of interests, PAPER was never merely a fashion magazine, a music magazine or a film magazine. We were most interested in how all of those separate worlds mingled and in the friction created by the rub of one against another. We preferred our heroes to have one foot in the underground and one above it. Our hearts were captured by the early work of artists. We preferred to watch the raw material take shape rather than follow the well-polished, moneymaking machine that is often a consequence of success. But we were there when it happened to movements like hip-hop and artists like Keith Haring.

On our editorial journeys, we discovered pockets of creativity where new worlds were being imagined that would one day influence the way we walk, talk, dress and think. We pay homage in this book to the young visionaries who pushed our culture in radically different directions, whether they came from music, art, hip-hop, skateboarding or adapted the gender-bending ways of drag as a means to get their message across.

Mainstream media looked down on fashion as frivolous and superficial. But we believed that it was possible to care about style *and* more serious matters, like politics and art—only our brand of politics glorified both personal expression and the ways that the arts confronted intense issues of the day. AIDS, urban development and the various manifestations of youth culture were our regular beats. When Chuck D of Public Enemy referred to rap music as the CNN of the streets, we understood what he was talking about. Our instincts were proven correct during the height of the culture wars, when self-appointed culture-watchdog Bill Bennett tried to shove his version of decency down peoples' throats, while performers like Karen Finley had their NEA grants rescinded. These were artists we not only endorsed but also knew as friends.

While PAPER is not for everyone, many understand it immediately and click with our style-centric sensibility. Others may be a bit perplexed by it all. Still, the people who understand us best are the artists at the forefront of their disciplines. We invited some of these important people, many of whom have become friends, to contribute to this book and shed some light on PAPER's roots. Our writers are culled from the widest possible array of artistic backgrounds and sensibilities, but their spheres overlap, not only with our magazine but also with each other. They are some of the progenitors of crossover culture, where music, fashion, film, sports and celebrities meld to create original works—and, more important, original ways of thinking about them. So dig in and enjoy the 20-year ride along with our amazing tour guides: Moby, Fab 5 Freddy, Harold Koda, Carlo McCormick, Michael Musto, Charlie Ahearn, RuPaul, Aaron Rose, Jeffrey Deitch, Kim Gordon, Todd Oldham, Anna Sui, Pedro Almodóvar, Isaac Mizrahi, Sandra Bernhard, John Waters and Patrick McMullan. ○ Kim Hastreiter and David Hershkovits are the founders, editors and publishers of PAPER magazine.

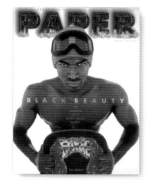

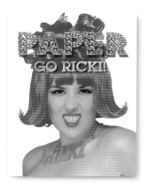

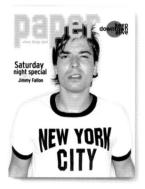

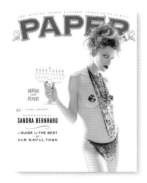

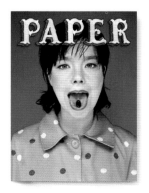

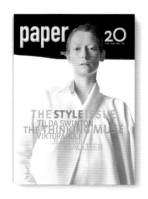

POP GOES THE WORLD

GOSSIP GURU MICHAEL MUSTO WAS WITH US EVERY SEQUIN-SPLASHED STEP OF THE WAY

1984 WAS HARDLY THE APOCALYPTIC HORROR WE'D been promised. Instead, it was a year of sheer joy, because both PAPER magazine and my *Village Voice* column were born like glitter twins of frolic and fabulosity! What a great moment to be birthed into, when *Dynasty* and MTV were selling cartoony expressions of glitz, glamour and ritualized showing off; when the only thing bigger than everyone's overflowing opportunities was their new-wave mall hair. My personal look was very Boy-George-meets-Punky-Brewster via Superfly Snuka, and like PAPER, I was on the outside looking in and loving every bedazzled minute. Then a mere fold-out, the mag addressed both the bubbling under and the frothing over, all with an adorably ragtag eye for trends and discoveries. Armed with an occasional ticket for a free drinky-poo, I hopped along for the ride.

This, of course, was way before the Sunday Styles section of *The New York Times* and fashion TV made insider talk accessible to virtually every stranger on the street. (My ma is now known to blurt stuff like, "I saw the Marc Jacobs show on the WE network. The Carnaby Street references and the winky nods to '70s luxe were simply *divoon*.") At this point, Seventh Avenue fashion seemed like something invented for *other* people—though by prancing around clubs that so crazily mixed drag, hip-hop and celebrity influences, it turned out we were trendsetting the whole time.

It's always been the nightlife and the streets where these phenomena start percolating; only the washing instructions tend to change with time. So by '87, the Felliniesque fiesta led to a more shocking playpen for gas-masked club kids who not only wanted that apocalypse, but actively tried to bring it on. But the globe kept spinning, and the mainstream kept noticing the underground murmurs—everything from AIDS-activist chic (combat boots and informed rage) to vogueing, a fab flaunting in the face of oppression, which Madonna turned into a Gaultier-coned 1990 hit that still has people alternately screaming, "She ripped us off!" and "Did you see me in the video?"

Meanwhile, *Vogue* itself was busy promoting supermodels Naomi Campbell, Christy Turlington and Linda Evangelista, a torrid trio who could walk and give attitude at the same time. Those fine-boned strutters were by far the most famous creatures who ever lived, and if you disagreed, they would hit you over the head with a cellphone. Fortunately, I agreed, and I even loved it when the eerily beautiful Evangelista made her immortal remark, "I don't get out of bed for less than $10,000 a day." (The woman was only speaking the truth!)

Even more controversially, rock stars started waking up for nothing, or at least they looked like it, thanks to the inevitable counter-trend, the dreaded grunge look. Grunge terrified everyone into thinking high fashion was over forever, until Marc Jacobs realized that it could simply be marketed *as* fashion, then consumed and digested. Soon enough, the smelly sneakers were tossed, and Fashion Week got its glitz back, becoming as hilariously crazed and overhyped as a British sitcom. Inevitably it spawned one, the ditzily funny *Absolutely Fabulous*, which commented on the absurdity of the wrong hag looking for the right bag and helped us all laugh at ourselves for a second before pushing maniacally toward the Prada register.

By the time the next century kicked in, fashion had become so famous that Winona Ryder couldn't wait to get home to start wearing it. High- and low-society lines had faded to the point where you couldn't differentiate the skimpy styles of socialites like the Hilton sisters from porn vixens like Jenna Jameson. And suddenly every starlet had a stylist, every straight man had a gay trainer, and every Anna Wintour had a P. Diddy to show her how to get the most bang for her bling-bling. Even species started mixing when an ultra-glamorous sheep turned up on Miguel Adrover's runway.

Best of all, my favorite designers ended up doing lines for Target in a marvy collision of couture talent and mass market, the merch perfectly matching my old '80s accessories—and budget. (Yes, I kept every single leg warmer, shoulder pad and faux-splattered Sprouse jacket. Everyone said I was out of my gay gourd, but excuse me, who's looking fine now?)

And that, stylishly enough, brings us up to date. Thank you, PAPER, for accompanying me on this incredibly jazzy journey and for growing along with my waist size. You're so 20 years from now. ◦ Michael Musto is downtown New York's gossip extraordinaire, writing weekly for the *Village Voice* while appearing on TV stations everywhere.

by michael musto

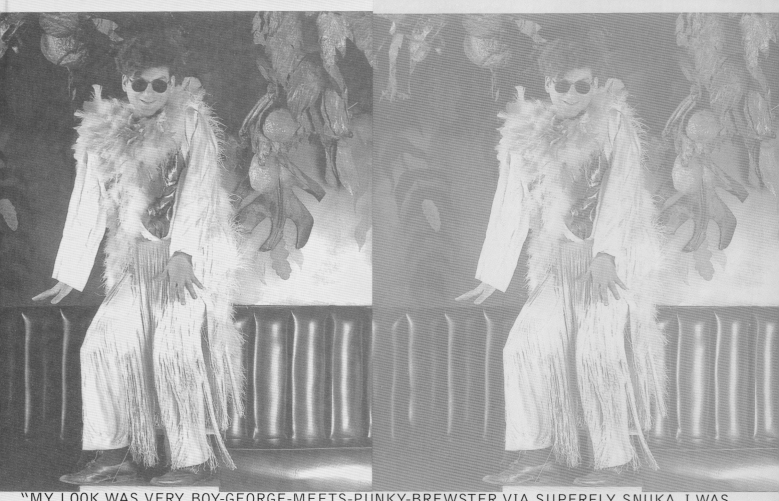

"MY LOOK WAS VERY BOY-GEORGE-MEETS-PUNKY-BREWSTER VIA SUPERFLY SNUKA. I WAS ON THE OUTSIDE LOOKING IN AND LOVING EVERY BEDAZZLED MINUTE." —MICHAEL MUSTO

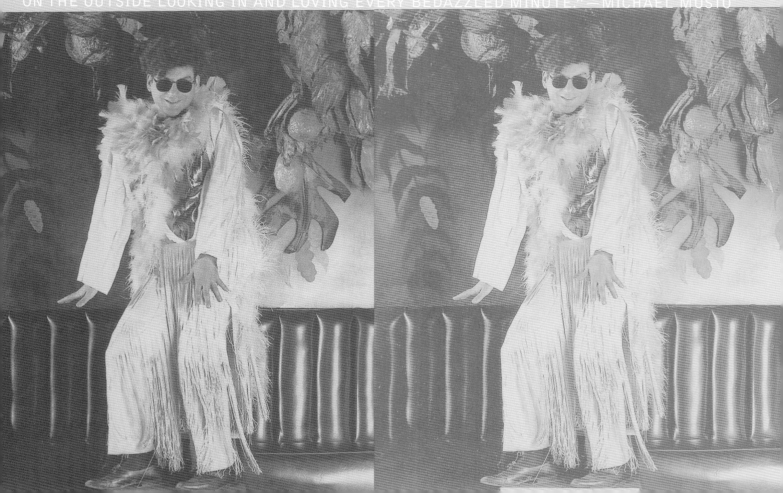

CULTURE WARS

WHEN OPPRESSION AND DISEASE STRUCK DOWNTOWN, *PAPER* BATTLED BACK. TWO DECADES LATER, WE'RE STILL FIGHTING THE GOOD FIGHT

WHEN *PAPER* WAS FOUNDED IN 1984, THE IDEA OF underground style as a rejection of mainstream values resonated in downtown New York. The magazine inherited a legacy from other alternative publications, part of a continuum where drag queens hobnobbed with artists and musicians spent their spare time sculpting, where the gulf between uptown Beaux Arts and downtown trash culture couldn't have been wider. On the outside, PAPER looked and acted differently from other journals, treating the grimy aesthetics of downtown as if they were highbrow. But internally our mandate seemed very much in line with the print tradition. Whether it was art or fashion, hip-hop or punk, graffiti or galleries, we reported what we loved because we thought it was important. Our directive, to expose downtown and illustrate everything that existed just beyond the scope of the mainstream, worked well within the established history of iconoclastic magazines. Since both of PAPER's founders had been editors at *The Soho Weekly News*, that gave us an even shot at gaining admission to the glorious but ultimately tragic pantheon of independents that survived just long enough to be memorable. (Until its demise in 1982, *The Soho Weekly News* was my bible for finding out what was going on downtown.)

Having now lived to the remarkable age of 20, PAPER has accrued enough hindsight to understand that 1984 was not merely one more step along the left-handed path of youth culture. It was the moment we stumbled into a new paradigm, one of both oppression and cultural convergence, where fashion could become art, art could become music, and music could become film. And though our party was still going full throttle, the date's Orwellian overtones resulted in more than empty fears. We'd all lived with 1984's ticking bomb of a literary metaphor, but few of us anticipated just how traumatic this emergent new reality would be. In the end, we had to fight for our right to party because, politically, the year was a disaster. We saw the landslide re-election of Ronald Reagan, a leader who not only detested our likes but until 1986 refused to publicly utter the term "AIDS," the disease that was quite literally killing downtown. As the creative community died all around us—including some of PAPER's brightest stars, like Haoui Montaug, John Sex, Keith Haring, Tseng Kwong Chi, Ethyl Eichelberger, David Wojnarowicz, Robert Mapplethorpe, Willi Smith and too many others to name—the political climate was moving toward a fundamental intolerance of the subcultures that made up the downtown scene. PAPER's stubborn insistence that there was still a community and a symbiotic sensibility within it was, in retrospect, both utterly delusional and sublimely visionary.

As publishers and editors, Kim and David never hesitated to confront the incremental homogenization of New York or to mourn our fallen comrades. But they also insisted that we keep our message positive, resist rage and morbidity, and always be open to the mercurial nature of youth culture. It really was as simple as that, a kind of apolitical Peter Pan complex that stressed the energies and innovations of youth. Eventually that attitude shifted from describing subcultures to exploring the junction between youth and popular culture. At the time hardly rocket science, this kind of engagement was nonetheless unique, separating PAPER from the burgeoning 'zine scene and the rest of the mainstream press. Most magazines could pursue edgy, urban trends only with the predatory gaze of the uninvited. PAPER, on the other hand, enjoyed the participatory understanding of an insider.

The idea was to bring the galaxy of downtown to the world above 14th Street. Like typical New Yorkers, we thought we were the center of the universe. But with a persistence born of never-say-die obstinacy, PAPER stopped thinking provincially and began to broker culture where uptown tastes and downtown styles met. And it worked. The style of refusal is no longer a nihilistic abnegation but a

by carlo mccormick

Ann Magnuson poses for the cover of *PAPER* in October 1992

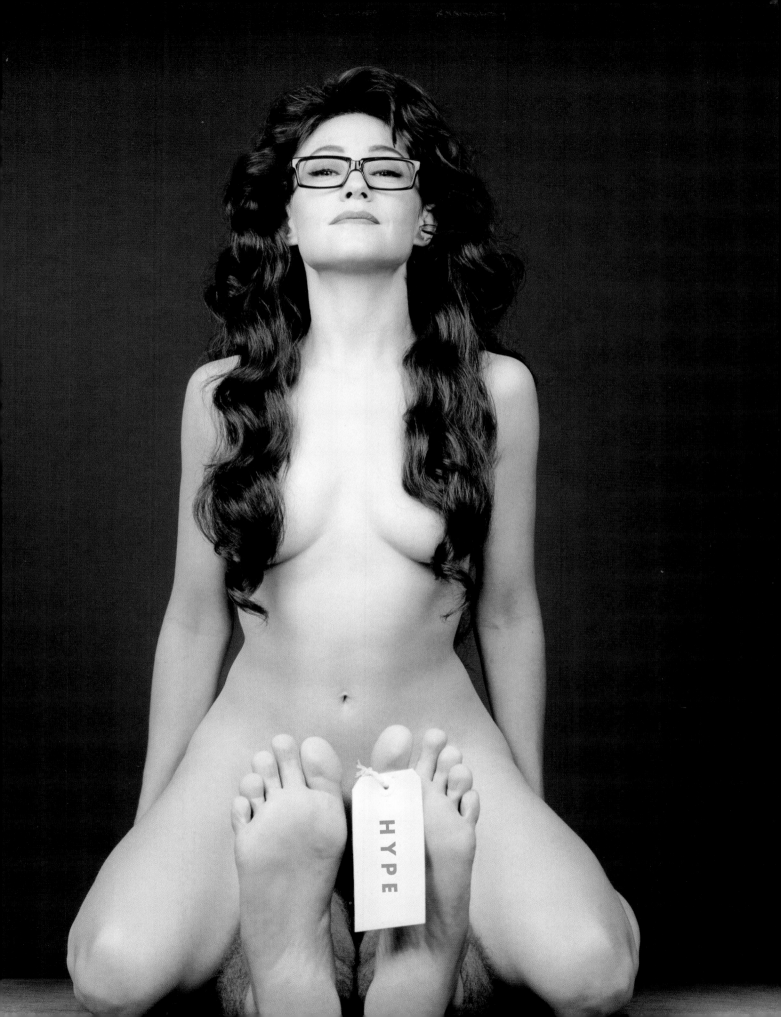

new notion of self-identity. Punkishly rejecting style the way the moneyed few defined it became a kind of style in itself. And our magazine reveled in it.

Never mind that no one got it or that anyone with advertising dollars didn't much care for what we were covering. When people asked us about our beats—whether we reported on art, music or fashion, food or film, gay or straight lifestyles, hot or cool hype, nightlife or shopping, celebrities or anti-heroes, the salons or the streets—we never knew what to say. The problem with PAPER was that it was all the same to us. We thought that subculture, pop culture and youth culture were parts of a whole, not divergent forces. That's the sort of folly that, two decades later, looks like wisdom. Though it sounds obvious now, it wasn't at the time—not at all.

After World War II, all hell broke loose in American culture. That story is rote to anyone who's ever passed the History Channel while flipping to MTV, but what's significant to remember is that every radical postwar movement was first perceived as a subculture. Whenever new modes of expression were born—from comics to graffiti art, motorcycle clubs to gangs, rock to rap—they were considered aberrant, anti-social and, most significantly, alarming new signs of juvenile delinquency. But if history is studied from the mid-'80s on, what PAPER intuited was both the blurring of these boundaries and, ultimately, the foregrounding of youth subculture as the dominant language of popular culture. Much more than merely a mainstreaming, the effect was more like a globalization.

When we experienced hip-hop, punk rock and hardcore, skateboarding, tattoos and body modification, drag performance and transgender identity in the late '70s and early '80s, we weren't the only ones, but we were among the first. Each passed through New York on its way to global prominence. And not only did everything we believe in turn out to be a legitimate genre (despite the culture industry's condescending assertions otherwise), each became a meme passed over continents and between cultures to emerge as international languages unto themselves. What PAPER witnessed over these past 20 years has been truly dramatic: criminals becoming established artists, established artists becoming martyrs, drag queens becoming pop stars, porn stars becoming movie stars, trespassers becoming sports heroes and even artists mass-

manufacturing toys and co-branding sneakers. Watching so many of the marginal achieve iconic status has been vindicating. But that's less exciting than the cumulative effect of this, the subjugation of every aspect of our culture to style. Under that rubric we must include life itself, which is now being marketed as a lifestyle. ◦ *Carlo McCormick has been writing about his famous friends for PAPER since the beginning. When not composing long e-mails, our renowned senior editor writes about the arts. Weegee's Trick Photography, his latest book, is forthcoming from Steidl, and he is currently curating an exhibit, "The Downtown Show: New York Art Scene 1974–1984," which will open in 2006 at New York University's Grey Art Gallery.*

Broome Street and West Broadway circa 2004 (above); Broome Street and West Broadway circa 1984 (right)

IT'S A PAPER PARTY

WE INVITED SOME OF OUR MOST CELEBRATED
FRIENDS TO SHARE HOW *PAPER* INSPIRED THEM ON THEIR WAY UP

moby on paper

I'VE BEEN ON THE COVER OF *PAPER* twice, which is pretty fucking cool. It's also pretty remarkable, since I was first exposed to the magazine in the mid-'80s while living in an abandoned lock factory in Stamford, Connecticut. I was quite poor at the time—my weekly pay hovered in the $50 range—so to save money I would take the train into Manhattan and avoid paying the $6.50 one-way fare by hiding in the toilets. Once in the city, I would pound the pavement, searching for DJ gigs and record companies that I could persuade to release my music. When I was on PAPER's cover a few years later, I knew that my little world had been turned upside down.

But before that, at the end of the night, I would almost always take the last train back to Connecticut. Otherwise I'd have to sleep in Grand Central Station (stinky, cold and scary) or stay awake with a bagel and coffee until the first train left in the morning (very depressing). While waiting for the train to leave, I'd kill time by reading PAPER and dreaming about what life might be like if I could actually enter New York's fantastic nightclubs rather than just stand outside them, being ignored by the beautiful door people.

By '88, the magazine had already achieved iconic status. It reported on everything in lower Manhattan that was glamorous, progressive and degenerate. PAPER defined success in below–14th Street terms: free drinks, DJing at Club MK, a studio apartment near 7th Street and Avenue B, having a girlfriend and maybe even enough money to buy records once a week. PAPER showed me what life could be like if I had a modicum of success, and it made that life seem almost narcotic. Now Kim and David have asked me to write a little essay to celebrate their magazine's 20th anniversary, and I'm happy to do so.

Even as it has continued to chronicle a very avant style, PAPER has also managed to remain egalitarian, an enthusiastic champion of culture that might otherwise be ignored. The magazine has stayed playful, and to its credit it has never taken itself—or the scene that it champions—too seriously. So happy birthday, PAPER. You've done great work, and you deserve to be proud. And should you ever want to know the best way to ride Metro North without having to pay (though the toilets can still be kind of stinky), feel free to ask. My days of returning cans to the A&P to make money might be behind me, but PAPER still excites me as much as it did when I was living in the good old abandoned Yale Town & Lock Factory in Stamford. So again, happy birthday—and I wish you many more. ○
Vegan, political activist and pop star, Moby is a force to reckon with. His album Play *sold 10 million copies. He appeared on two* PAPER *covers, first in November 1993 and then December 1999.*

fab 5 freddy on paper

BACK IN THE LATE '70S AND EARLY '80S, *THE SOHO Weekly News* was mandatory reading for those who wanted to know where "it" was and "who" would be there doing it. At that time, the East Village had become the center of all things cutting edge and creative, primarily because of the then-affordable rents. Art spaces opened there every other week following the success of the Fun Gallery, where I showed my paintings—as did Keith Haring, Dondi White, Kenny Scharf and Jean-Michel Basquiat. The tacky and terminally un-hip would travel from the outer boroughs into the city on weekends to invade our haunts and lairs, stinking up the vibe and spoiling the party. We called them "bridge-and-tunnel people." You'd know them immediately by their bad hairstyles, tasteless dress and often-rowdy attitudes. That was the chief reason for doormen and velvet ropes: to hold those squares at bay so the truly hip could play. That East Village edge has all but vanished now, but in those days the neighborhood credo was, "Avenue A, you're all right; Avenue B, be careful; Avenue C, you're crazy; and Avenue D, you're dead!"

One day in 1983 while hanging at my friend Bernard Zekri's sprawling East Village apartment, a friend of his named David Hershkovits stopped by. David was a writer for *The Soho Weekly News* (which, unfortunately, had just gone out of business), and he sported a cool, '50s-inspired outfit, wearing his ubiquitous porkpie hat and glasses. He pulled a huge sheet of paper about the size of a poster

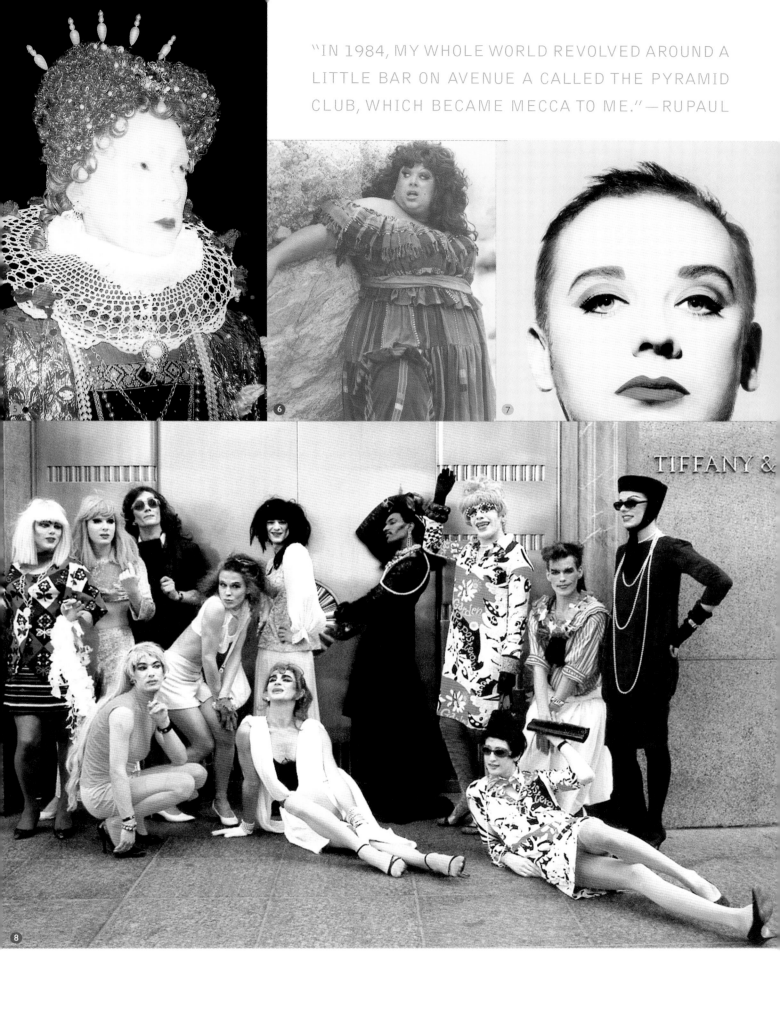

"IN 1984, MY WHOLE WORLD REVOLVED AROUND A LITTLE BAR ON AVENUE A CALLED THE PYRAMID CLUB, WHICH BECAME MECCA TO ME." —RUPAUL

SKATE

PUT THAT IN YOUR HALF-PIPE AND SMOKE IT

SKATEBOARDERS ARE FORWARD-THINKING INDIVIDUALS by nature. Creativity, innovation and rebelliousness are built into skate culture at its most basic levels. Although skaters may have influenced style during the last 20 years, one thing is for sure: They didn't plan to. When a skateboarder wakes up in the morning, they do not think about how their fashion sense is going to influence the world around them. The thought of that is almost laughable. In the '90s, skaters wore baggy pants because they made it easier for them to perform the technical tricks that were popular at the time. True skateboarding style has always been a reaction *against* fashion and the herd mentality. That's not to say skaters haven't been influenced by fashion; they most certainly have. They usually interpret it, though, as an ironic statement or a commentary on consumer culture. As a side note, I should mention that Mark Gonzales *was* wearing foam trucker hats in 1991—but he doesn't now.

In the early '90s, skateboarding became cool to people outside of the culture. For that you can blame MTV, the X-Games, Tony Hawk's video game and a host of other pop-cultural phenomena that helped demystify skaters' outsider aesthetic. Large companies spent tens of thousands of dollars a year to find out what was happening on the streets and in the subcultures. Each season they'd get their little report and try to copy what it said. That's how skate style made it into the malls. PAPER magazine has always subscribed to a philosophy that is very similar to that of skate culture. It's an innovative publication that pushes itself to be better and doesn't base its coverage on what's popular in the market, but rather on what the editors feel is important to the culture at large. It doesn't compare itself with other publications, though it could be argued that PAPER invented the mold for the myriad alterna-pop magazines that followed and now pollute our newsstands. Time and time again, PAPER has reported on people, events and movements long before they were of interest to a wide audience. Like skaters, the staff at PAPER just does what they do best, and as a result, people follow. Sometimes we all pay the price for this. The skate style that made it into mainstream consciousness could be a direct result of their coverage. There's little doubt that all the trendspotters have subscriptions, but that's not PAPER's fault.

As long as the world keeps turning, skaters and other alternative subcultures will continue to inform the mainstream, because the establishment fuels itself off the underground. Skateboarding is and will continue to be a subculture simply because it keeps *moving*. In most places in the world, skateboarding is still very much an illegal act. Security guards and police constantly accost skaters for practicing their art. Luckily, mainstream culture can never totally assimilate a movement that involves breaking the law, since it threatens the power structure. This is a good thing, because as long as skateboarding stays underground, it remains vital. ○

Aaron Rose is the founder of the seminal art/skate gallery Alleged, which dazzled both Los Angeles and New York during the '90s. His recently published book *Beautiful Losers* places the work of skate heroes Mark Gonzales, Chris Johanson and Shepard Fairey alongside modern masters like Jean-Michel Basquiat and Keith Haring. An accompanying exhibition toured the U.S.

skate + style according to aaron rose

"WHEN A SKATEBOARDER WAKES UP IN THE MORNING, THEY DO NOT THINK ABOUT HOW THEIR FASHION SENSE IS GOING TO INFLUENCE THE WORLD AROUND THEM. THE THOUGHT IS ALMOST LAUGHABLE."

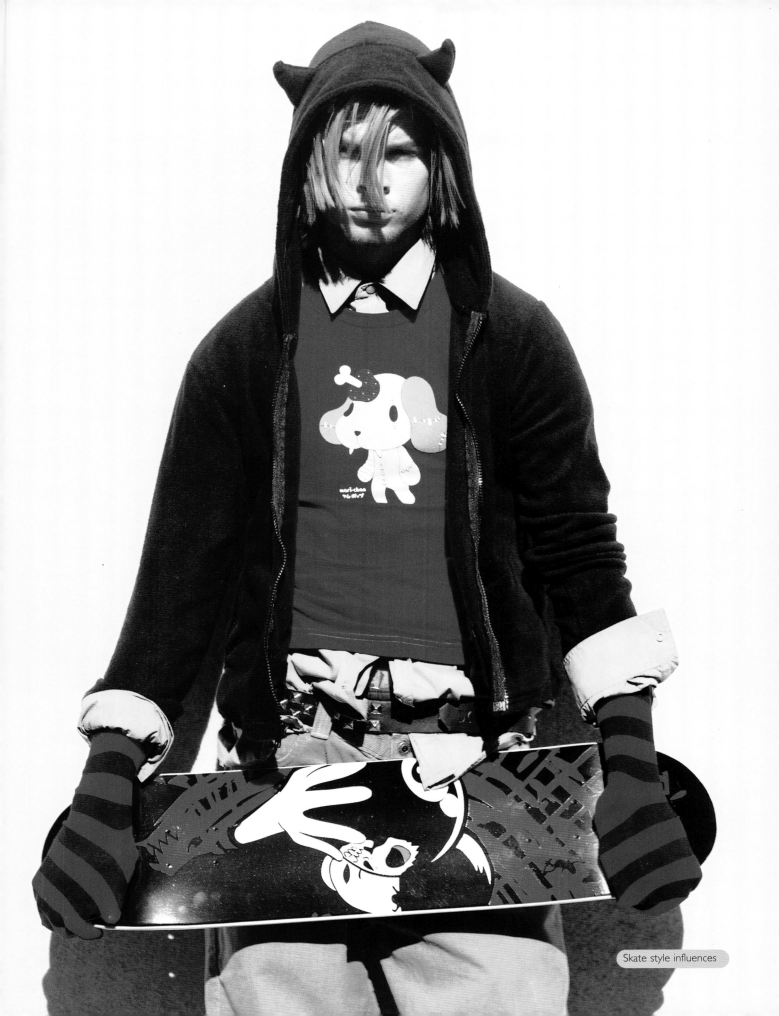

Skate style influences

SKATE

● I *Girl* skateboards became collectible.

● 2 Skate stores became social hangouts.

● 3 Cartoons on the bottom of skateboards are big. ● 4 Urban sidewalk skating

● 5 Artist Phil Frost skateboard becomes a collectors' item.

● 6 Skater Jason Lee designed a sneaker, then went on to become a movie star.

● 7 Skate artist/director Mike Mills' graphic depiction of Yves Saint Laurent

● 8 Art from the skate movement at Aaron Rose's Alleged Gallery

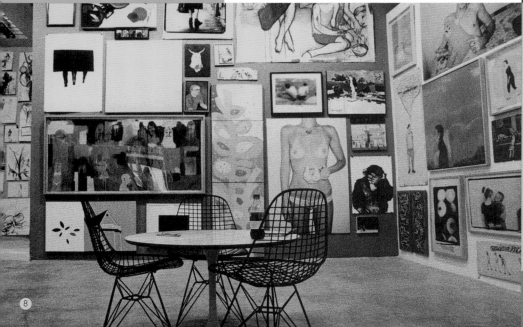

7 YVES SAINT LAURENT FASHION DESIGNE

BEFORE SKATERS THERE WERE JUST SURFERS, AND their look was something like yachtsman-meets-beach-bum. Clean, wide competition stripes on shirts; brown hair sun-bleached orange; shaggy, long bangs; baggy surf jams (always low enough to reveal china-white skin and pubes) bursting forth to the sun. The tan line was everything. Britney Spears' midriff-bearing-thong style owes a lot to this (and to *The Little Mermaid*).

By comparison, skaters have always had a less wholesome image. They dressed like suburban sur-vivalists, with the drabness of military greens and browns camouflaging them against the gray concrete and colored mirror walls of corporate America, where they found their best rides. L.A. was the per-fect landscape to find skating surfaces: empty swim-ming pools, business plazas with wide steps devoid of humans, showplaces for cars passing by.

Frowned upon as delinquents who were disre-spectful of private property, skaters and their casual attire were a great source of reinvention and inspira-tion for fashion—a world also built on a slouch, that gesture of offhanded worldliness. Skatewear was just another trend in the tradition of packaging the Southern California lifestyle as an aesthetic ideal and then exporting it throughout the country via MTV and lifestyle magazines. ○ Kim Gordon not only plays bass in Sonic Youth, but also created X-Girl, her own cloth-ing label, and started a family with fellow band mem-ber Thurston Moore. (They have a daughter, Coco.) Gordon has guest-starred with Sonic Youth on the animated television series *The Simpsons* and pro-duced Hole's first album, *Pretty on the Inside*. She appeared on PAPER's cover in March 1994.

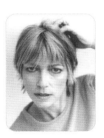

according to kim gordon

STYLE IS EVERYWHERE

SO WHERE DOES IT START ANYWAY?

OVER THE YEARS, WE HAVE BECOME WHAT WE LIKE TO CALL "SUBCULTURAL ANTHROPOLOGISTS." WE'VE DISCOVERED AND DOCUMENTED A NUMBER OF HUGE STYLE MOVEMENTS THAT BEGAN IN OUR SMALL, PERSONAL WORLD—ON THE FRONT-LINES OF DOWNTOWN'S EDGY CREATIVE COMMUNITY. WE'VE WATCHED SEEDS OF INNOVATION GERMINATE AND DEVELOP FROM THE DARK, ROUGH ROOTS OF UNDER-GROUND SCENES INTO TRENDS THAT EVENTUALLY BECAME DILUTED BY THE MAIN-STREAM, WHICH APPROPRIATES AND REPACKAGES THESE IDEAS FOR THE MASSES. • SO HOW DOES STYLE START? ONE SURE THING IS THAT IT DOES *NOT* BEGIN ON THE PAGES OF FASHION MAGAZINES. STYLE DOESN'T BEGIN ON SEVENTH AVENUE OR THE FASH-ION DESIGNERS' CATWALKS EITHER. CONTRARY TO PUBLIC OPINION, IT DOESN'T EVEN ORIGINATE IN TRENDY PLACES OR THROUGH TRENDY PEOPLE. TRENDS MAY BE WHAT BRIDGE STYLE INTO MAINSTREAM CULTURE, BUT A TREND'S DAYS ARE NUMBERED, IF NOT OVER, AS SOON AS IT'S NOTICED. THE TRUTH IS THAT STYLE ALWAYS BEGINS WITH CREATIVE PEOPLE WHO NEVER CONSCIOUSLY SET OUT TO INFLUENCE IT.

by kim hastreiter

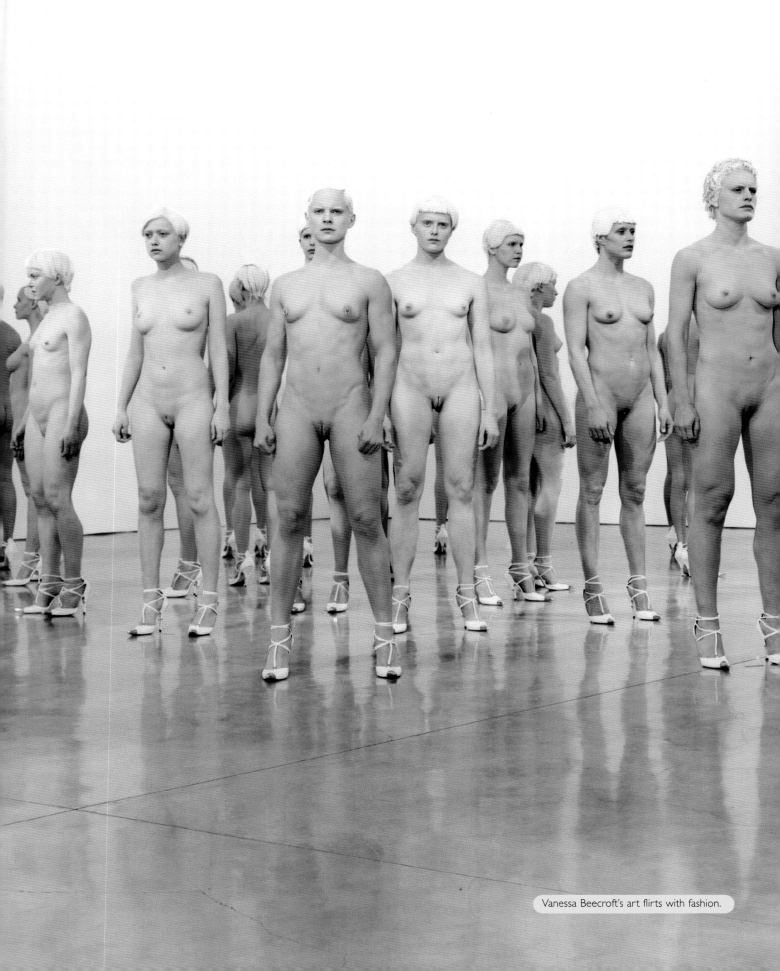

Vanessa Beecroft's art flirts with fashion.

"WHEN I TRANSFORM MY GALLERY INTO A FASHION EXHIBIT, A SKATEBOARD HALF-PIPE, A PEEP-SHOW EMPORIUM OR A TATTOO PARLOR, PEOPLE NO LONGER ASK, 'IS IT ART?' THEY ASK, 'HOW DO YOU MAKE MONEY?'" —JEFFREY DEITCH

40

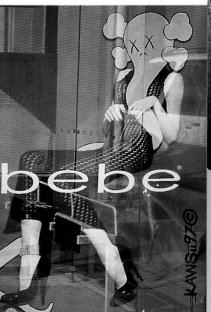

bebe

● 1 Jeffrey Deitch shows the art/style/music collective Fischerspooner
● 2 Designer Jean-Charles de Castelbajac's Mona Lisa ● 3 Stylin' performance artists Forcefield ● 4 Performance artist Karen Finle●
● 5 Robert Longo's chic women
● 6 Artist Kenny Scharf makes fashion mannequins for Pucci. ● 7 A Keith Haring–tagge● motor bike ● 8 Jean-Michel Basquiat fabric in a Stephen Sprouse collection ● 9 Sneaker companies sponsor artist billboards in L.A.
● 10 Stephen Sprouse's stereo paintings
● 11 A KAWS-tagged bus shelter

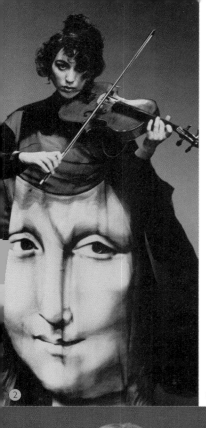

2

3

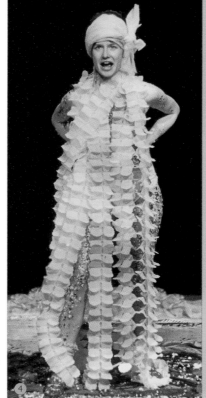

4

5

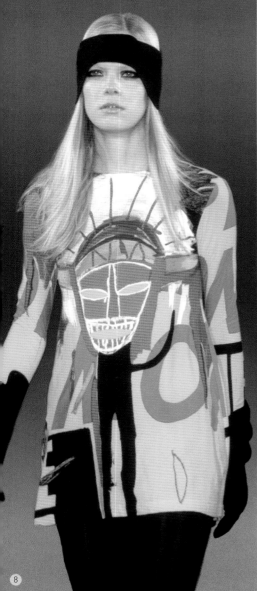

8

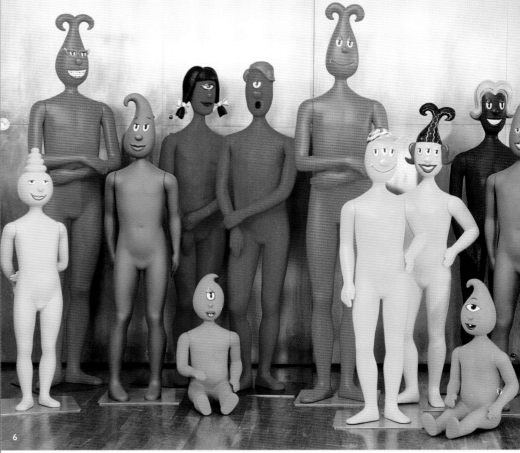

6

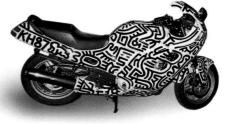

7

MUSIC

WHICH CAME FIRST: THE SOUND OR THE LOOK?

IF FASHION IS A REFLECTION OF THE TIMES, THEN MUSIC is the soundtrack. I started my own company to make clothes for rock stars and people who went to see bands. The first gangs of punks I saw on the King's Road in the mid-'70s were a visual shock to me. The Sex Pistols music they listened to transformed the kids into style rebels who wore bondage trousers, spiderwebby mohair jumpers and studded brothel creepers. The hair was the most important—cropped and sticking up every which way and dyed black, bleached white or crazy-colored. This look was pioneered by designer Vivienne Westwood and her husband, music impresario Malcolm McClaren.

Punk's more commercial cousin of the '80s was new wave. Blondie was the most successful of these artists. It was led by Debbie Harry, who was movie-star beautiful à la Marilyn Monroe. Her mini-dresses, designed by Stephen Sprouse, gave her the cool of a Warhol superstar and inspired the most stylish kids. Stripes or polka dots in black and white, red and black, turquoise and black or hot pink were the essential new-wave design and the core of music-lover Betsey Johnson's first solo collection, which she showed at the ultra-hip Mudd Club. Johnson always had a rocker-chick following and made clothes to dance in.

When goth arrived, black became the color choice of fashion: black hair, black clothes and black pointy shoes, all contrasted with the prerequisite pale skin. Siouxsie and the Banshees and the Cure inspired both the music and the look. Haunting dirges mixed with electronic backgrounds evolved into dance music, and cavernous clubs like the Tunnel and Limelight (which was in an old church) became the scene. Goth has stuck around for a long time, reinventing itself with influences like Tim Burton's film *Beetlejuice* and musicians like Marilyn Manson.

Heavy metal was personified by Bon Jovi and Whitesnake. Some bands took rock 'n' roll style elements to cartoon proportions—the tightest pants, the longest fringe, the biggest, blondest hair. Mötley Crüe and Guns n' Roses inspired every suburban teen to get tattooed. Music exploded into big business and made mega-bucks. Alternative rock also appeared, a genre that appealed to the intellectual, underground college circuit, with bands like the Smashing Pumpkins, Jane's Addiction and the Jesus and Mary Chain. The alternatives reacted against '80s big hair and shoulders, and fashion followed their lead. One minute fashion was about mega-brands, and then overnight people wanted something different, something alternative. I remember the same women who were head-to-toe designer switching to a vintage lingerie top with jeans and an ethnic shawl. This was the '90s answer to '80s power dressing—until grunge came along.

Grunge became the new underground style. In the '80s, the major cities became too expensive for an underground scene, forcing aspiring musicians to move to smaller cities like Austin and Seattle. Bands like Nirvana, Pearl Jam and Soundgarden sent the music industry into a turmoil. Suddenly everyone was scouting Seattle for the new music, and dressing-down became the look. It was all about vintage. Laundered, deconstructed and faded all became desirable design techniques. Every fashion rule was broken, everything wrong became right.

While these have been important influences behind my designs, there were other musical movements that had a great influence on style. The most dominant has been hip-hop, which changed the way the world dressed: Jogging suits replaced business suits, and sneakers became more precious than handmade leather shoes.

So much of the music from the last 20 years immediately evokes to me the styles of each particular era. As the world's taste continues to change in both style and music, I'm sure music will go on to inspire me, as will the artists behind the music who personify the style. ○ Anna Sui has been designing hip clothes inspired by music since the early '80s, when she started a business in her home. She has since become a global fashion star whose clothes, shoes, cosmetics, eyewear and perfumes are coveted by groovy kids worldwide—as well as by pop stars like Madonna, Cher, Gwen Stefani, Courtney Love and Stevie Nicks.

music + style according to anna sui

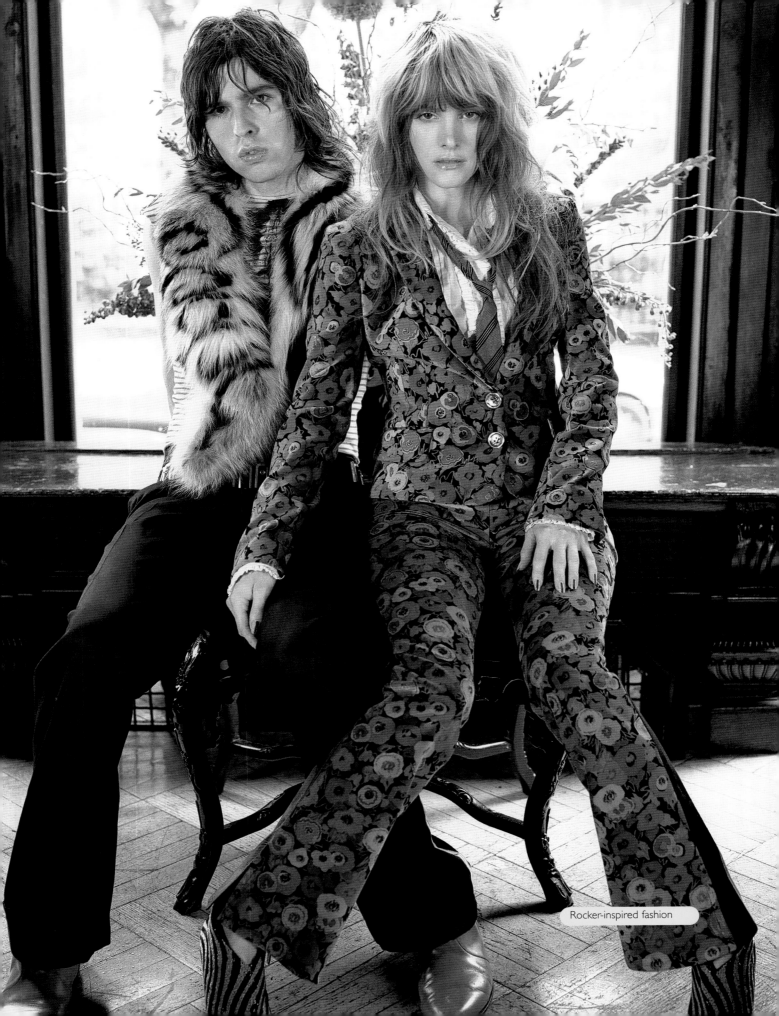

Rocker-inspired fashion

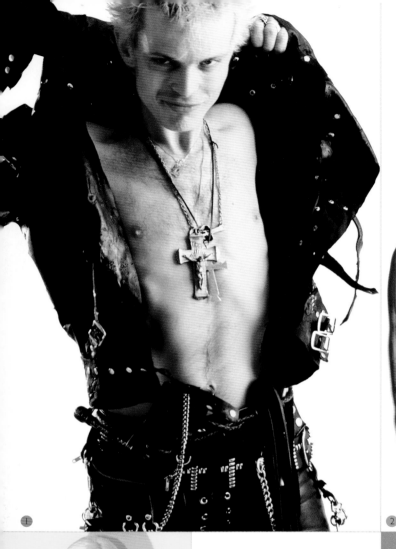

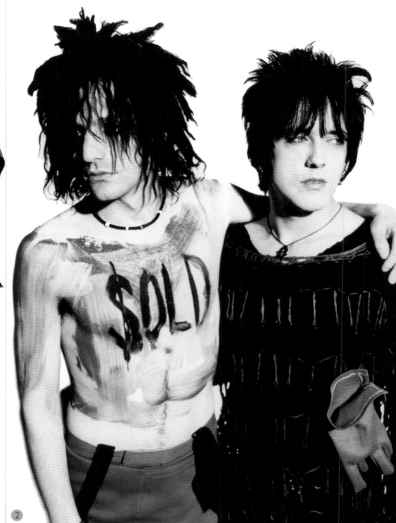

MUSIC

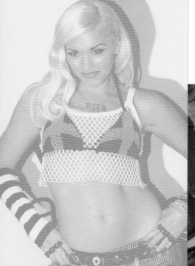

"THE FIRST GANGS OF PUNKS I SAW ON THE KING'S ROAD WERE A VISUAL SHOCK TO ME. THE SEX PISTOLS MUSIC THEY LISTENED TO TRANSFORMED THE KIDS INTO STYLE REBELS."—ANNA SUI

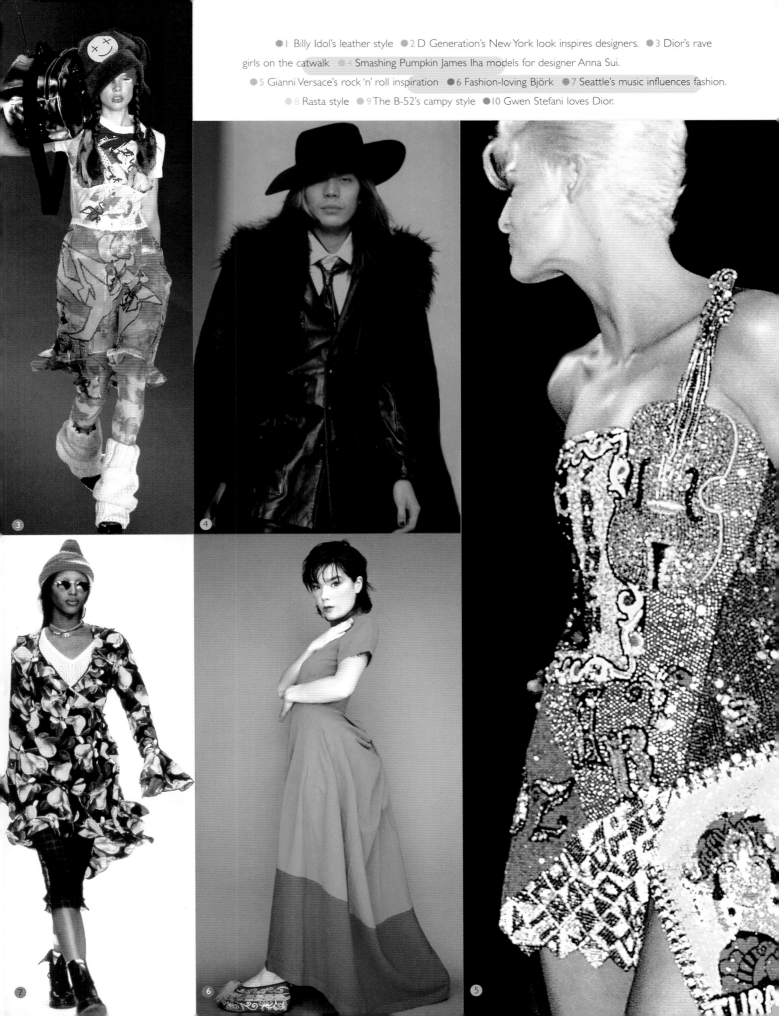

●1 Billy Idol's leather style ●2 D Generation's New York look inspires designers. ●3 Dior's rave girls on the catwalk ●4 Smashing Pumpkin James Iha models for designer Anna Sui.
●5 Gianni Versace's rock 'n' roll inspiration ●6 Fashion-loving Björk ●7 Seattle's music influences fashion.
●8 Rasta style ●9 The B-52's campy style ●10 Gwen Stefani loves Dior.

ENTERTAINMENT

A THOUSAND CHANNELS, A MILLION LOOKS

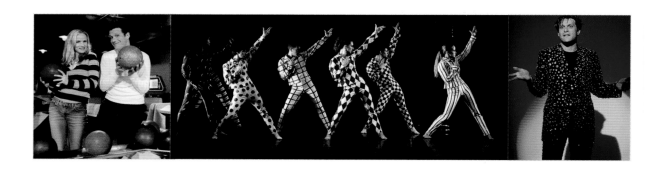

THE FIRST WORDS I UTTERED WHEN I CAME OUT OF the womb were, "Fashion is a form of entertainment." I love to be entertained. I often go to plays, concerts and dance events, and I see a lot of live theater, but mostly everything reaches me through TV. I may go to seven movies in a month, but in that same month I'll see 35 movies on TV. It's a guilty, lazy, wonderful pleasure. Since all this fashion-emphasis television became available, people have evolved stylistically. Whether it's *Sex and the City, Full Frontal Fashion* or *The Isaac Mizrahi Show*, TV's made people more aware of style and raised America's level of taste. That's also been helped by the advent of mass good-taste emporiums like the Gap, Banana Republic, Pottery Barn, Ikea and Target. These days, a person who's stylish seems much better then a person who's fashionable. If a person's fashionable, it's almost bad. If she's dressed in a look from head to toe, you think, "Wow, what's her problem?" Designers *do* put looks together that are perfectly wonderful, and you're supposed to buy the whole outfit that way, yet sometimes that feels like a weird form of tyranny to me. Style comes from everywhere.

Years ago, I did this collection about rappers. I was so inspired by them—I couldn't believe that they could have so little money and so much style. They would do these crazy things with their hair and wear this insane jewelry, half of which they made themselves. That was before bling-bling and all those diamonds, before ghetto-fabulous, which I adore! *Please*, wear a mink coat in August, you know? Those kids really thought style through rigorously. It was important to them, and they unveiled it all in a very dramatic way, almost like designers themselves. It was true creativity,

and it had a great influence on me. In my mind, fashion is either that—the smartest thing in the world, so chock-full of references you don't even recognize it—or the most earnest thing in the world, like a great T-shirt or a great pair of shoes.

As much as I love to be entertained, I love to entertain. I sing, I do a TV show, I wrote a bad screenplay, I design clothes and I even made a movie. That movie, *Unzipped*, was a big moment in my life and sort of made me into this cult figure. People were like, "I love you! I love your mother!" In some ways it made my personality as important as my clothes. Sometimes I think, "How can people look at me and reconcile that I'm a clothing designer *and* a talk show host?" But to me they're the same. I really believe that in the next century, artists will do everything they want to do without boundaries. It's not going to be about the mastery of just one craft or the notion that if you do this, then you can't do that. People are diversifying more and more because boredom has become so extreme today. We are bombarded by so much information, so many images and so many media choices, it feels like you have to do the things that resonate with you personally as an antidote. Diverse things. Things you do because you can't help doing them. Even if it doesn't make sense, sometimes that's the best way to progress.

○ Isaac Mizrahi became a fashion star during the '90s, when his documentary *Unzipped* gave the world a glimpse into his life. After closing his ready-to-wear line a few years later, he created and performed a one-man show, became a talk show host and now designs an enormously successful line of inexpensive clothes for Target—bringing great taste to the masses.

entertainment + style according to isaac mizrahi

From top: Talk show host Mizrahi bowls with Juliette Lewis; Mizrahi-designed costumes for the Mark Morris Dance Troupe; Mizrahi's one-man show. Opposite: Fashion's favorite late-night character, Maya Rudolph, channels Donatella Versace on *Saturday Night Live*.

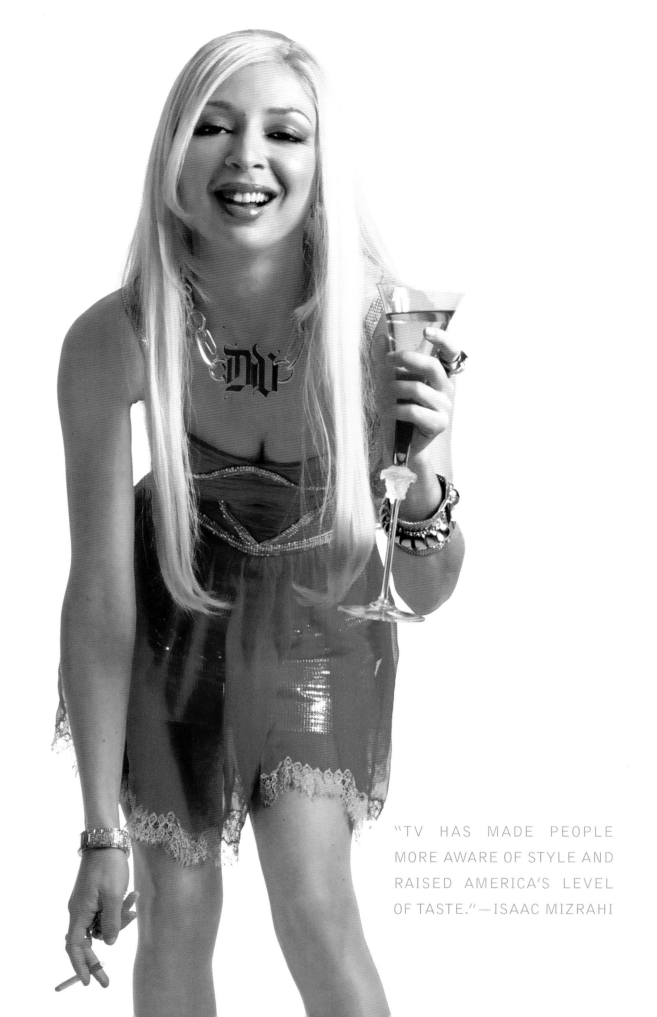

"TV HAS MADE PEOPLE MORE AWARE OF STYLE AND RAISED AMERICA'S LEVEL OF TASTE."—ISAAC MIZRAHI

ENTERTAINMENT

DRESS ME UP! DRESS ME DOWN!

MOVIES OFTEN HAVE AN INSTANT IMPACT ON STYLE. Audrey Hepburn was an inspiration in all the clothes she wore on film. She wore Givenchy in *Sabrina*, while in *Two for the Road*, Paco Rabanne and Mary Quant dressed her. The latter is the story of her marriage to Albert Finney, narrated through her dresses, which keep changing on their trip to marital disaster. But most recently fashion and cinema have united on the red carpet, which, as we all know, has become a catwalk. I don't know if it's necessarily good for fashion, but I will say that being a celebrity does not automatically mean you have good taste or a perfect body. We've also seen the emergence of dirty-chic celebrities. Their style is inspired by the desire to go unnoticed. Uma Thurman, Julia Roberts, Winona Ryder and Kim Basinger made this a trend by wearing huge T-shirts, torn pants, no makeup, messy hair—a simple and anonymous look that actually takes a lot of time and effort to produce.

My taste was formed in the '60s, during the birth, explosion and development of the pop movement. The movies that made an impression on me from my childhood, like *Johnny Guitar* and *Duel in the Sun*, were all very bright. That explains my passion for color. When I started shooting my own films, I used those screaming colors I'd seen back then for the costumes and interiors. My first films were dominated by postmodern style, the very eclectic European design movement of the '70s and '80s. My inspirations ranged from Andy Warhol, Edward Hopper and Doris Day to the English new wave, glam and Frida Kahlo. Furniture and objects, such as pieces by the Italian postmodern designer Ettore Sotsass, also helped give my films their style sensibility. I mixed them with hints of Frank Lloyd Wright, Frank Gehry and kitsch, especially in *Kika*, *High Heels* and *Tie Me Up! Tie Me Down!* Mixing high and low styles has always been heavily featured in my work

and also in my life. I'd visit the clearance sales in Madrid and buy stuff at airport souvenir shops to mix with high design from the Guggenheim or MoMA stores. It all ended up being in my films.

Then fashion—early Versace, Armani, Gaultier, Mugler and Chanel—burst into my work. For example, the star of my film *High Heels*, Victoria Abril, was dressed in a Chanel suit that gave her news-reporter character a sort of uniform in which she was always ready to confront a TV camera. I also worked with Jean Paul Gaultier in my films *Kika* and *Bad Education*. In *Kika*, he designed a "suit" for one of the characters—a dress with the tits torn out, filled with zippers, Velcro and cables. He also designed a matching motorcycle helmet and placed a video camera on top of it. I'd wanted her to be a sort of information soldier, and he solved this problem with spectacular humor.

Fashion in cinema is such an important element of narrative. It not only helps describe the social class of the characters, but also expresses emotions. In *Casablanca*, when Bergman and Bogart meet at Rick's Café, she reminisces of the day they met, "That was the day the Germans marched into Paris." His expression stony, Bogart responds: "I remember every detail. The Germans wore grey, and you wore blue." Through mentioning style, the tough guy is only speaking of his feelings. ○ Spanish filmmaker Pedro Almodóvar is a cult hero not only in Hollywood, where he received a standing ovation when he won an Academy Award, his second, for Best Original Screenplay, but also with the alternative-film crowd. Best known for masterpieces like *Women on the Verge of a Nervous Breakdown*, *Kika*, *All About My Mother* and his most recent, *Bad Education*, his colorful, kitschy, quirky aesthetics add depth and high emotion to his work.

film + style according to pedro almodóvar

Pedro Almodóvar and Jean Paul Gaultier collaborate on costumes for *Kika* (1993). • • • •

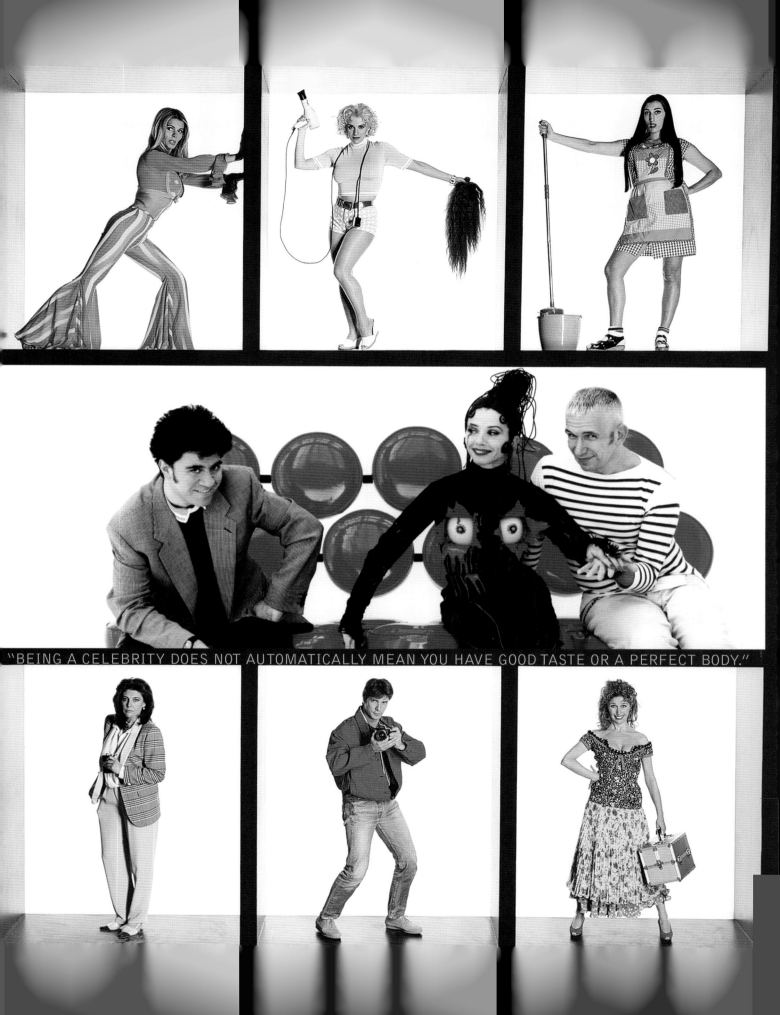

"BEING A CELEBRITY DOES NOT AUTOMATICALLY MEAN YOU HAVE GOOD TASTE OR A PERFECT BODY."

ENTERTAINMENT

SUPERSTARS AS SUPERMODELS

BACK IN THE GOLDEN AGE OF FILM, ACTRESSES KNEW inherently how to dress themselves. But I would say that within the past five to eight years, many celebrities, performers, entertainers and creative people stopped thinking for themselves. It's really become an epidemic. Celebrities seem to have lost their sense of identity. Because they're now on the cover of every fashion magazine, they get stylists and designers to dress them. It's symbiotic, though. They're "dressed" and given clothes, and the designers want to give them clothes because it's good for their businesses. So these artists give themselves over without much input as to who they are or who they are trying to be. I think when you just throw the average actress onto the cover of a fashion magazine, it usually doesn't serve either the actress *or* the magazine.

Gwen Stefani is one celebrity who really loves fashion and gets it. She knows how to dress herself. What she's wearing comes from her, not from a stylist. But if you're going to talk about actresses, to me the Renée Zellwegers and Nicole Kidmans of the world are completely fabricated. Those girls were blank slates, and the stylists just kind of glommed onto them. But there are some celebrities who don't bother me so much. P. Diddy certainly has great style and even designs great clothes. And I think ladies like Mary J. Blige and Missy Elliott have a lot of style. The African-American sensibility has always informed fashion, from Chanel on down. The big, clunky gold jewelry and the big, fake diamonds—I think they're a little bit above the fray. The bling-bling thing has been fun too—it's on the fine line between the street and fabulousity. It's always good when the street crosses over. ○ Sandra Bernhard's career has defied convention. She rose to national attention in Martin Scorcese's *King of Comedy*. A comedian, actor and writer, her book *Confessions of a Pretty Lady* received accolades, and her one-woman show on Broadway, *Without You I'm Nothing*, was later made into a movie. A style lover, she raised the bar when she hosted the CFDA awards, injecting humor into the fashion business. She has appeared on the cover of PAPER three times: April 1988, May 1990 and January 1998.

●1 Stella McCartney and Kate Hudson ●2 Narciso Rodriguez and Rachel Weisz at the CFDA awards ●3 Liza Minnelli and the late Kevyn Aucoin ●4 Designer Tom Ford is a star himself. ●5 The CFDA Awards attracts stars like Renée Zellweger. ●6 Celebrities love Dolce & Gabbana. ●7 Sarah Jessica Parker and *Sex and the City* set fashion trends. ●8 Gwyneth Paltrow front row at Calvin Klein ●9 Todd Oldham dresses his friend Susan Sarandon. ●10 Zac Posen brings Claire Danes to the CFDA Awards. ●11 The Hilton sisters and stylist Patricia Field ●12 Celebrity stylist Phillip Bloch and Lauren Holly

celebrity + style according to sandra bernhard

DAYLIFE

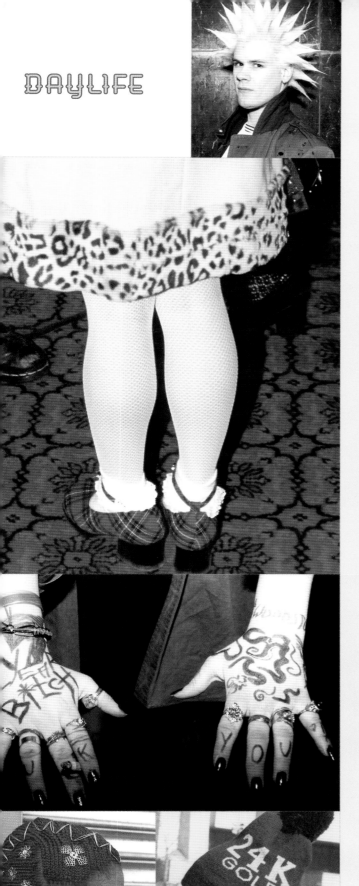

BILL CUNNINGHAM IS ONE OF NEW YORK'S MOST BRILLIANT DOCU-
MENTARIANS OF STYLE. HIS SPRITE FIGURE CAN BE SEEN ALL OVER THE
CITY SHOOTING LOOKS THAT CATCH HIS EYE FOR HIS WEEKLY
COLUMNS IN THE SUNDAY *NEW YORK TIMES*—WHETHER AT FASHION
SHOWS, GALA PARTIES OR ON THE SIDEWALKS. CUNNINGHAM IS
BELOVED BY BOTH THE FASHION COMMUNITY AND THE STYLE-
SAVVY STREET KIDS HE CHASES AND PHOTOGRAPHS WITH GLEE.

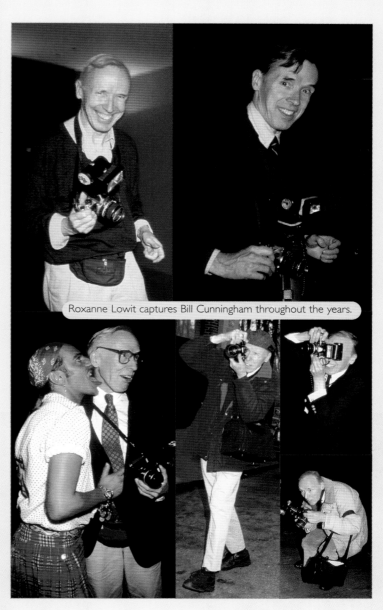

Roxanne Lowit captures Bill Cunningham throughout the years.

◇ ◇ ◇ ◇ ◇ RUBEN TOLEDO ON BILL CUNNINGHAM ◇ ◇ ◇ ◇ ◇

Bill Cunningham is a true subversive. He defies definition. He is a real genius, but
don't tell him I said that! He is a lover of the ridiculous and the beautiful, but
above all the sincere. He captures with his third eye the big blur of style—the
shadow of the next big movement, the aura of creative electricity. He witnesses
fashion the way a sportscaster follows a game. He can sense a home run before
it happens and smell a foul a mile away. He knows the team members by heart,
as well as the crowds that are cheering or booing. He knows when the game is
over and when a new sport is about to be invented. He is both a wise man and
a wise guy. He gave us the best advice we ever got: "Keep your enthusiasm,
kids!" He is the Weegee of style. ◇ Ruben Toledo is an artist and illustrator.

NIGHTLIFE

THEY COME OUT AT NIGHT—AND SPARKLE

OVER THE YEARS, I'VE SEEN SO MANY FRESH LOOKS come out of the club scene: hip-hop, neo-punk, club kids, pirate wear, the sexy wet look and vintage, vintage, vintage. Back then the kids didn't have money, so they raided their parents' or even grandparents' closets. They scoured second-hand stores to put their outfits together for a dollar. Then they'd bring their own style to it. You'd see guys in jackets with skinny ties and girls wearing big hair with an old dress. That's why vintage clothes have always inspired so many designers. They got their ideas from kids at the clubs.

The club diva always led the pack at night. These women would stop traffic. I've always loved divas, because they are larger than life and make a good entrance every time. They're the kind of people who say, "Look at me," with their style. Goddesses like Dianne Brill, Sally Randall and Susanne Bartsch were so influential. They went out every single night. In the early '80s, Dianne was queen of the scene and on everyone's A list. With her big personality, big hair and big bust, everything about her was cartoony. Drag queens took a lot of their inspiration from her; I think she even influenced RuPaul. Jean Paul Gaultier and Thierry Mugler used Dianne in their runway shows in Paris; years later, Versace showed some elements of her as well with his Jayne-Mansfield-meets-Wonder-Woman looks. Susanne Bartsch also did intense drag and had a fashion-crowd following. She brought British inspiration with her, paying homage to Leigh Bowery and Vivienne Westwood.

Depending on the club and the drug of choice, there were usually different style movements going on simultaneously. Ecstasy ruled the rave kids and affected their style. They ate lollipops and sucked on pacifiers at the Limelight. In contrast to the black-clad downtown crowd, they all wore bright colors and childlike clothes. And gay ravers really pushed drag to clowndom.

Then there were the vogueing balls in Harlem, which were amazing. Uptown, the gays of color came out at night and invented these drag "gangs" that competed in runway contests for huge trophies. Emulating fashion from the pages of *Vogue*, they fought to see who could look the most real as a supermodel, banjee queen or homegirl. Realness meant passing—female drag that was so authentic the boys could walk the streets without being found out. Eventually, these house balls were discovered by downtown, and Madonna even wrote a song about them.

The downtown scene also embraced potheads and grunge. Everyone had a flannel shirt. Girls wore them around their waists, over their dresses. It was definitely not glam. Some called it the "brown movement." Jackie 60 used to throw brown parties. Marc Jacobs loved them and went all the time.

There are still style leaders these days who show their stuff at night, like Chloë Sevigny, As Four, Tara Subkoff, Hope Atherton and the Schnabel and Marden daughters. The bottom line is that it's always the creative people—the artists—who have real style. ○ Patrick McMullan has been photographing the nightlife scene since the early '80s, capturing eras of style through his camera lens. His work, which can be seen in myriad magazines every month, has now made him a celebrity, as the rich and the famous vie to pose for him. His latest book, *So80s*, debuted in the windows at Bergdorf Goodman, where his launch party drew close to a thousand celebrities and other fabulous people.

nightlife + style according to patrick mcmullan

Kenny Kenny at Spa, 2000 • • • • • •

56

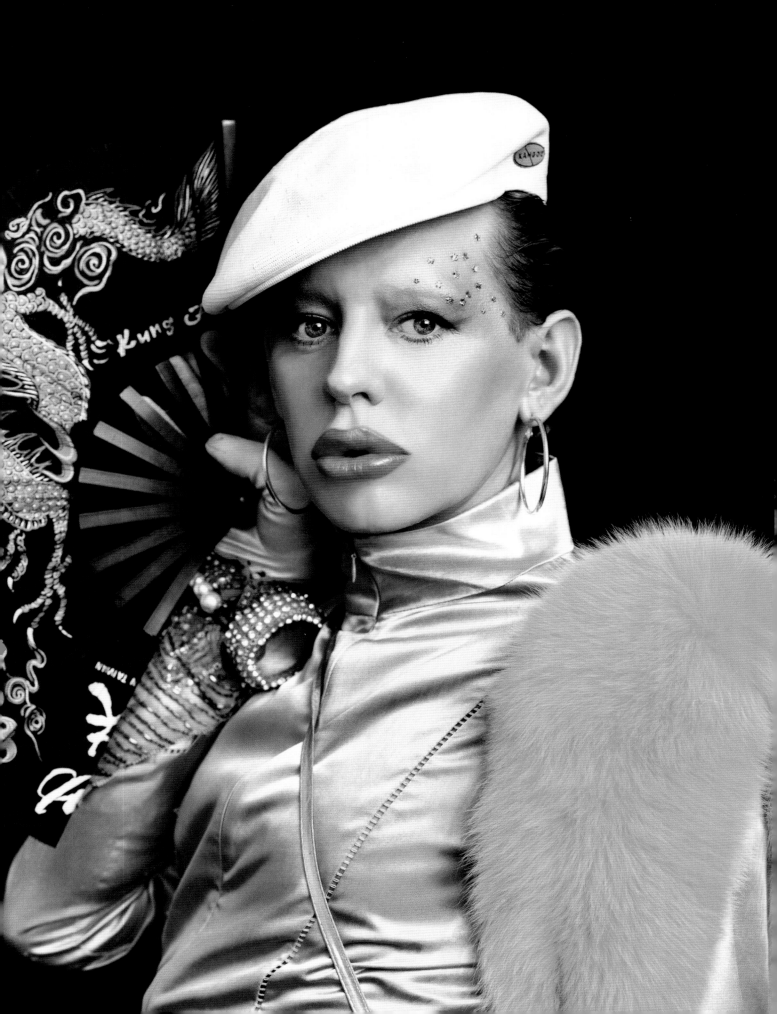

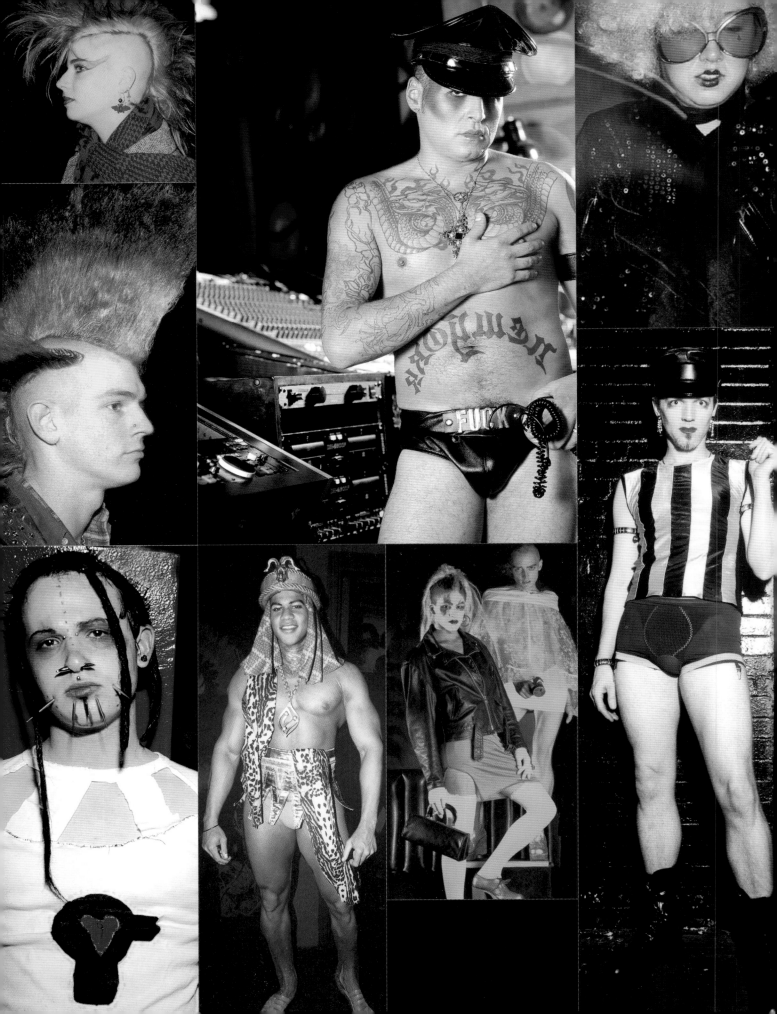

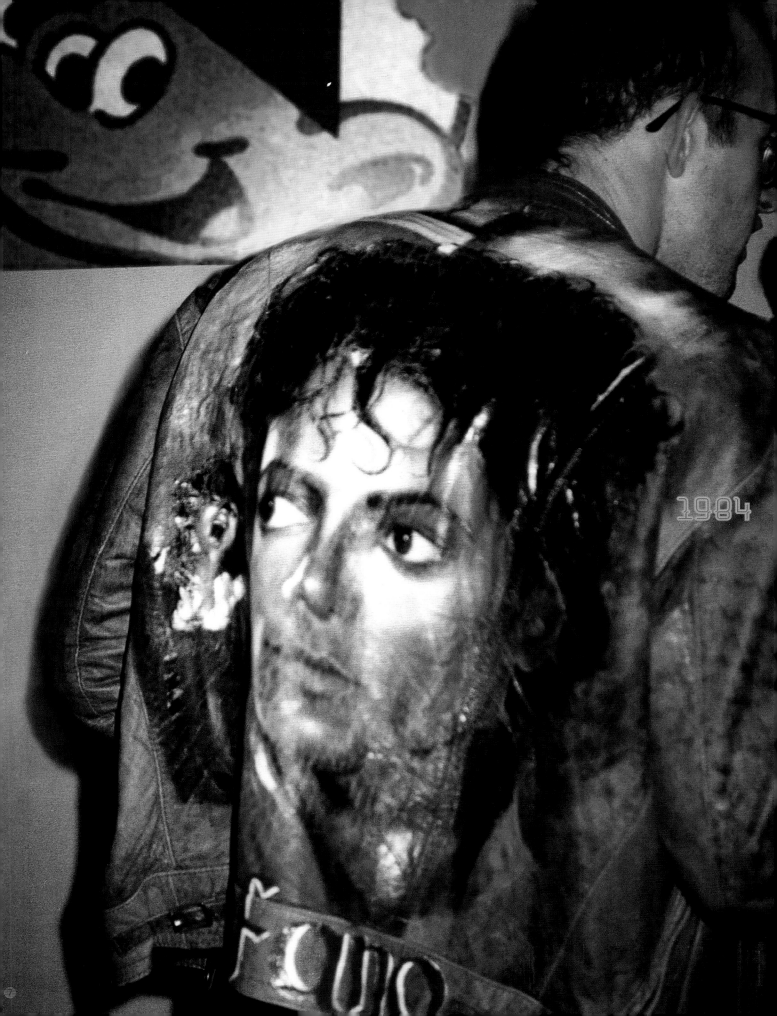

1984

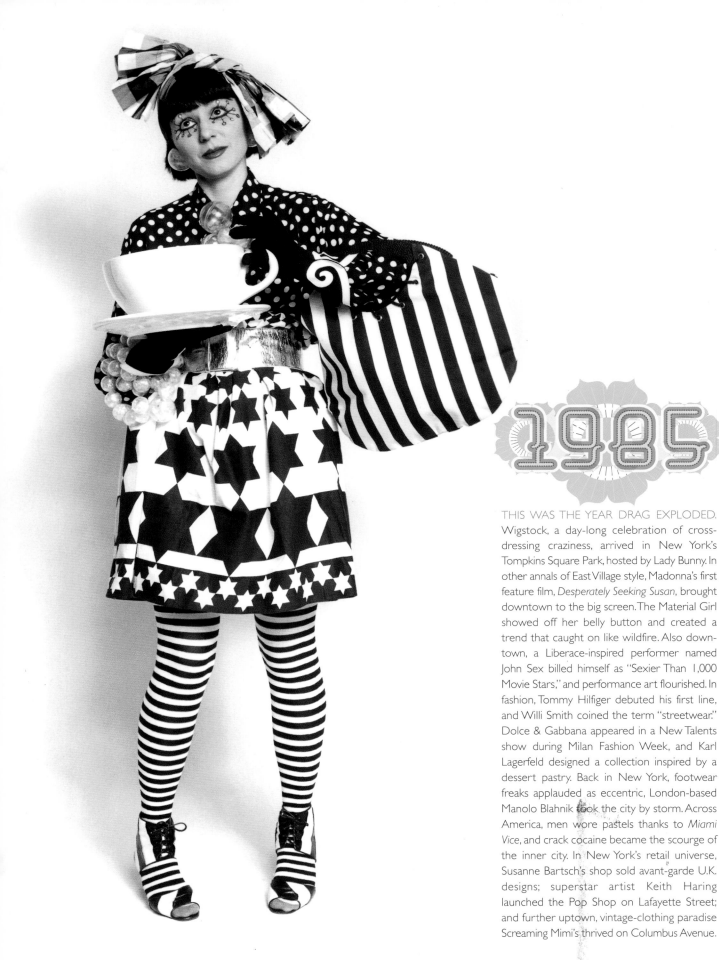

1985

THIS WAS THE YEAR DRAG EXPLODED. Wigstock, a day-long celebration of cross-dressing craziness, arrived in New York's Tompkins Square Park, hosted by Lady Bunny. In other annals of East Village style, Madonna's first feature film, *Desperately Seeking Susan*, brought downtown to the big screen. The Material Girl showed off her belly button and created a trend that caught on like wildfire. Also downtown, a Liberace-inspired performer named John Sex billed himself as "Sexier Than 1,000 Movie Stars," and performance art flourished. In fashion, Tommy Hilfiger debuted his first line, and Willi Smith coined the term "streetwear." Dolce & Gabbana appeared in a New Talents show during Milan Fashion Week, and Karl Lagerfeld designed a collection inspired by a dessert pastry. Back in New York, footwear freaks applauded as eccentric, London-based Manolo Blahnik took the city by storm. Across America, men wore pastels thanks to *Miami Vice*, and crack cocaine became the scourge of the inner city. In New York's retail universe, Susanne Bartsch's shop sold avant-garde U.K. designs; superstar artist Keith Haring launched the Pop Shop on Lafayette Street; and further uptown, vintage-clothing paradise Screaming Mimi's thrived on Columbus Avenue.

1 Style eccentric Louise Doktor goes pop. ● 2 Black and white is the new navy blue. ● ● ● ●

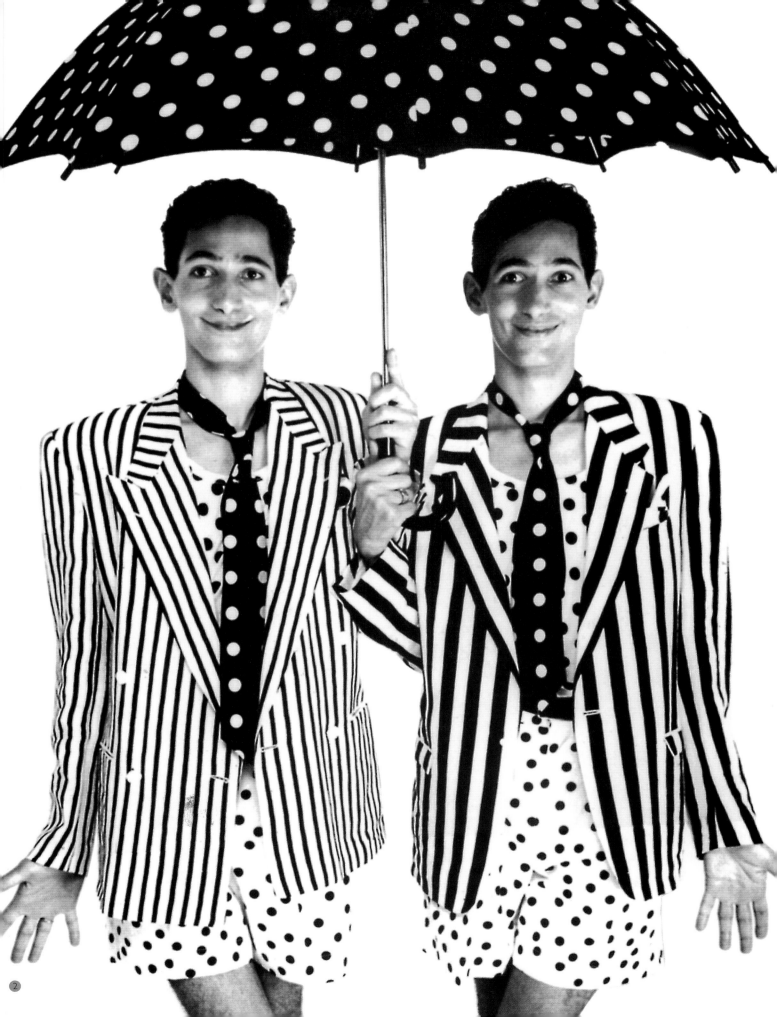

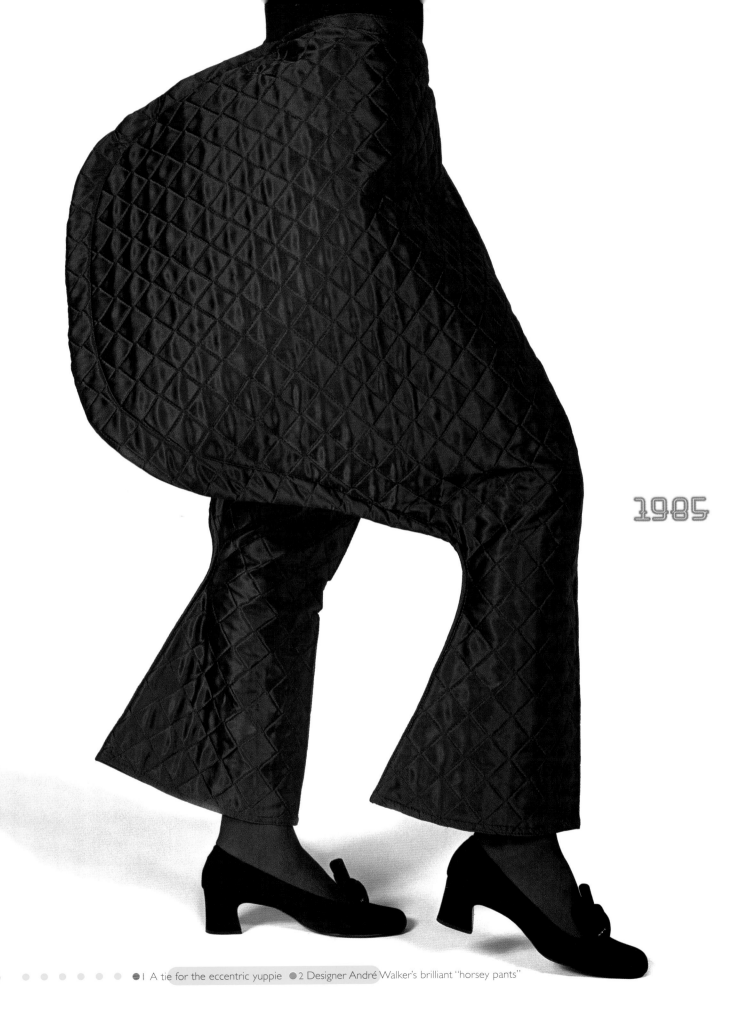

1985

●1 A tie for the eccentric yuppie ●2 Designer André Walker's brilliant "horsey pants"

●1 Manolo Blahnik shows his downtown side. ●2 Karl Lagerfeld designs pastry accessori

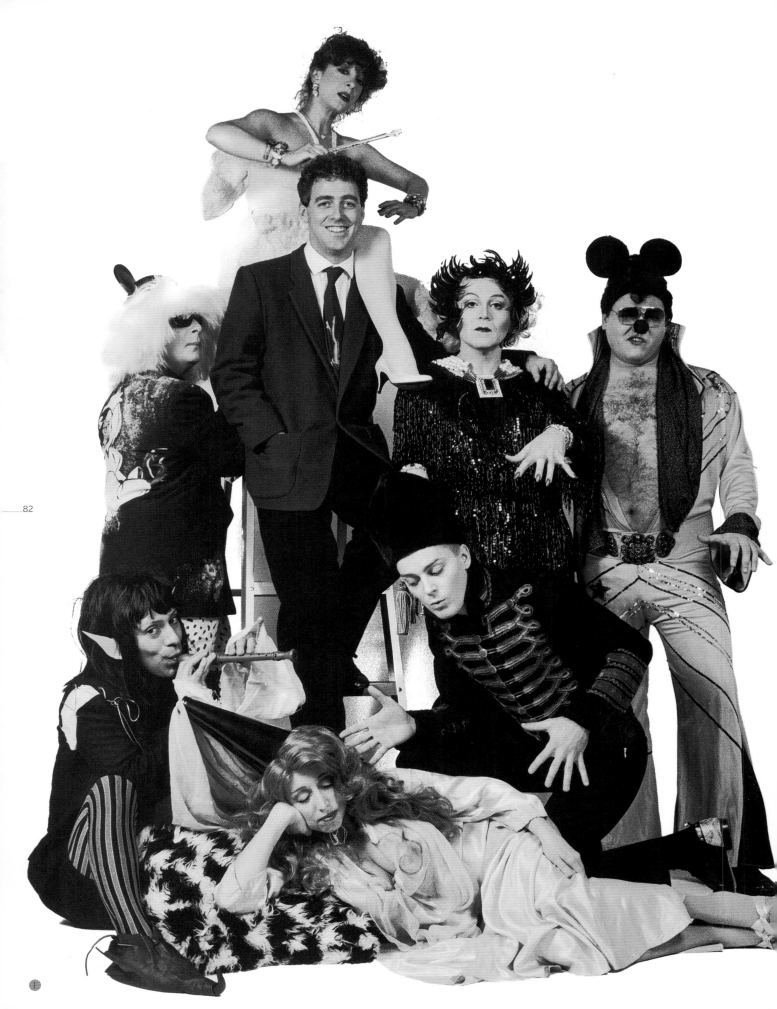

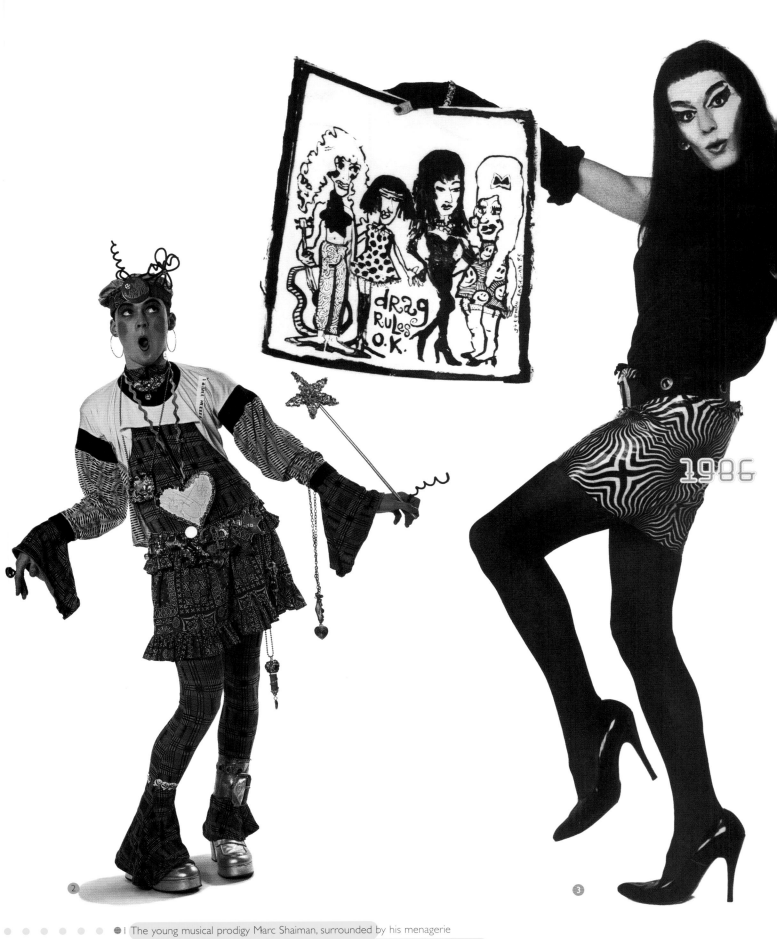

1986

1 The young musical prodigy Marc Shaiman, surrounded by his menagerie
2 Billy Erb wears Bodymap. 3 Artist Tabboo! rocks East Village drag style at the Pyramid Club.

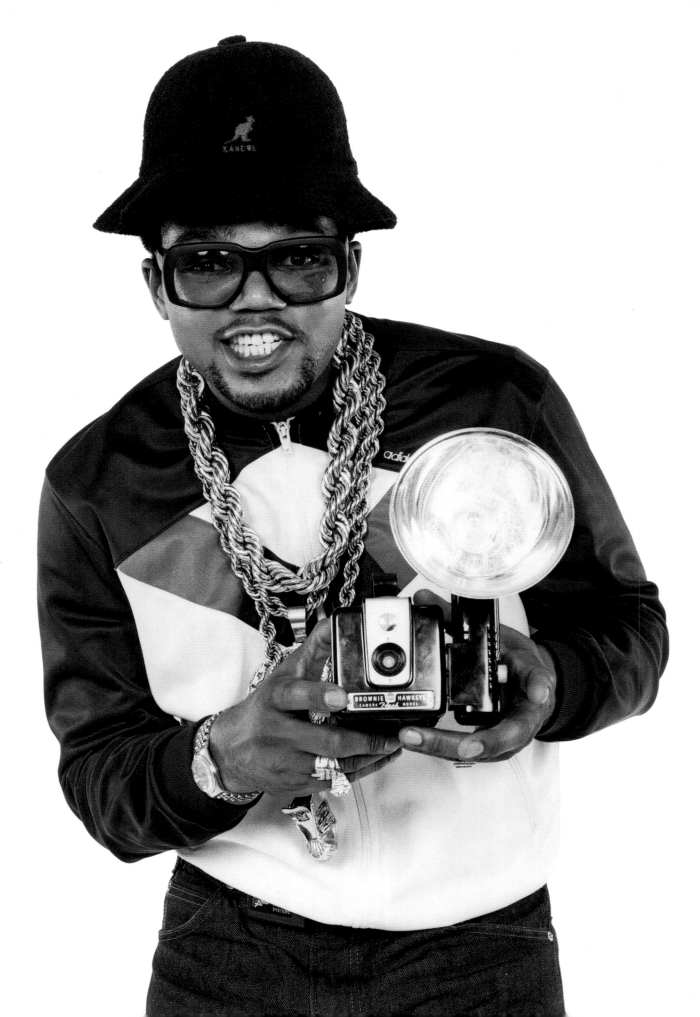

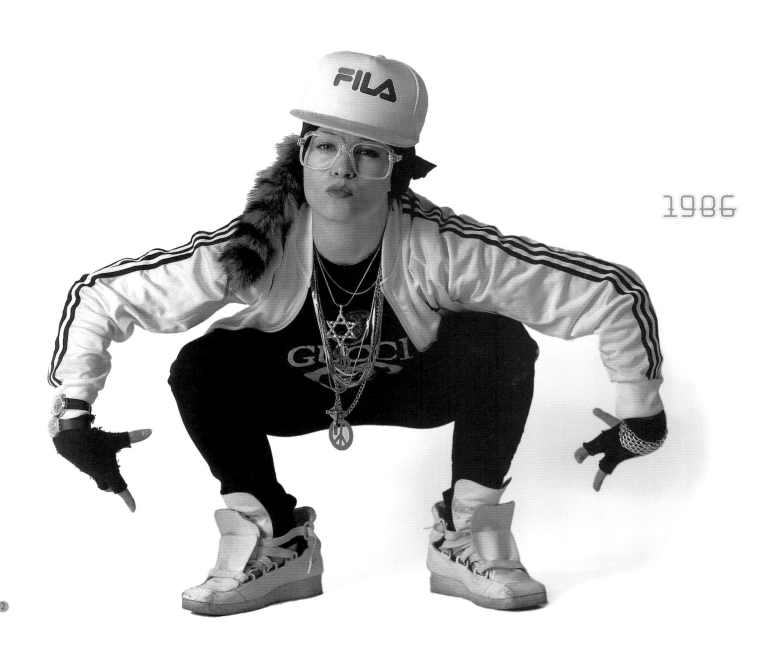

1986

● 1 Darryl McDaniels of Run-DMC shows off his rapper style. ● 2 Performance artist Ann Magnuson spoofs hip-hop.

FRANKIE SAYS USE CONDOMS

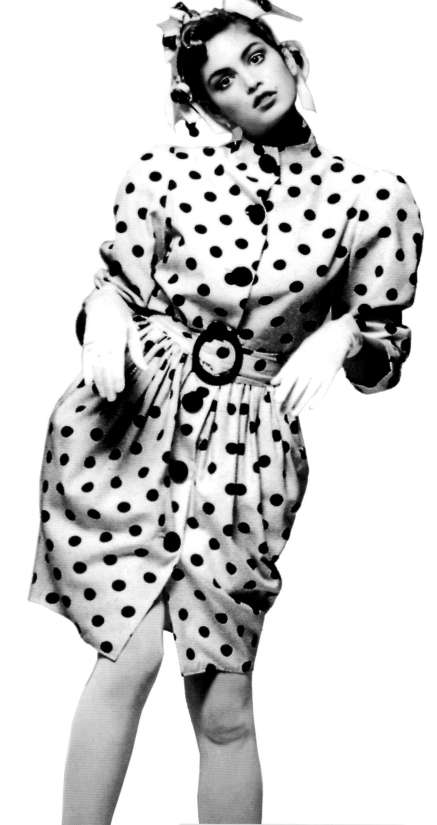

●1 Katharine Hamnett's anti-AIDS T-shirts ●2 The father of streetwear, Willi Smith dies of AIDS. ●3 Gold-tooth accessories for girl rappers ●4 Early bling-bling ring ●5 Street-bootleg Gucci ●6 Cindy Crawford modeling Willi Smith ●7 Sports influenced fashion.

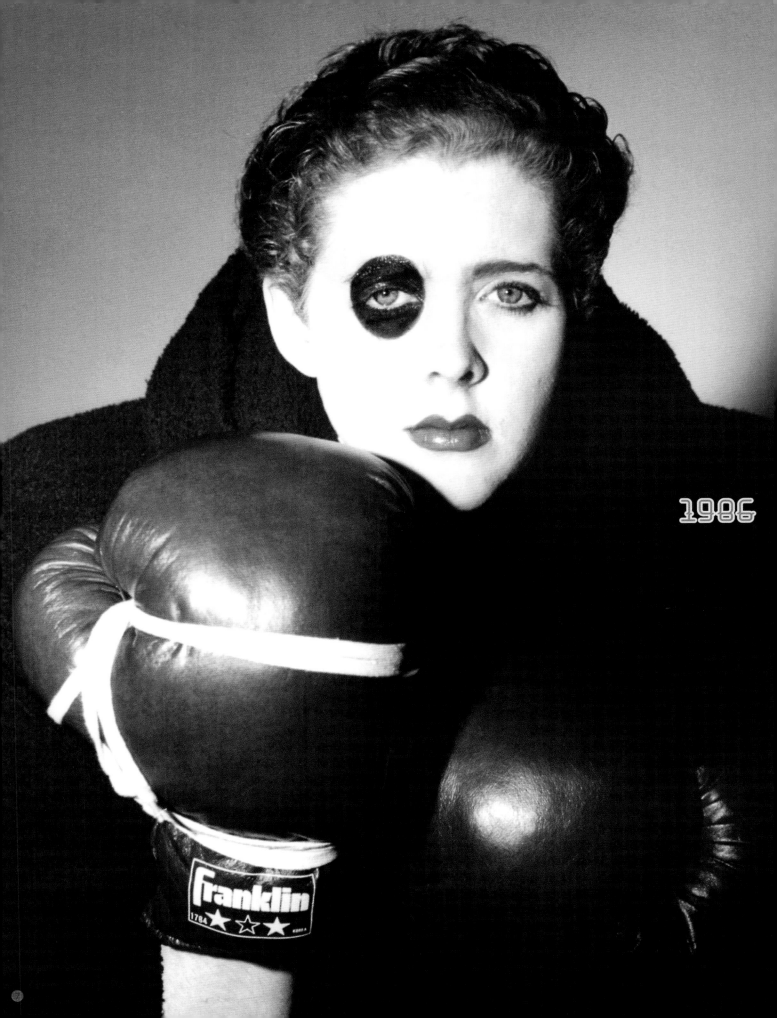

1986

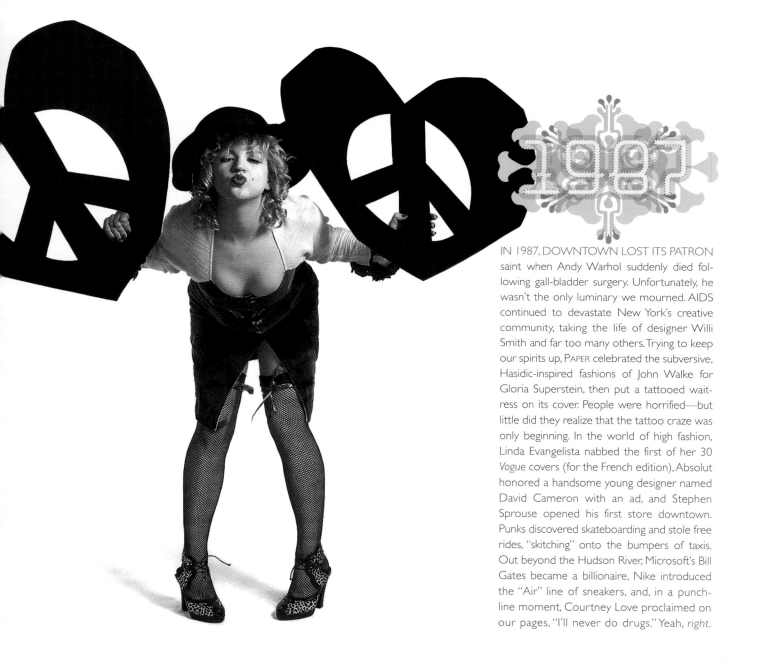

1987

IN 1987, DOWNTOWN LOST ITS PATRON saint when Andy Warhol suddenly died following gall-bladder surgery. Unfortunately, he wasn't the only luminary we mourned. AIDS continued to devastate New York's creative community, taking the life of designer Willi Smith and far too many others. Trying to keep our spirits up, PAPER celebrated the subversive, Hasidic-inspired fashions of John Walke for Gloria Superstein, then put a tattooed waitress on its cover. People were horrified—but little did they realize that the tattoo craze was only beginning. In the world of high fashion, Linda Evangelista nabbed the first of her 30 *Vogue* covers (for the French edition), Absolut honored a handsome young designer named David Cameron with an ad, and Stephen Sprouse opened his first store downtown. Punks discovered skateboarding and stole free rides, "skitching" onto the bumpers of taxis. Out beyond the Hudson River, Microsoft's Bill Gates became a billionaire, Nike introduced the "Air" line of sneakers, and, in a punch-line moment, Courtney Love proclaimed on our pages, "I'll never do drugs." Yeah, *right*.

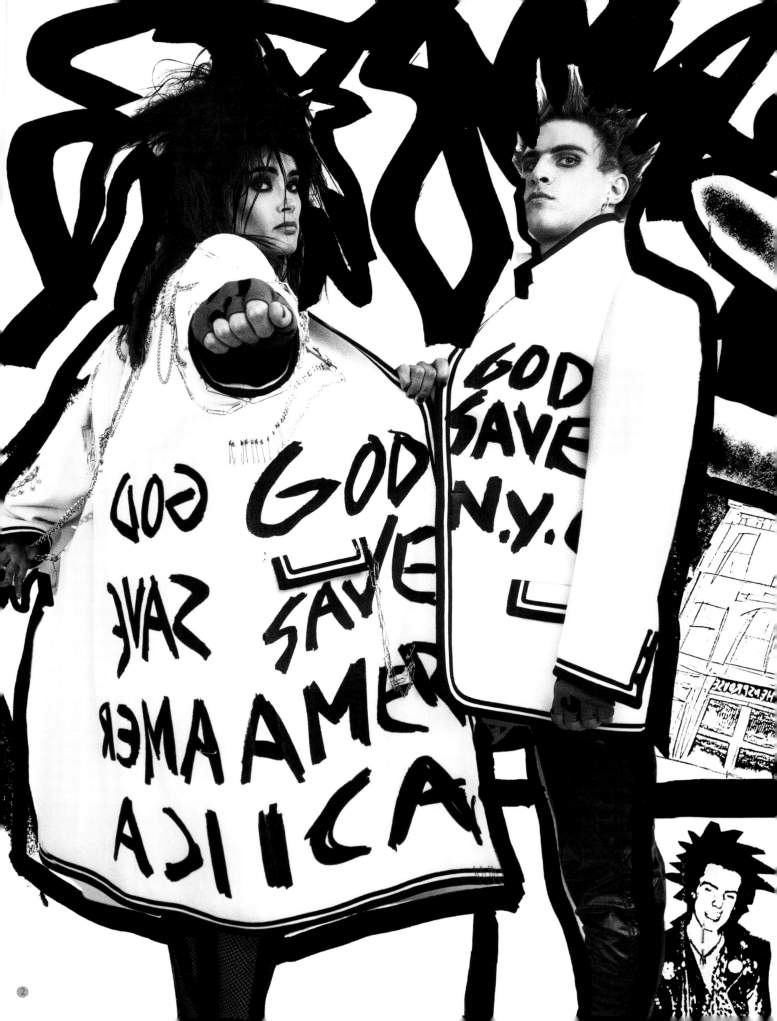

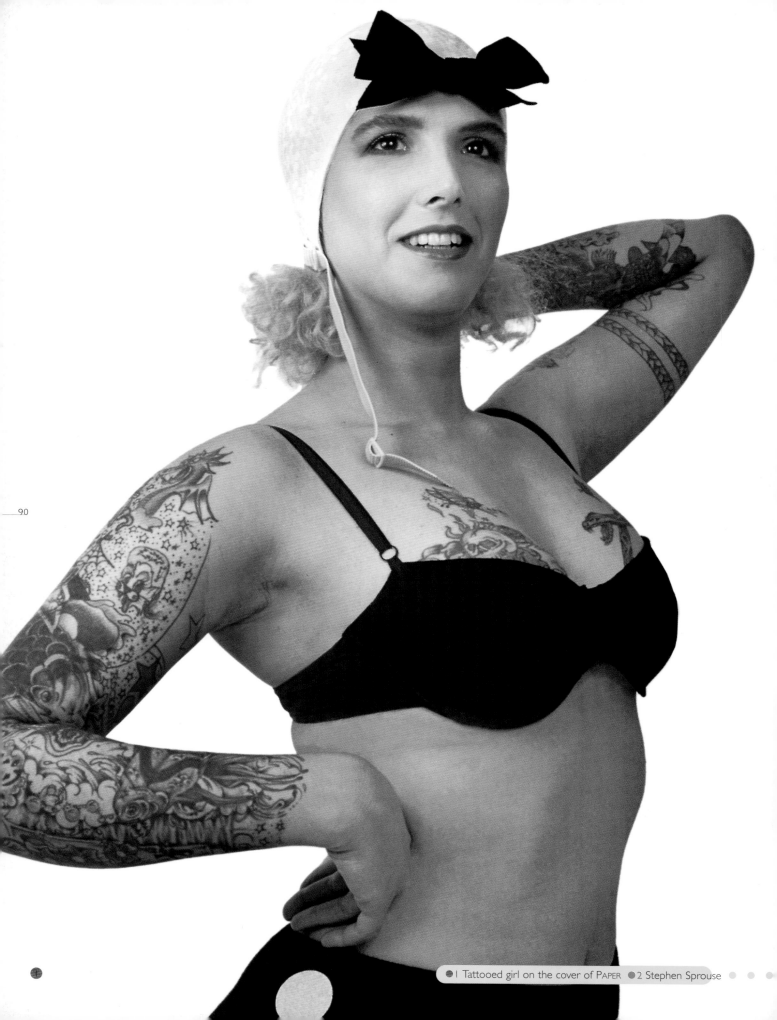

90

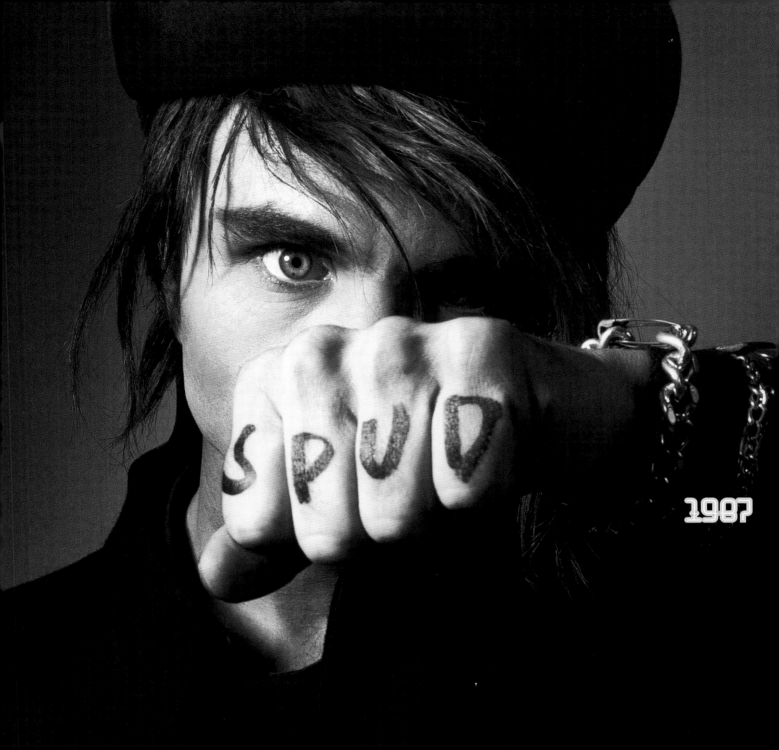

1987

● 1 School-teacher style ● 2 Joey Arias as Salvador Dalí ● 3 Early skater style

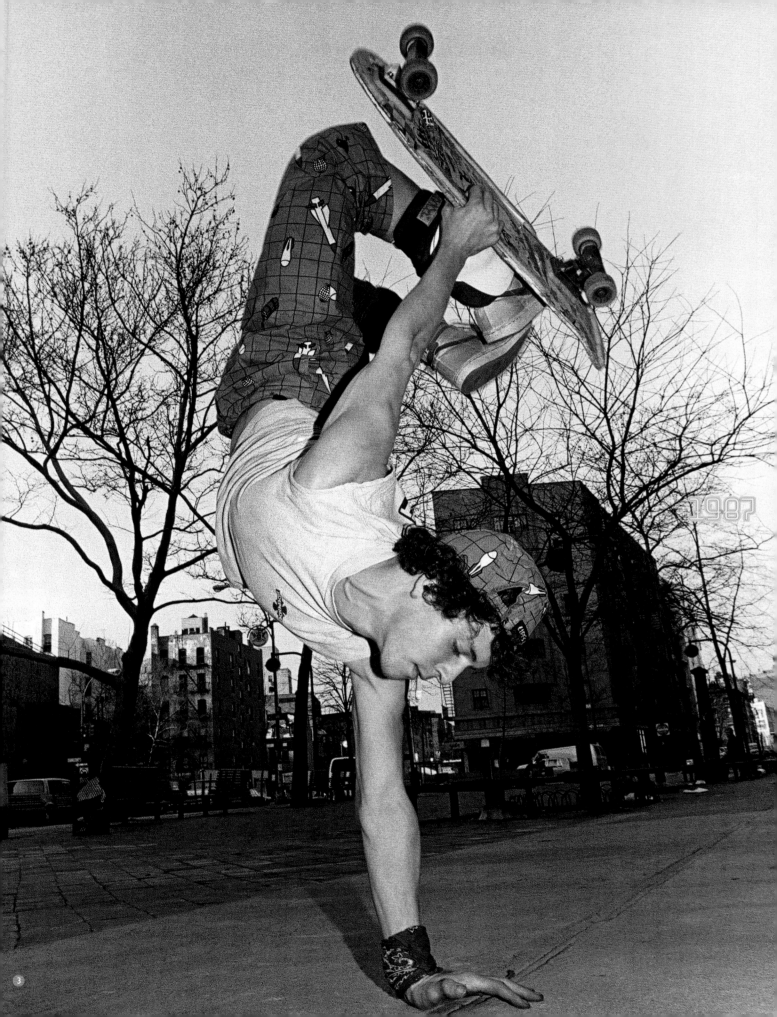

1987

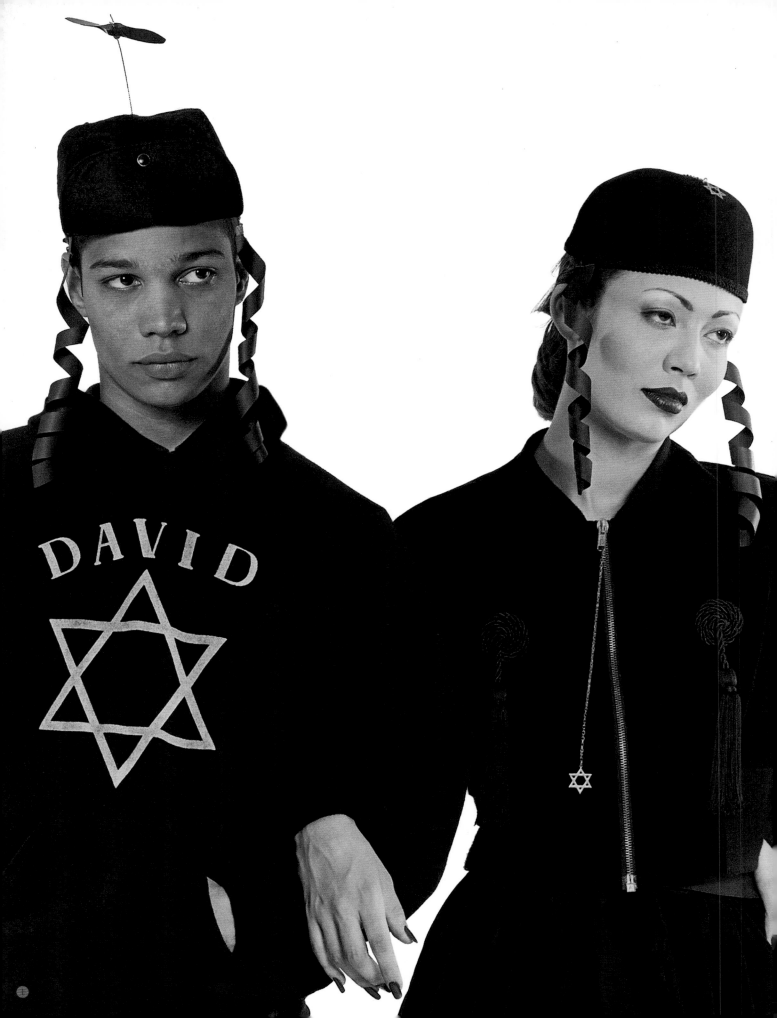

 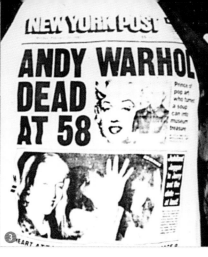 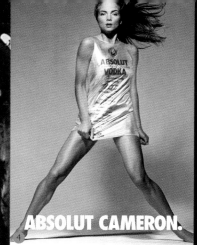 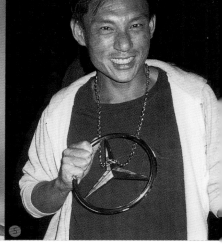

● ● ● ●1 Hasidic fashion by Canadian John Walke for Gloria Superstein
●2 Naomi Campbell as a teen model ●3 Andy Warhol dies following gall-bladder surgery.
●4 Absolut partners with hot designer David Cameron.
●5 Artist Tseng Kwong Chi wears a hip-hop necklace. ●6 Superfly '70s style

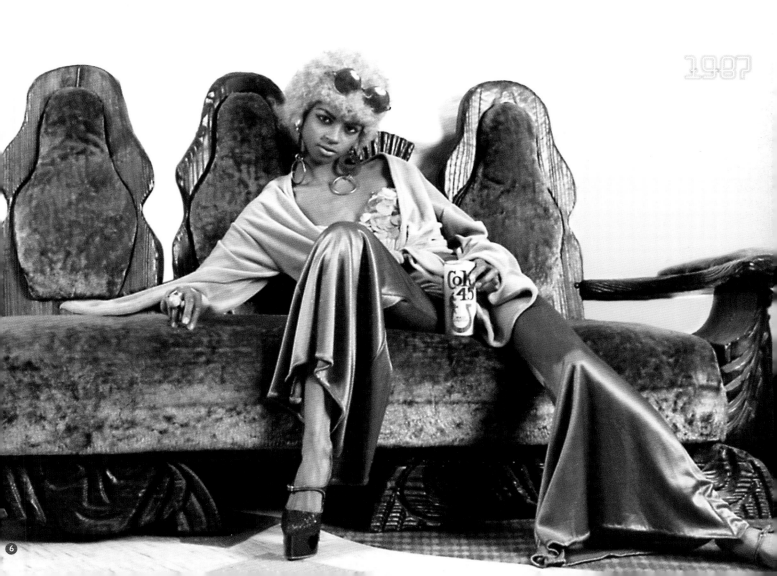

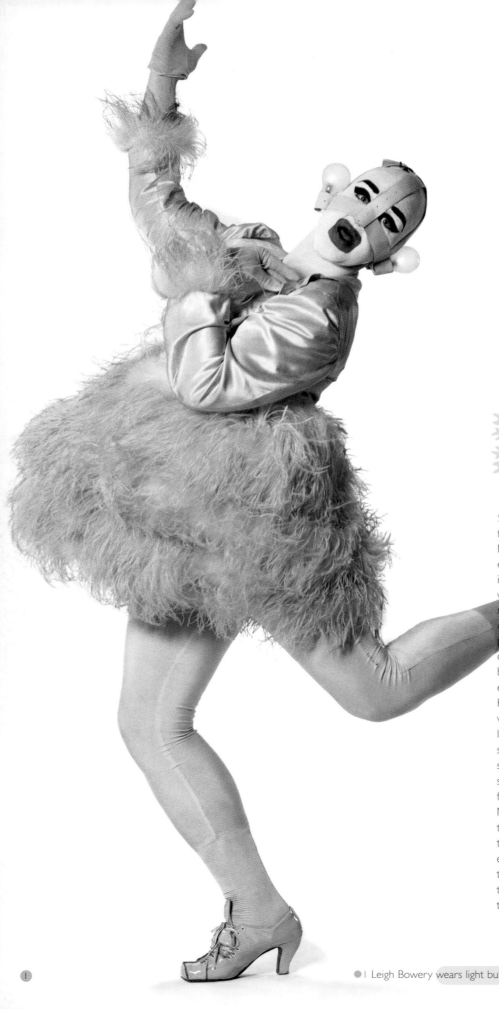

SHOCKING PERFORMANCE ARTIST AND fashion-visionary Leigh Bowery bowled over New York in 1988 with his outrageous ensembles and anatomy-defying looks. He inspired clubgoers but horrified yuppies—and we were all right with that. A young model named Cecilia Dean (who later went on to co-found the magazine *Visionaire*) was the pretty girl of the moment and posed on the cover of PAPER wearing a coat by Brooklyn-born designer André Walker. Meanwhile, a talented artist and photographer named Tseng Kwong Chi documented the phenomenon of vogueing balls in Harlem, and PAPER fell in love with Coney Island, shooting a fashion spread with the tattooed man from the sideshow. In Paris, Jean Paul Gaultier showed skirts for men, which would become the focus of an exhibit at the Metropolitan Museum of Art 15 years later. Speaking of the mainstream, Prozac hit the market—much to the relief of depressed folks—and offices everywhere were using the fax machine. The technology made it possible for self-important gasbags across the country to bark into their telephones, "Fax me on the coast!"

● 1 Leigh Bowery wears light bulbs and feathers. ● 2 Fabu-lash fashion ● ● ● ● ● ● ●

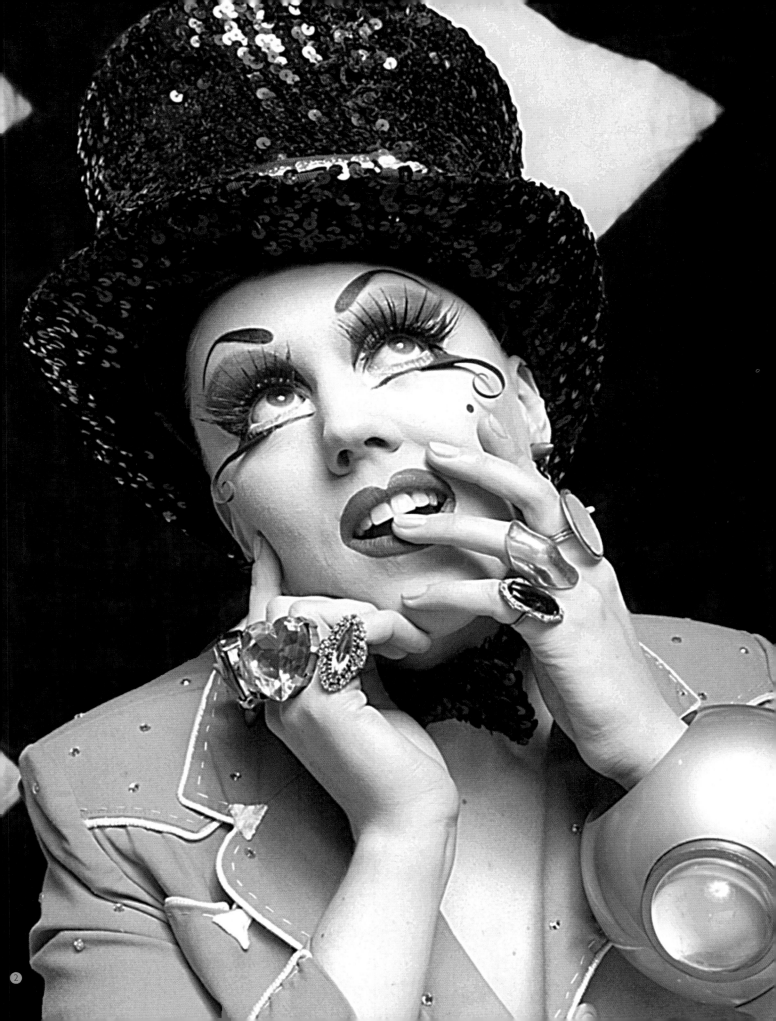

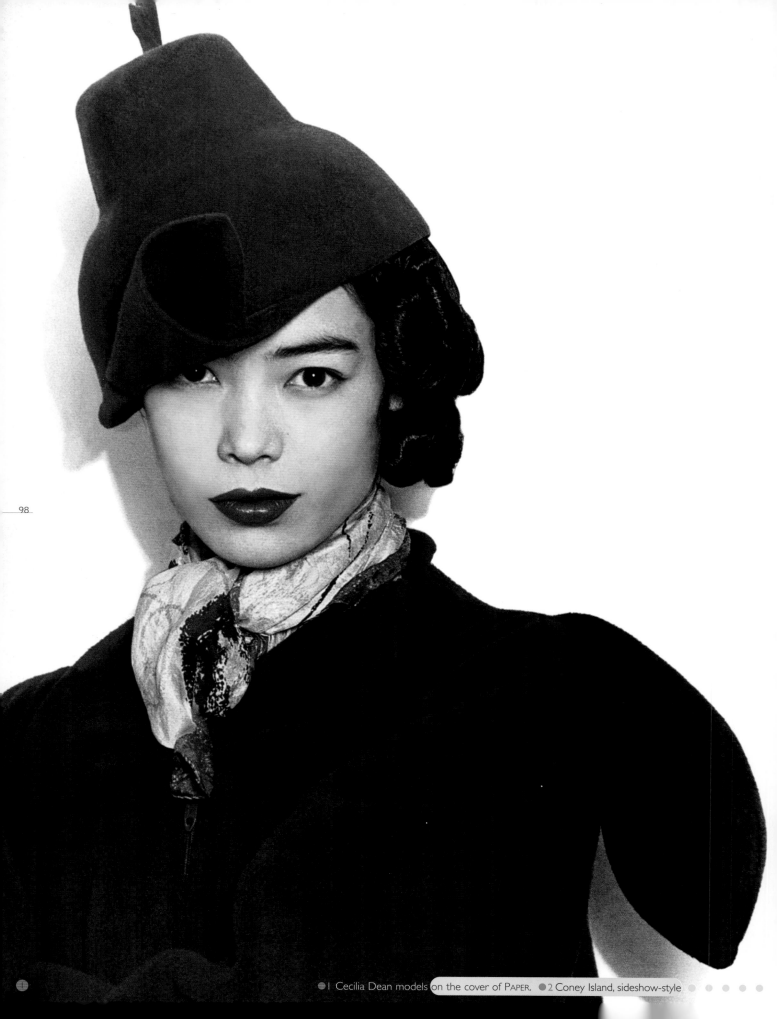

●1 Cecilia Dean models on the cover of PAPER. ●2 Coney Island, sideshow-style

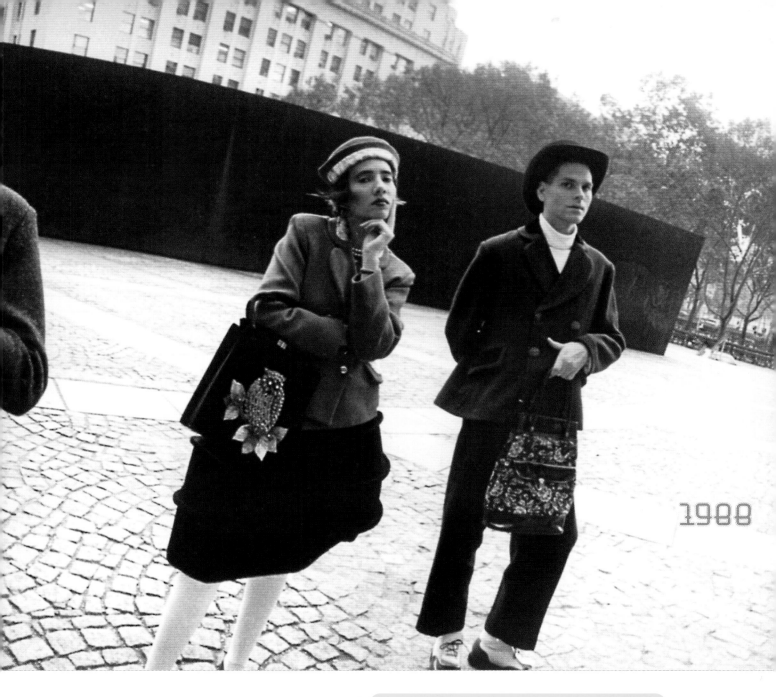

1988

●5 Lypsinka strikes a pose. ●6 Wig genius Danilo Dixon gets sprayed by the B-52s' Kate Pierson.

●7 David Hockney appears in an l.a. Eyeworks ad. ●8 Ted Muehling's exquisite earrings.

A face is like a work of art.
It deserves a great frame.

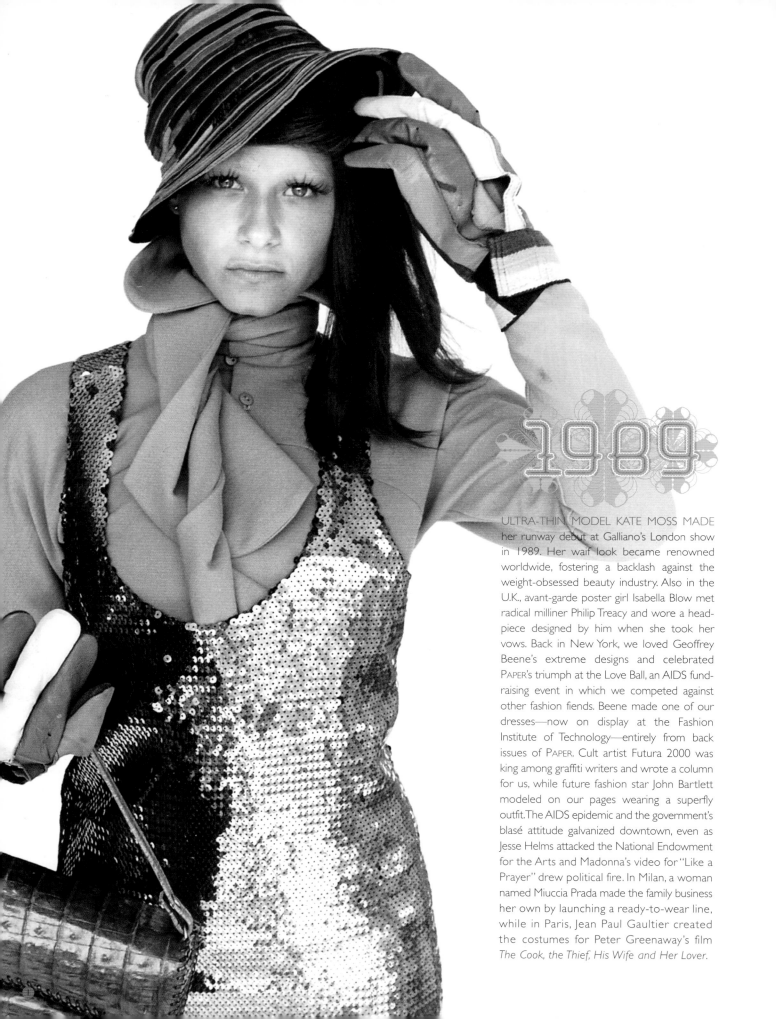

1989

ULTRA-THIN MODEL KATE MOSS MADE her runway debut at Galliano's London show in 1989. Her waif look became renowned worldwide, fostering a backlash against the weight-obsessed beauty industry. Also in the U.K., avant-garde poster girl Isabella Blow met radical milliner Philip Treacy and wore a head-piece designed by him when she took her vows. Back in New York, we loved Geoffrey Beene's extreme designs and celebrated PAPER's triumph at the Love Ball, an AIDS fund-raising event in which we competed against other fashion fiends. Beene made one of our dresses—now on display at the Fashion Institute of Technology—entirely from back issues of PAPER. Cult artist Futura 2000 was king among graffiti writers and wrote a column for us, while future fashion star John Bartlett modeled on our pages wearing a superfly outfit. The AIDS epidemic and the government's blasé attitude galvanized downtown, even as Jesse Helms attacked the National Endowment for the Arts and Madonna's video for "Like a Prayer" drew political fire. In Milan, a woman named Miuccia Prada made the family business her own by launching a ready-to-wear line, while in Paris, Jean Paul Gaultier created the costumes for Peter Greenaway's film *The Cook, the Thief, His Wife and Her Lover.*

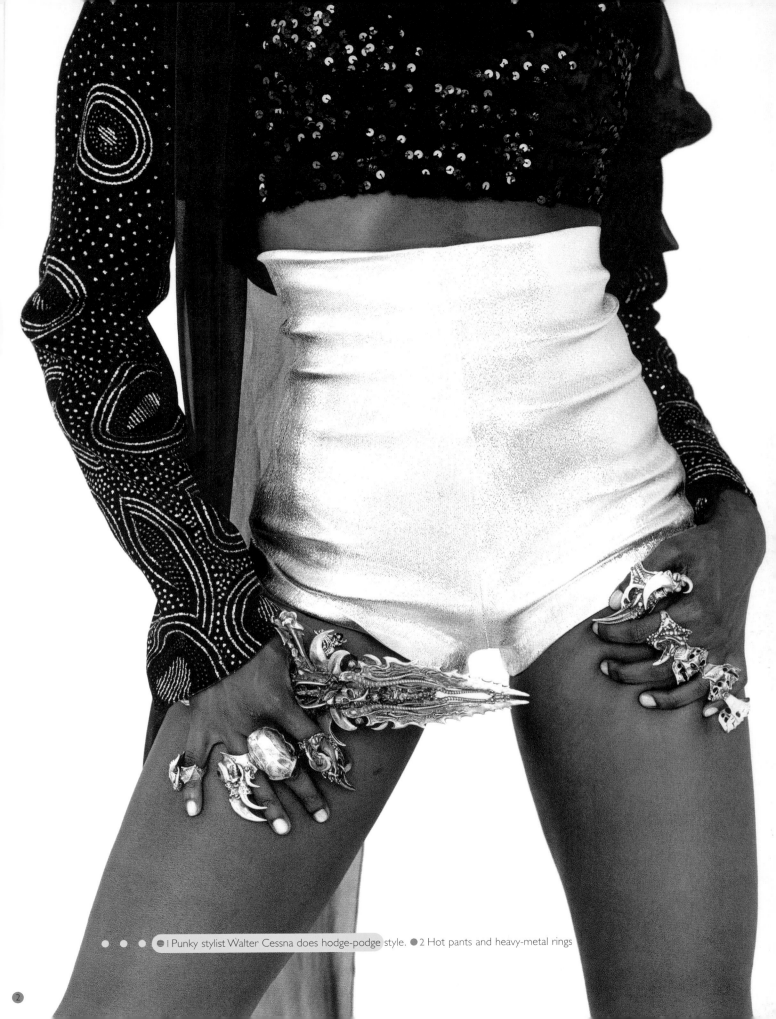

● ● ● ● ●1 Punky stylist Walter Cessna does hodge-podge style. ●2 Hot pants and heavy-metal rings

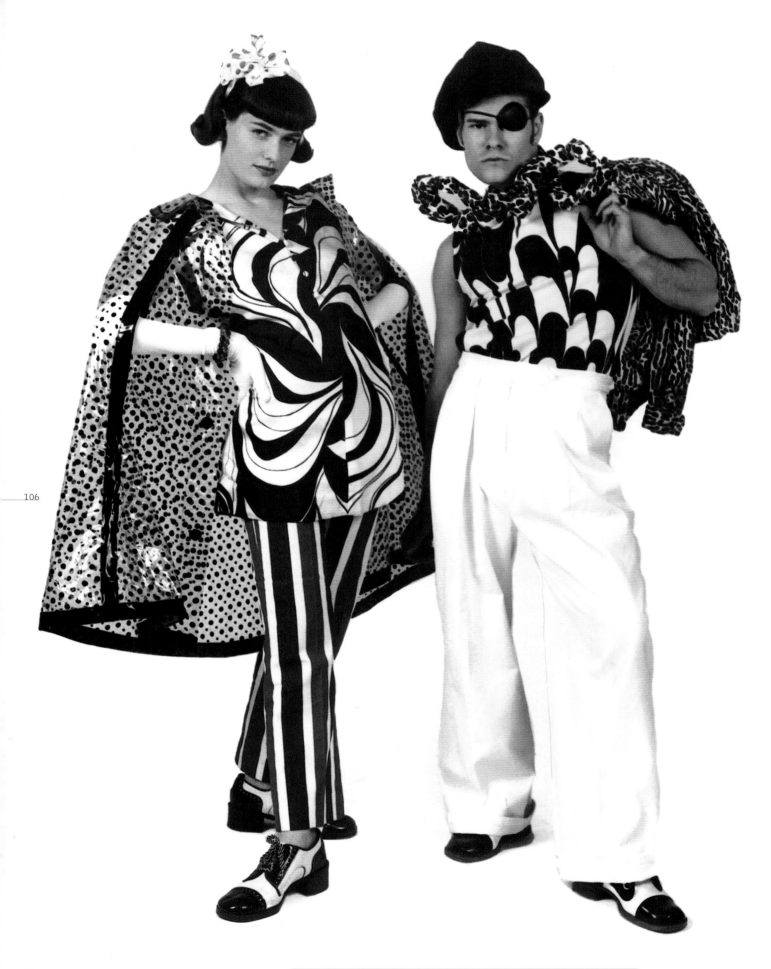

●1 A young John Bartlett strikes a pose with Laurie Pike. ●2 Cult artist Futura 2000

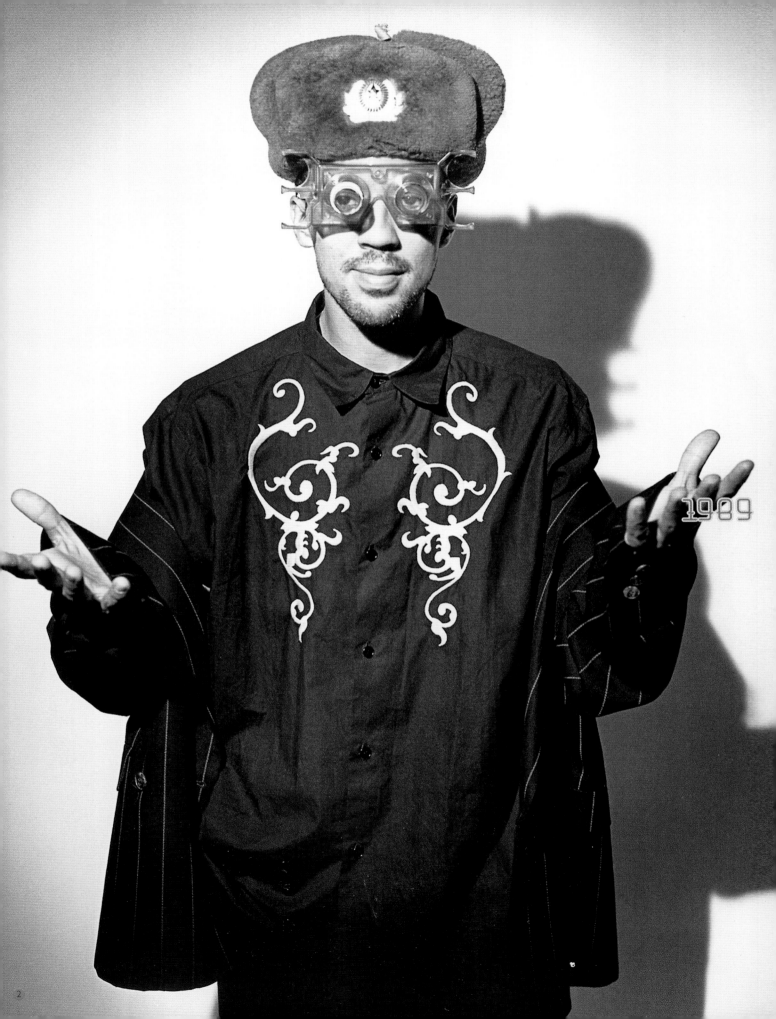

1989

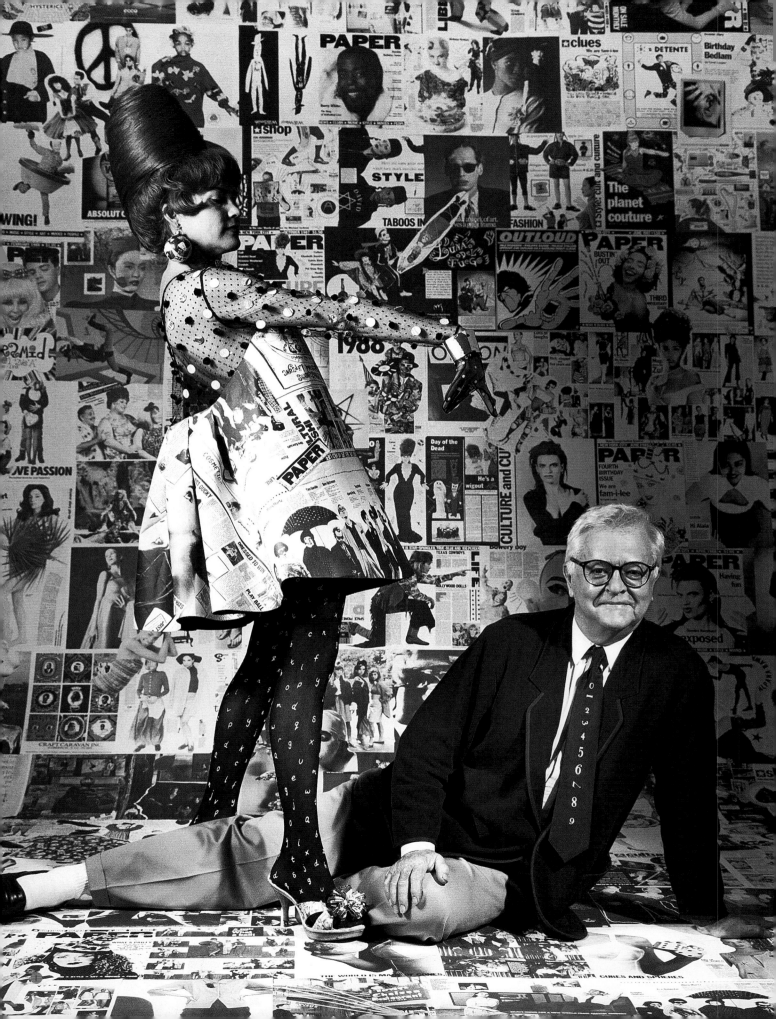

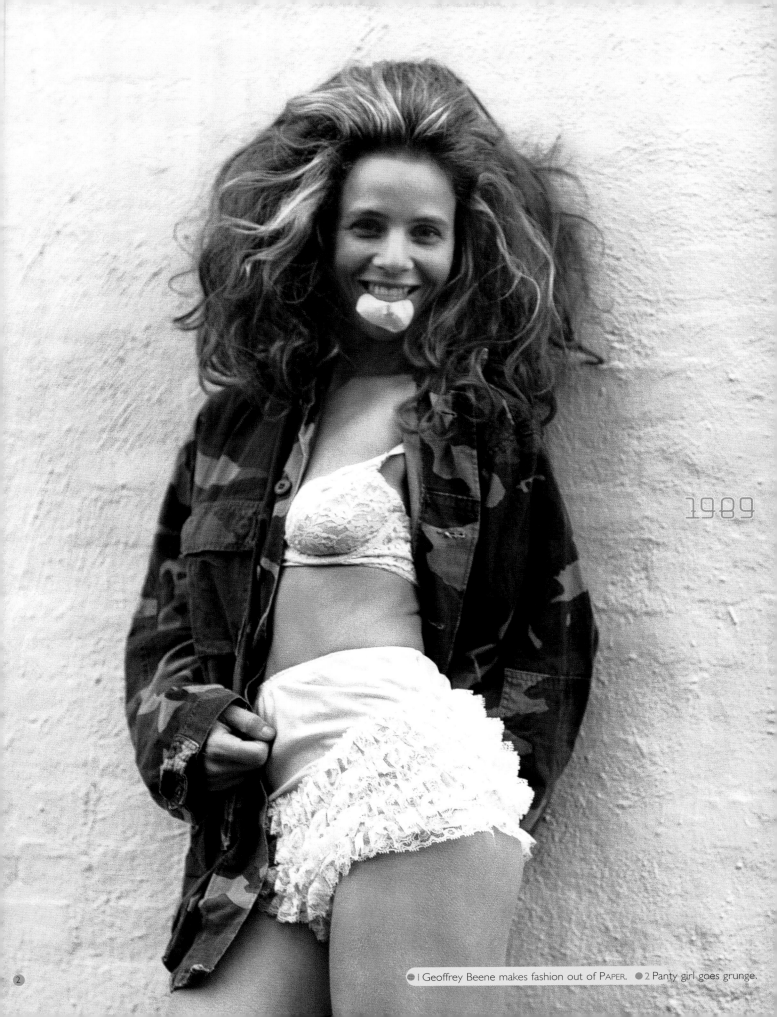

1989

●1 Geoffrey Beene makes fashion out of PAPER. ●2 Panty girl goes grunge.

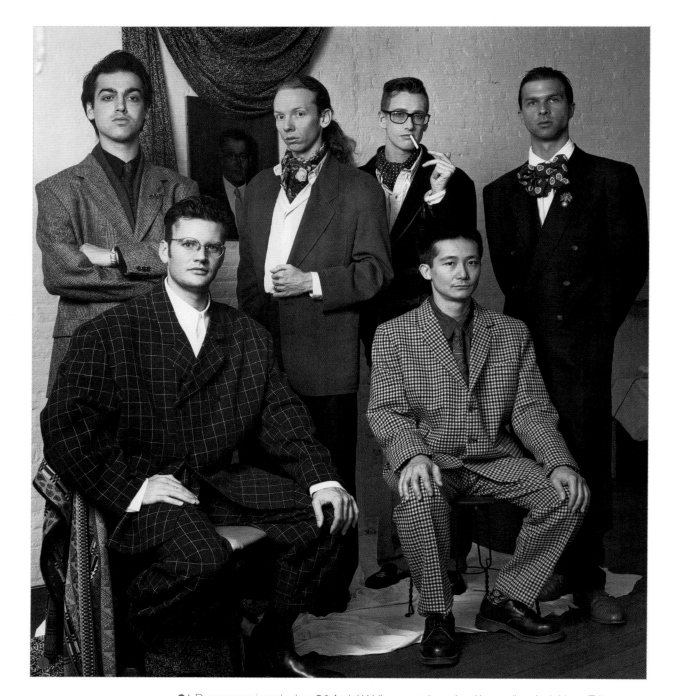

●1 Drag queens in male drag ●2 André Walker meets legendary *Vogue* editor André Leon Tally.

●3 T-shirts go political. ●4 Bethann Hardison's model agency promotes women of color to the fashion industry.

●5 A young Marc Jacobs has his first show as designer of the label Perry Ellis.

●6 Designer Betsey Johnson moves to Woodstock. ●7 Presto! Drag queens!

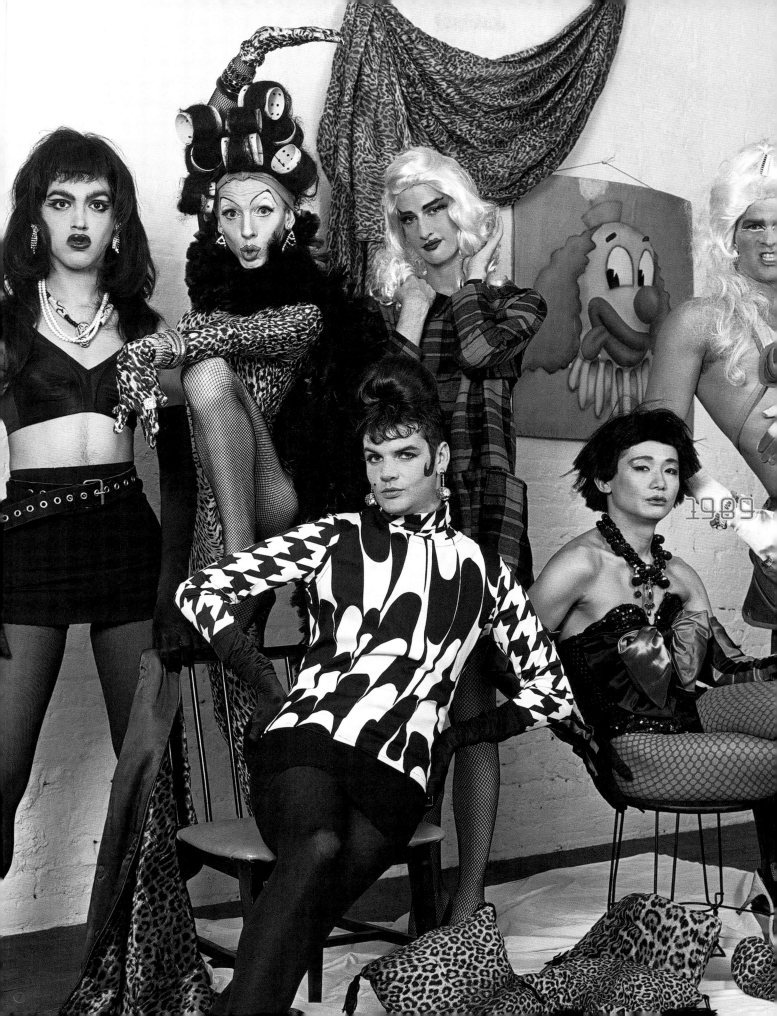

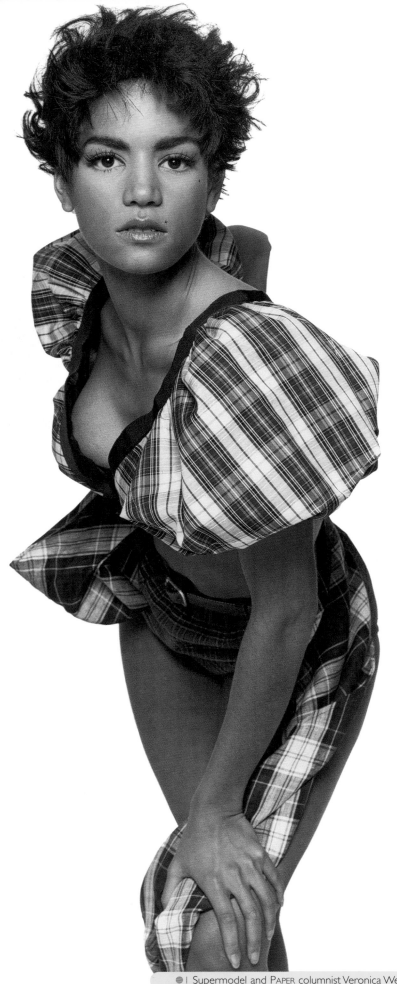

1990

DANCE BLEW UP THIS YEAR, AS PARTY people went crazy for the lambada. Vogueing reached the masses with the release of both the Madonna song and Jennie Livingston's film *Paris is Burning*. Back in the underground, this was the year that now-infamous club promoter Michael Alig became king of the club kids. His parties at the Limelight featured gaggles of demented-looking clubbers, who took ecstasy, sucked on lollipops and went out dressed up—in clown faces, baby clothes and gigantic platform sneakers. Then there was downtown disco-diva Lady Miss Kier, whose band Deee-Lite turned Pucci tights and John Fluevog's shoes into the groove of the moment. Madonna wore her Gaultier-designed cone bra on her Blonde Ambition tour, and a handsome Texan named Tom Ford was named chief women's ready-to-wear designer for Gucci. PAPER was feeling makeovers in 1990, so we turned pretty baby Brooke Shields into a hot drag king and transformed supermodel Naomi Campbell and R&B legend Isaac Hayes into the baddest of blax-ploitation couples. Another upcoming super-model, Veronica Webb, became the muse to designers Isaac Mizrahi and Azzedine Alaia before becoming a monthly columnist in PAPER.

1 Supermodel and PAPER columnist Veronica Webb, wearing Isaac Mizrahi ●2 Isaac Hayes features early bling-bling.

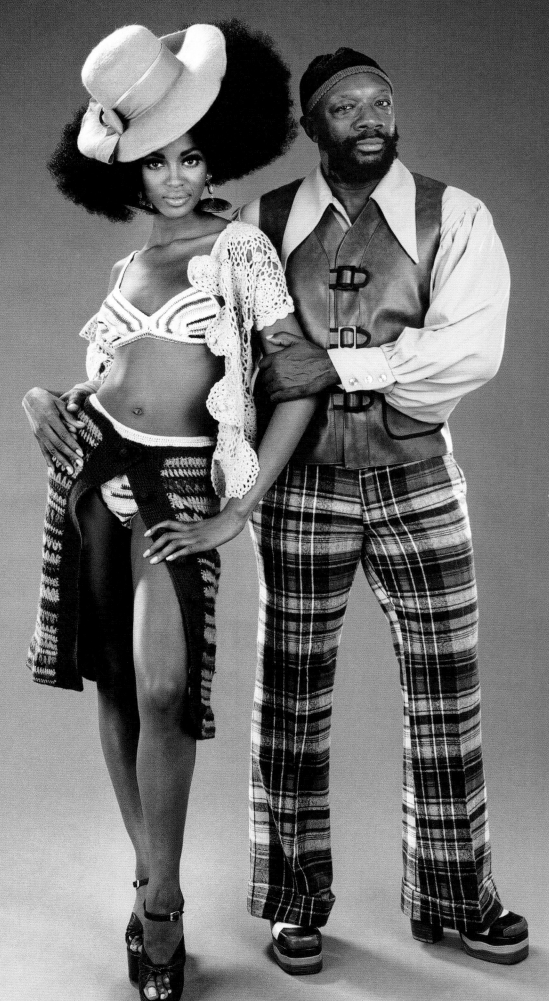

1990

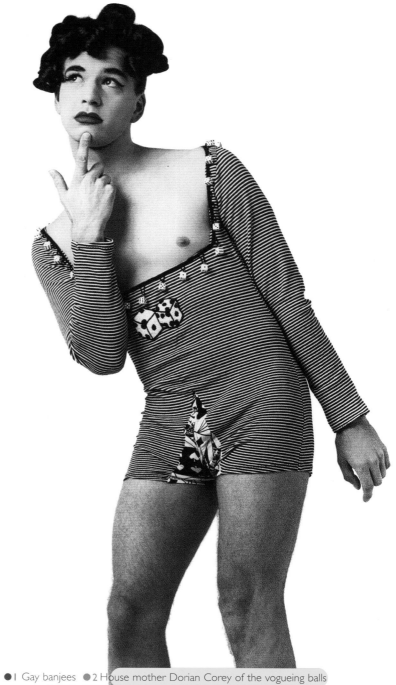

●1 Gay banjees ●2 House mother Dorian Corey of the vogueing balls

●3 Todd Oldham ●4 *House Party* hairdos ●5 Italian designer Franco Moschino

●6 Michael Alig was king of the club kids. ●7 Haircut with a message

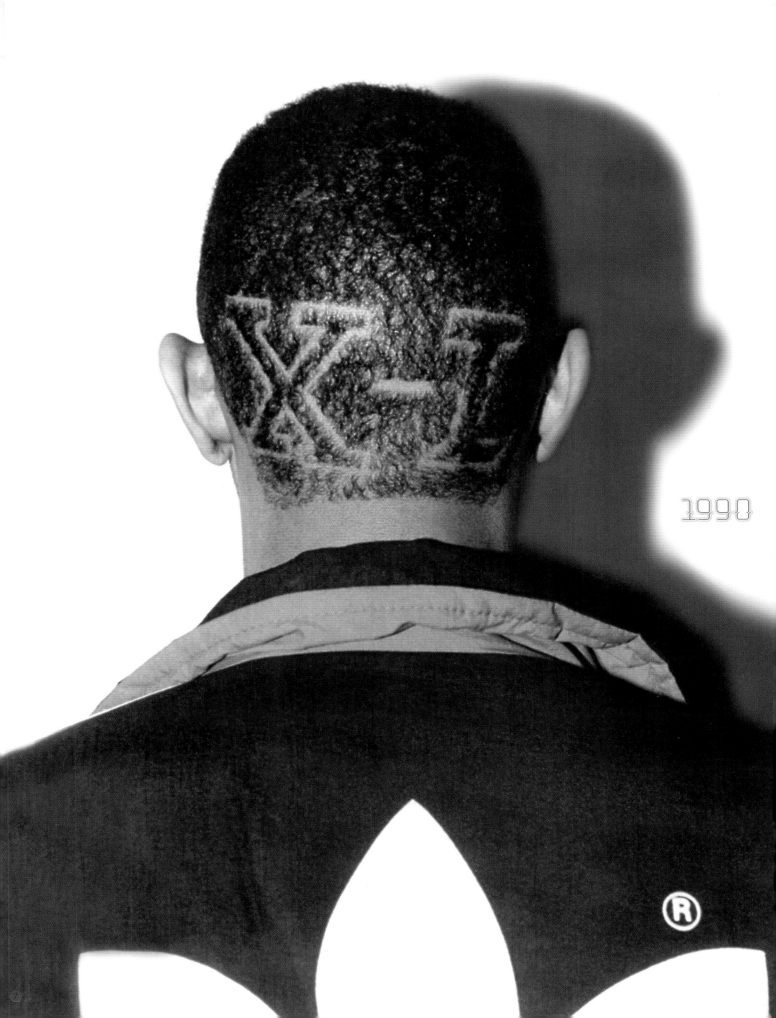

1990

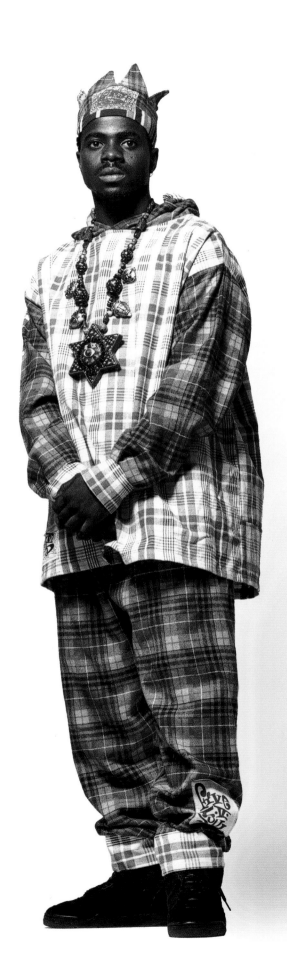

IN 1991, APARTHEID ENDED, AND AN Afrocentric style took hold in New York City, promoted by indie brand Triple 5 Soul. In music, Nirvana's "Smells Like Teen Spirit" launched the grunge era, which put pretty girls in shapeless shifts and dirty-haired men in dresses. On the glamour front, the supermodel movement reached its apex when Gianni Versace sent Linda, Naomi, Christy and Cindy down the runway *together*. Marge Simpson schooled television viewers in fashion when she wore cartoon Manolo Blahniks during prime time. Downtown's It Couple was comprised of DJ/producer Jellybean Benítez and magazine editor Elizabeth Saltzman. Former makeup artist Debi Mazar moved to L.A. and became an actress. It was also the year that the Belgian deconstruction movement invaded the fashion houses of Paris, while AIDS continued to ravage our friends and contributors. Party princess Susanne Bartsch raised $750,000 for the cause at her second Love Ball.

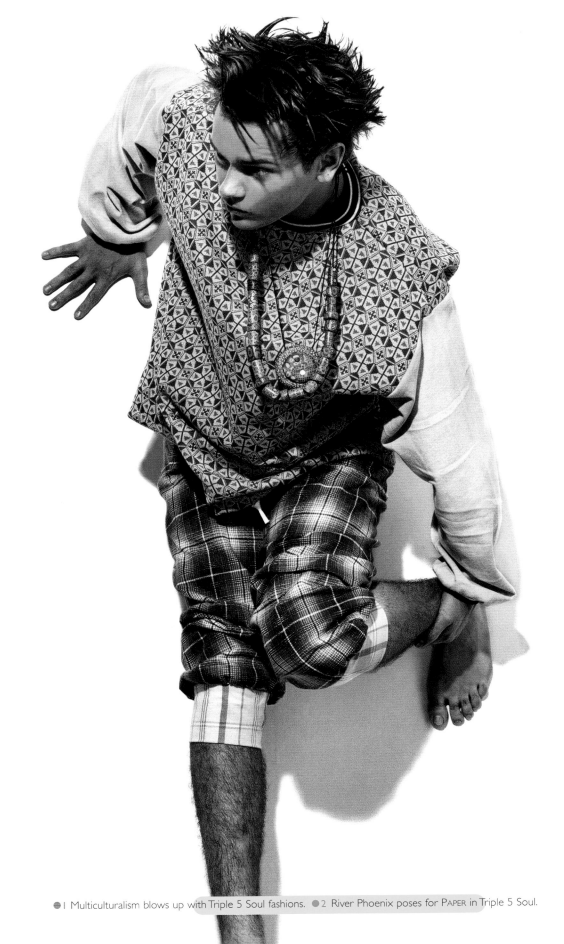

● 1 Multiculturalism blows up with Triple 5 Soul fashions. ● 2 River Phoenix poses for PAPER in Triple 5 Soul.

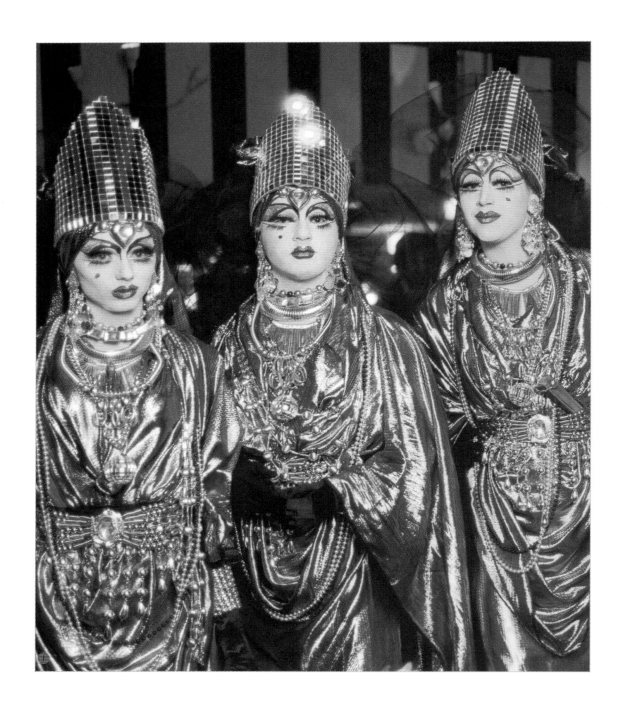

122

●1 Love Ball lovelies ●2 Deconstruction from Belgium hits the Paris runways. ● ● ● ● ●

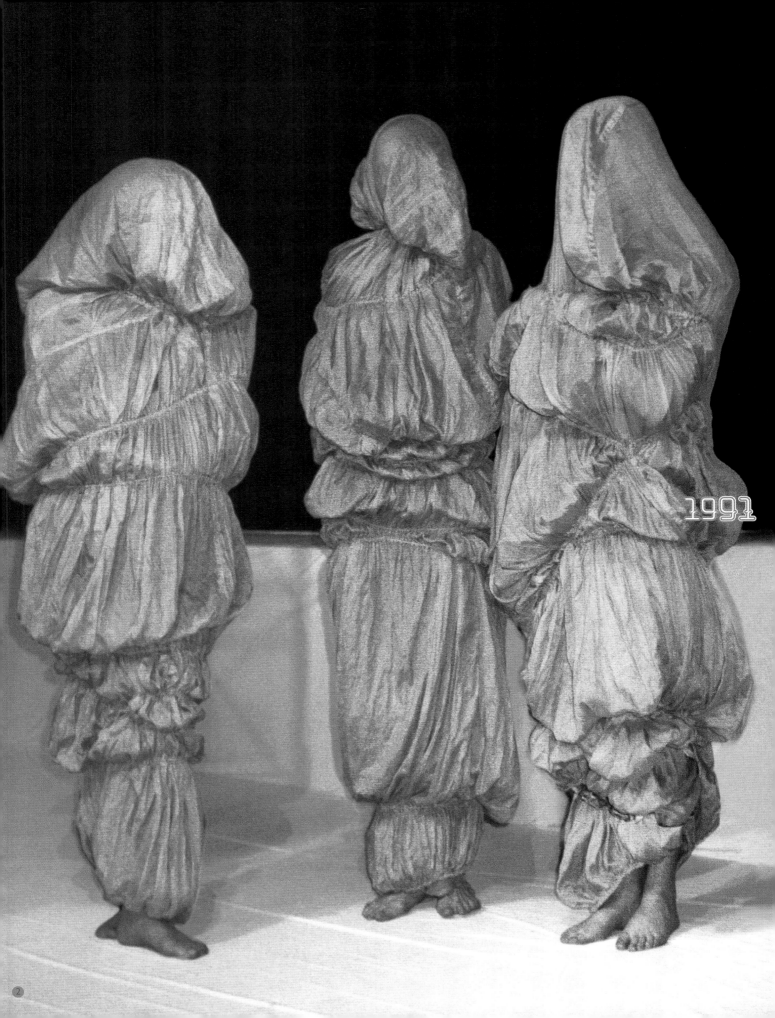

1991

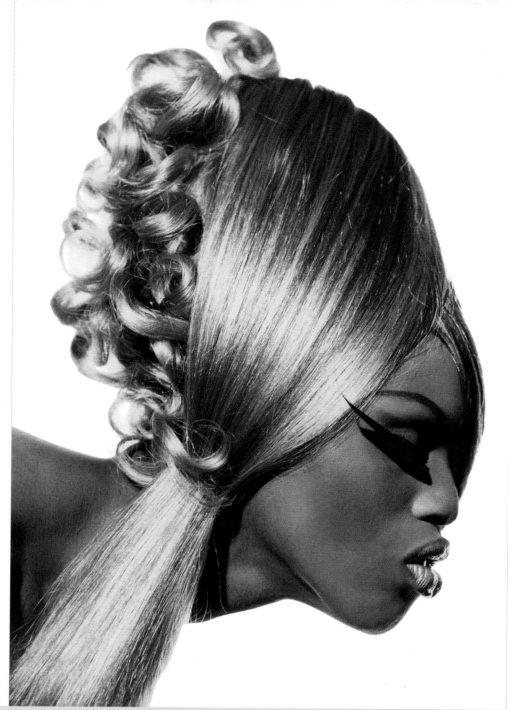

● 1 High-end hair-raisers: (top) Danilo's do; (below l-r) Orlando's hair magic, Mugler's plastic wigs ● 2 Boys will be girls at the Love Ball. ● ● ● ● ●

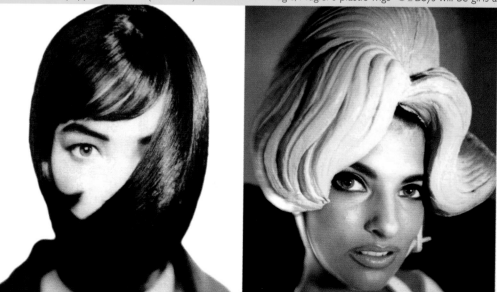

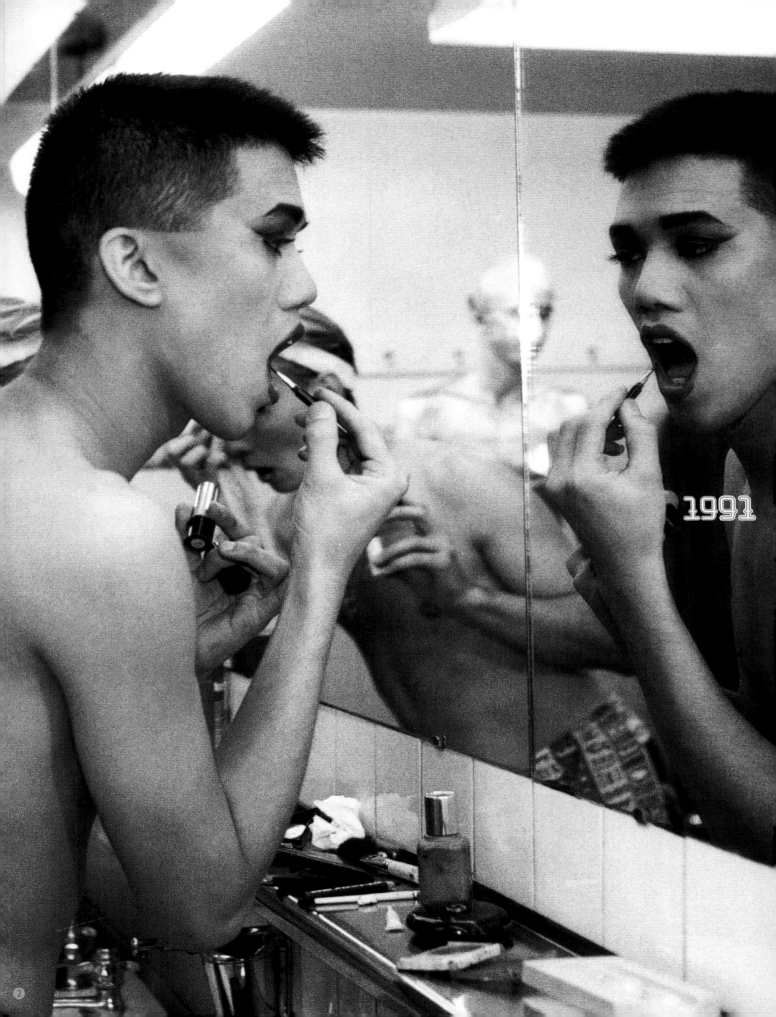

1991

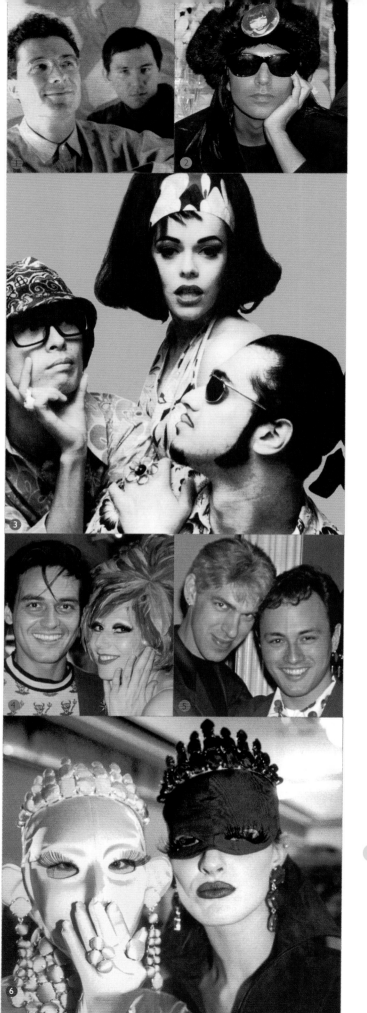

●1 André Balazs and Serge Becker announce the opening of the first hotel in Soho on Mercer Street. ●2 Photographer Steven Meise[r] ●3 The band Deee-Lite has a hit with "Groove is in the Heart." ●4 Hair guru Oribe and Susanne Bartsch ●5 Makeup genius Kevyn Aucoin and friend Don ●6 Giving "Face" ●7 House of PAPER celebrates the female icon and takes first prize at Love Ball 2 with Brooke Shields.

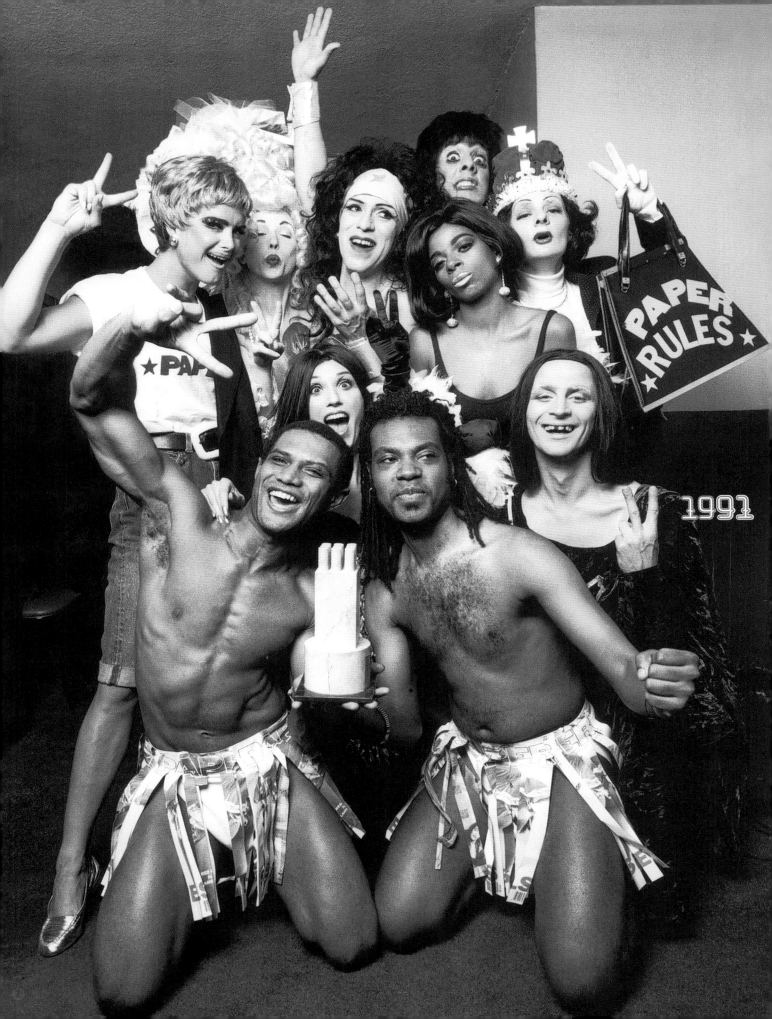

1991

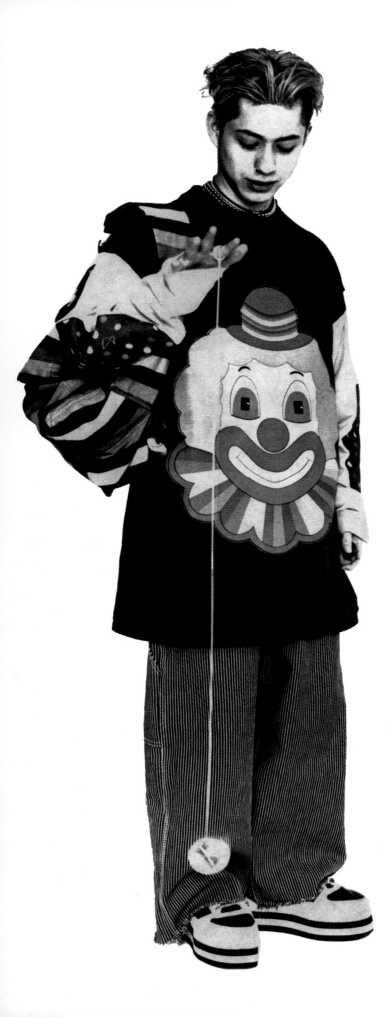

IN 1992, PETA SUPPORTERS WERE ARRESTED while protesting against fur at the offices of *Vogue*. Clubgoers left the animal skins behind and rocked outer-space looks instead. Though 1992 was still pre-cellphone, the beeper-pager was the city's must-have item. Mike Tyson's rape conviction was big news, but the riots in L.A. were even bigger—the city erupted after the cops accused of beating Rodney King were acquitted. Brooklyn rap trio the Beastie Boys became the top-selling hip-hop act of all time, while U2 frontman Bono appeared on the cover of British *Vogue* with model Christy Turlington. Across the nation, people slipped on Birkenstocks to match the nouveau-hippie styles endorsed by various fashion houses. In Paris, Thierry Mugler (with a little help from Mr. Pearl, corseter to the stars) worked the hourglass silhouette. Pearl worked his own silhouette when he trimmed his waist down to 21 inches.

Club kids: The drug was X, the style futuristic cyber-baby. ● ● ● ●

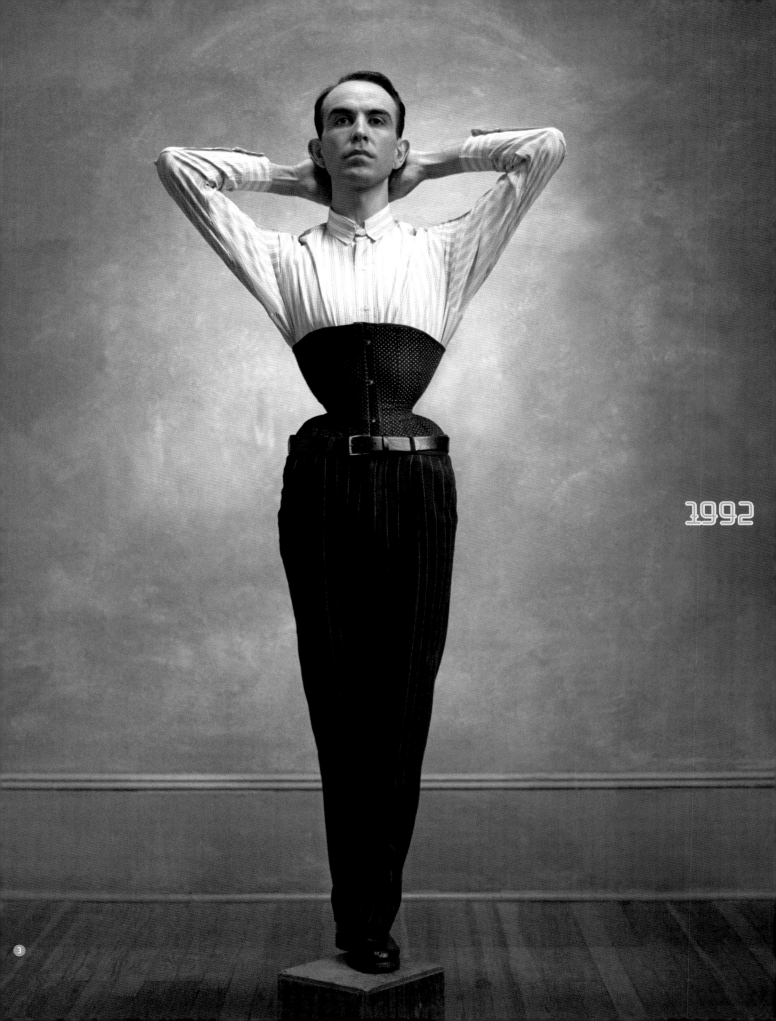

1992

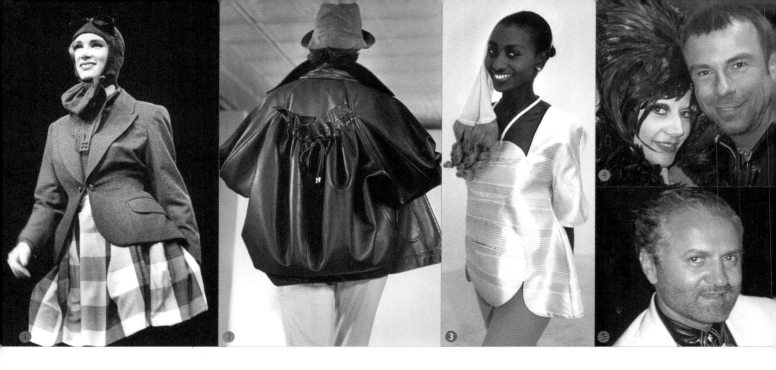

●1 The brilliant designer Byron Lars ●2 Isaac Mizrahi's backpack jacket ●3 André Walker's wig scarf ●4 Designer Thierry Mugler ●5 Designer Gianni Versace ●6 It's all about sneakers and skateboard bagginess. ●7 Kids with boards ●8 The pre-cellphone beeper pocket

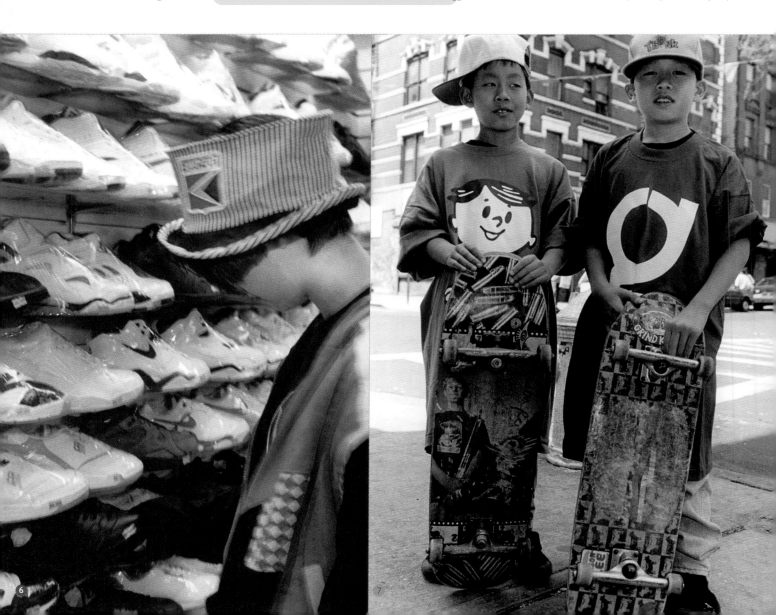

1992

8

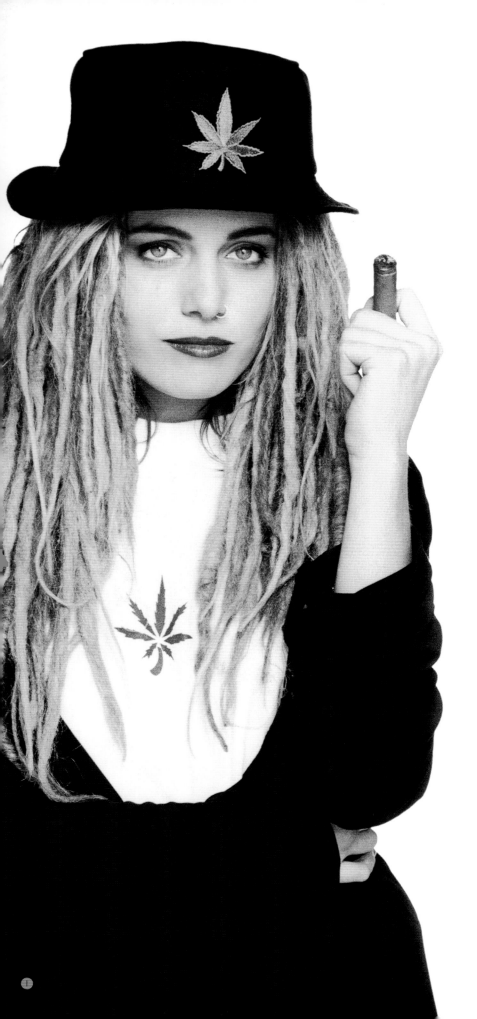

1993

TEXAS NATIVE TODD OLDHAM WAS fashion's pin-up boy in 1993. His charm and design talents landed him on MTV's *House of Style*, which he co-hosted with Cindy Crawford. A new fashion line, Label, was the next big thing. Inspired by old-school Adidas, Puma and Champion sportswear, it came complete with racing stripes. The skate movement was raging in Southern California and with it came new styles of dress, art and sport. Marijuana smoking was another trend, and the pot-leaf symbol seemed to be on nearly every T-shirt and baseball cap on New York's Canal Street. Piercing and body modification reached their peak of popularity as a new primitivism emerged from the East Village. Even supermodels began piercing their belly buttons, introducing the fad to the mainstream. Christy Turlington's likeness was grafted onto mannequins, and New York agent Bethann Hardison organized the Black Girls Coalition, a group of African-American models that included Iman, Naomi Campbell and Veronica Webb. The BGC raised awareness about racism in the fashion industry and questioned why models of color were not on magazine covers and in advertising as frequently as Caucasians. And fashion met music when concertgoers worldwide lost it over the Dolce & Gabbana costumes Madonna wore on her Girlie Show tour.

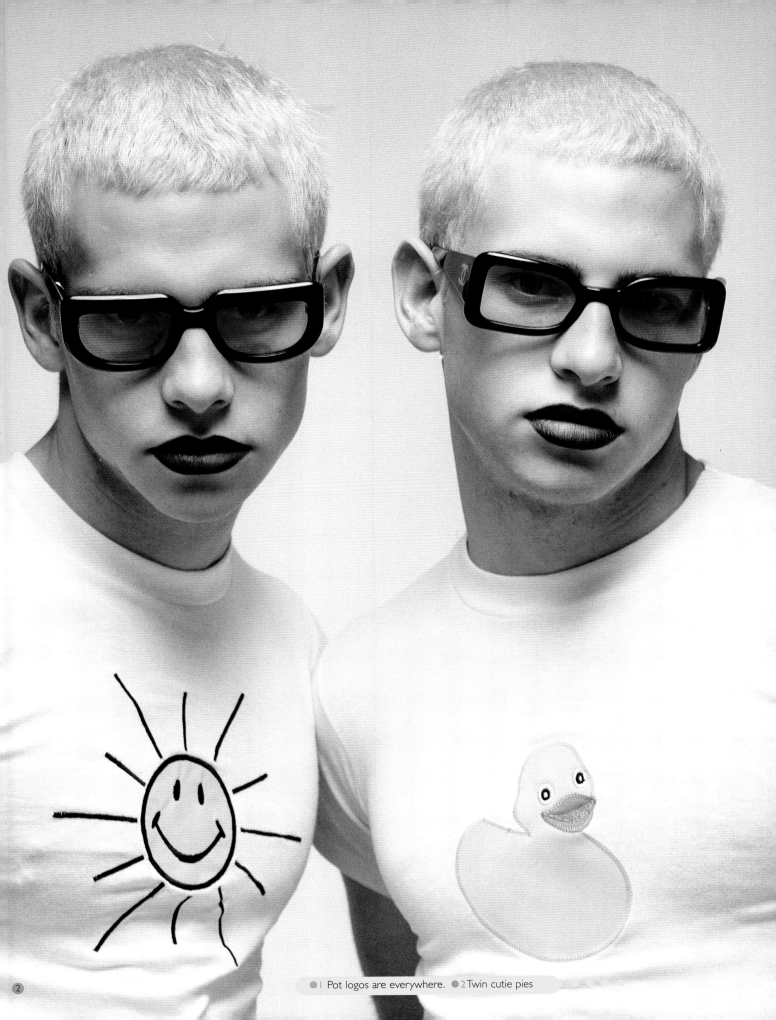

● 1 Pot logos are everywhere. ● 2 Twin cutie pies

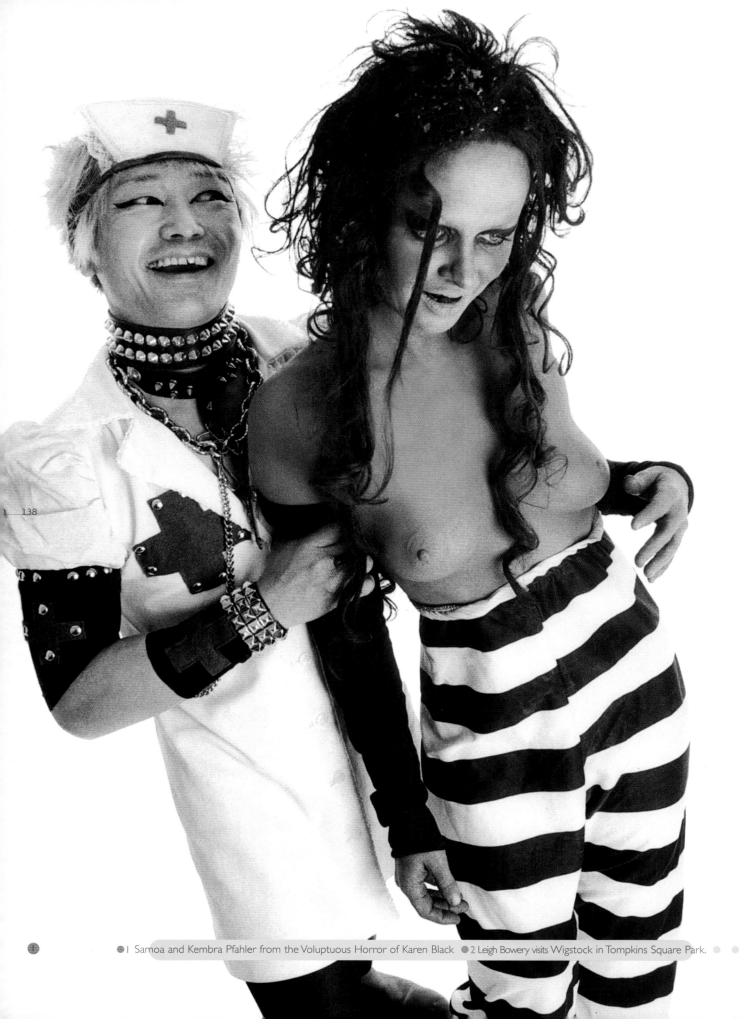

138

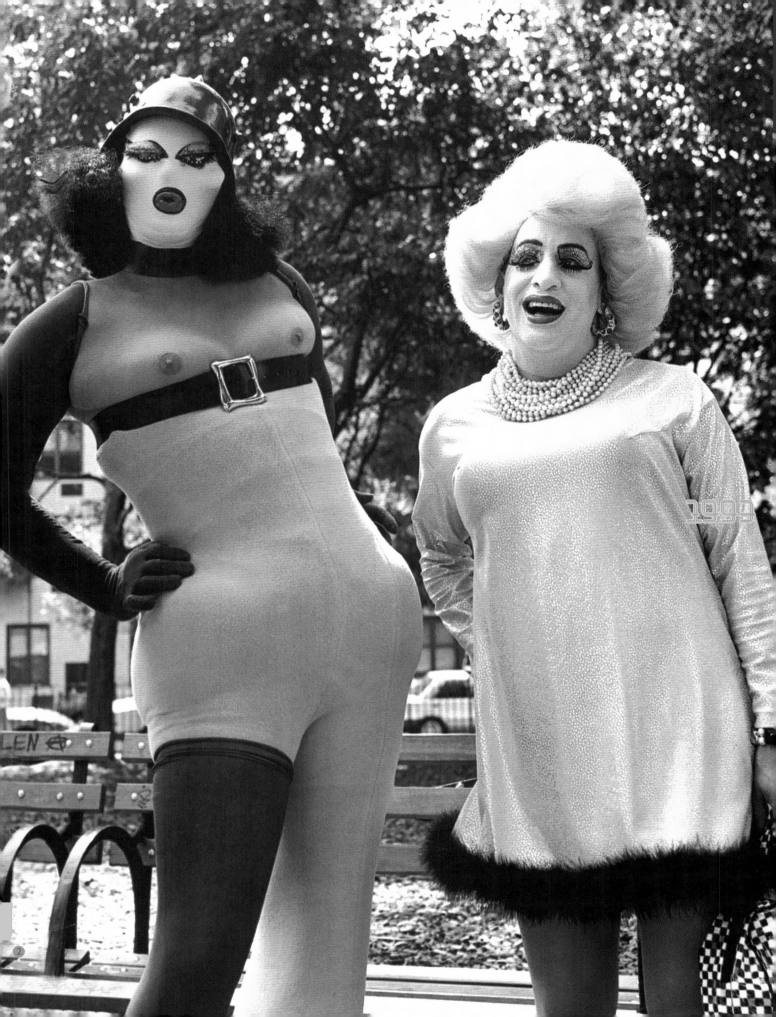

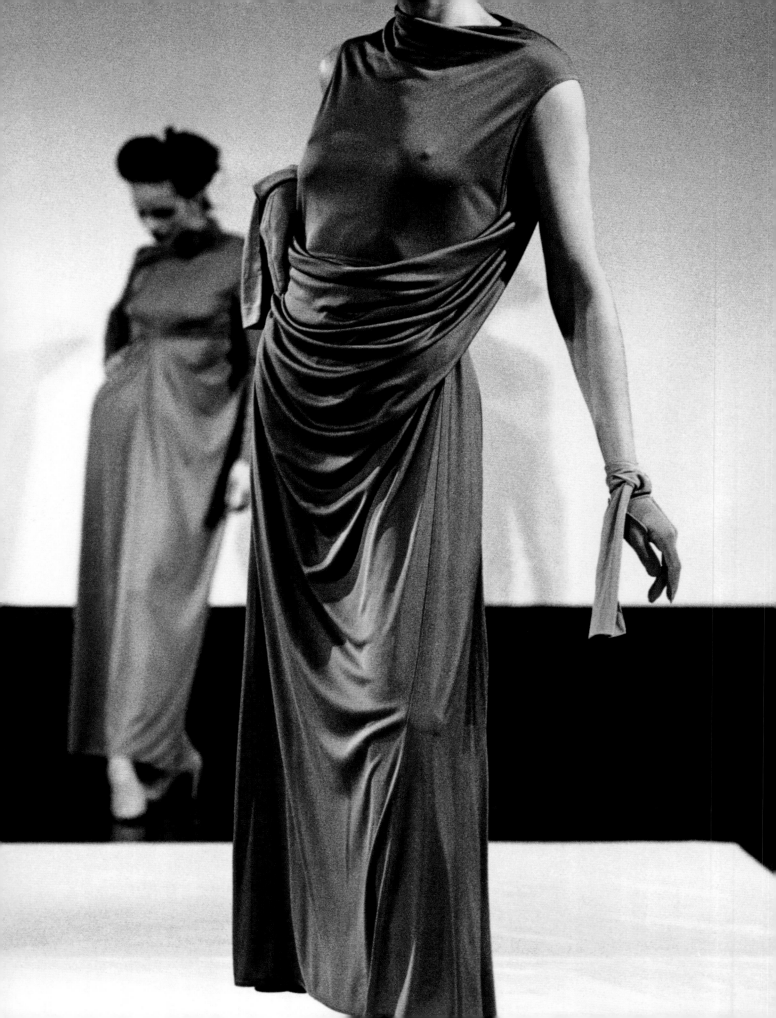

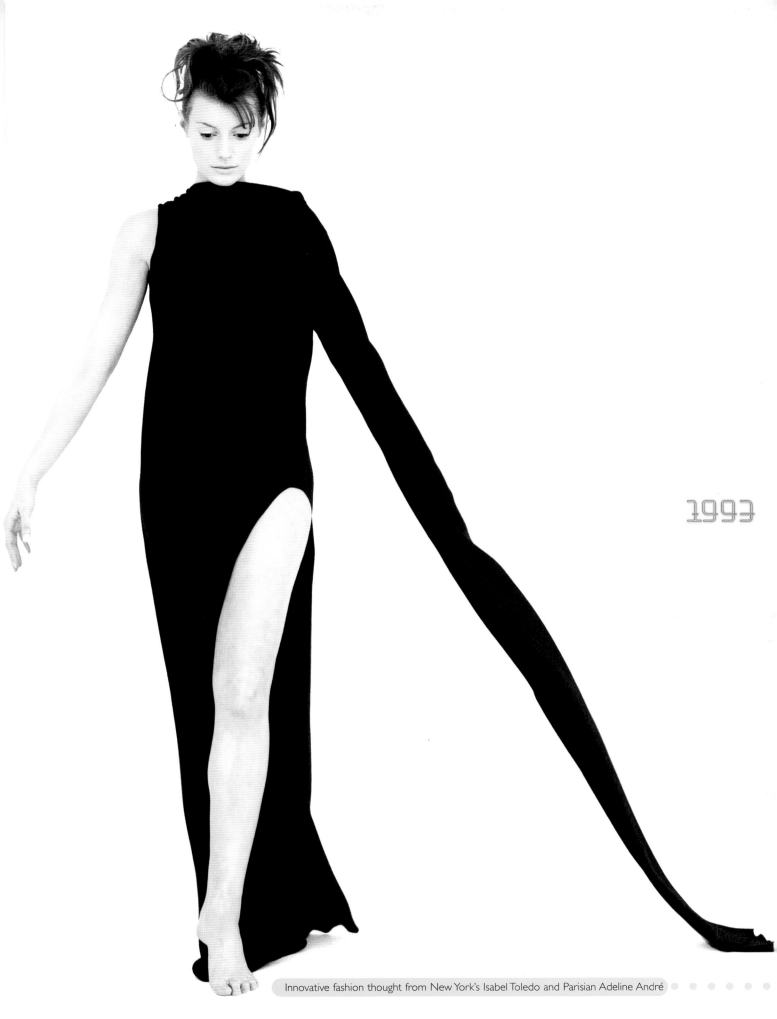

1993

Innovative fashion thought from New York's Isabel Toledo and Parisian Adeline André

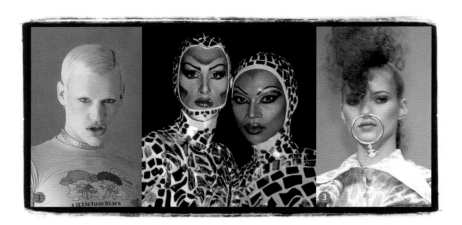

142

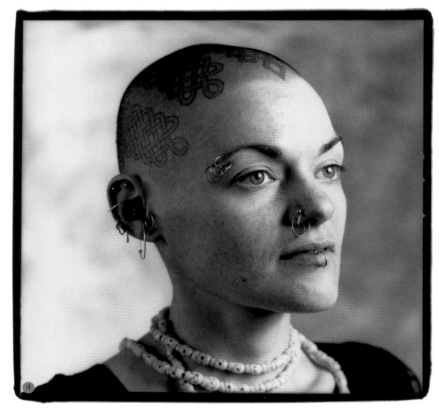

●1 Club kid and future Heatherette star Richie Rich ●2 Amazing-looking style team Mathu and Zaldy
●3 Vivienne Westwood puts a giant nose ring on Kate Moss. ●4 Piercings and tattoos are everywhere.
●5 Diesel ads start appearing in hip magazines. ●6 Sport-inspired fashion design by Label

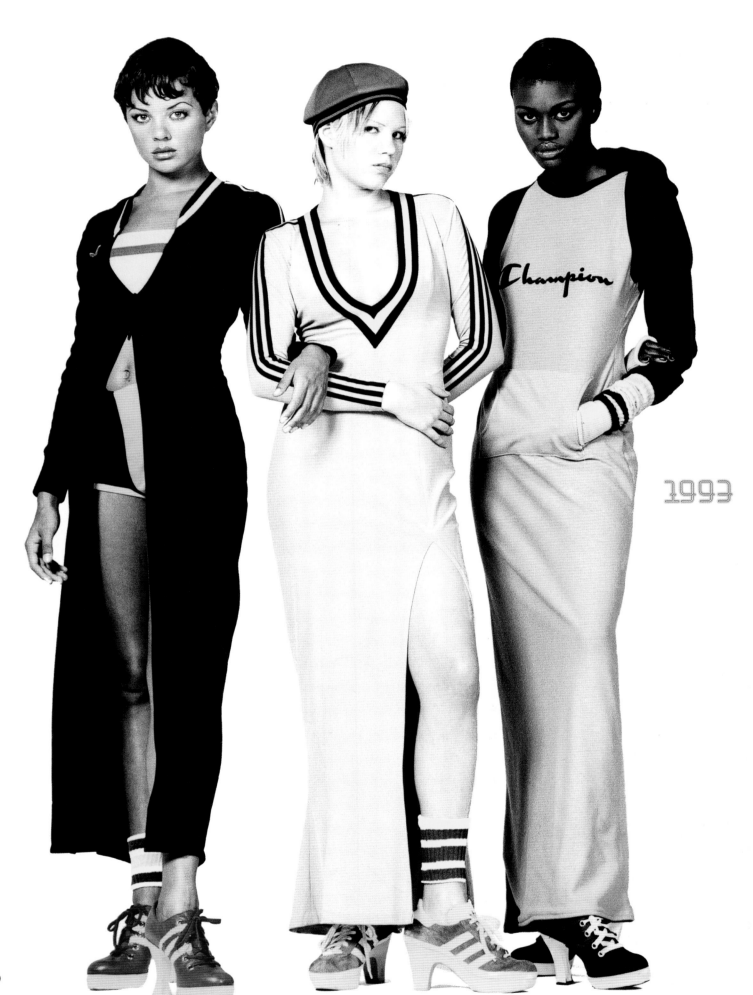

1993

6

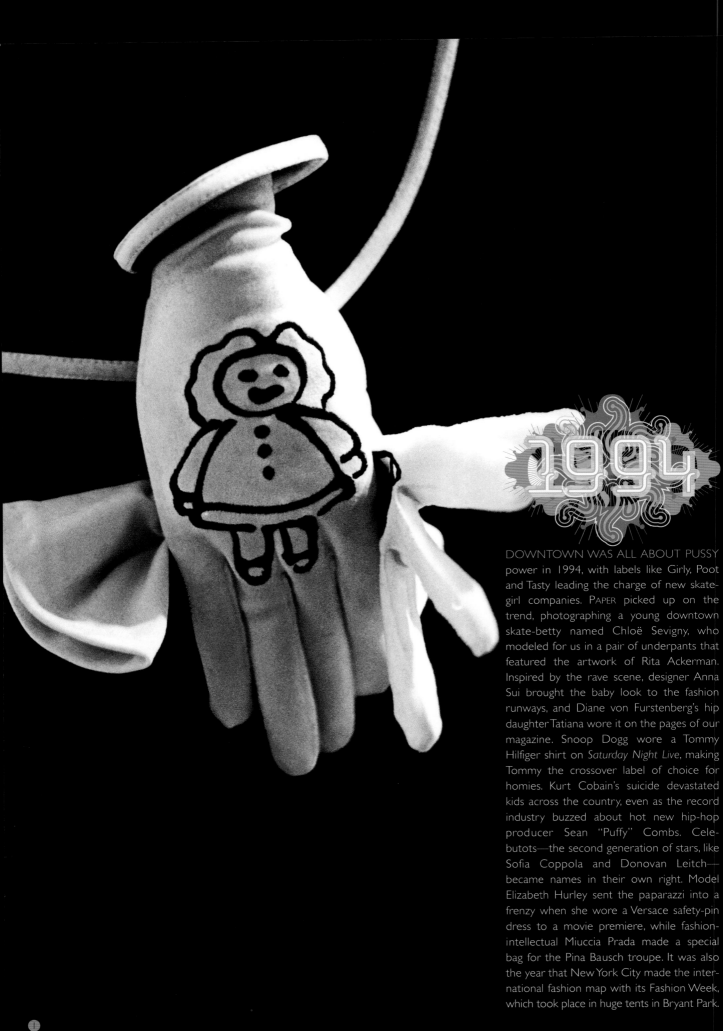

DOWNTOWN WAS ALL ABOUT PUSSY power in 1994, with labels like Girly, Poot and Tasty leading the charge of new skate-girl companies. PAPER picked up on the trend, photographing a young downtown skate-betty named Chloë Sevigny, who modeled for us in a pair of underpants that featured the artwork of Rita Ackerman. Inspired by the rave scene, designer Anna Sui brought the baby look to the fashion runways, and Diane von Furstenberg's hip daughter Tatiana wore it on the pages of our magazine. Snoop Dogg wore a Tommy Hilfiger shirt on *Saturday Night Live*, making Tommy the crossover label of choice for homies. Kurt Cobain's suicide devastated kids across the country, even as the record industry buzzed about hot new hip-hop producer Sean "Puffy" Combs. Cele-butots—the second generation of stars, like Sofia Coppola and Donovan Leitch— became names in their own right. Model Elizabeth Hurley sent the paparazzi into a frenzy when she wore a Versace safety-pin dress to a movie premiere, while fashion-intellectual Miuccia Prada made a special bag for the Pina Bausch troupe. It was also the year that New York City made the inter-national fashion map with its Fashion Week, which took place in huge tents in Bryant Park.

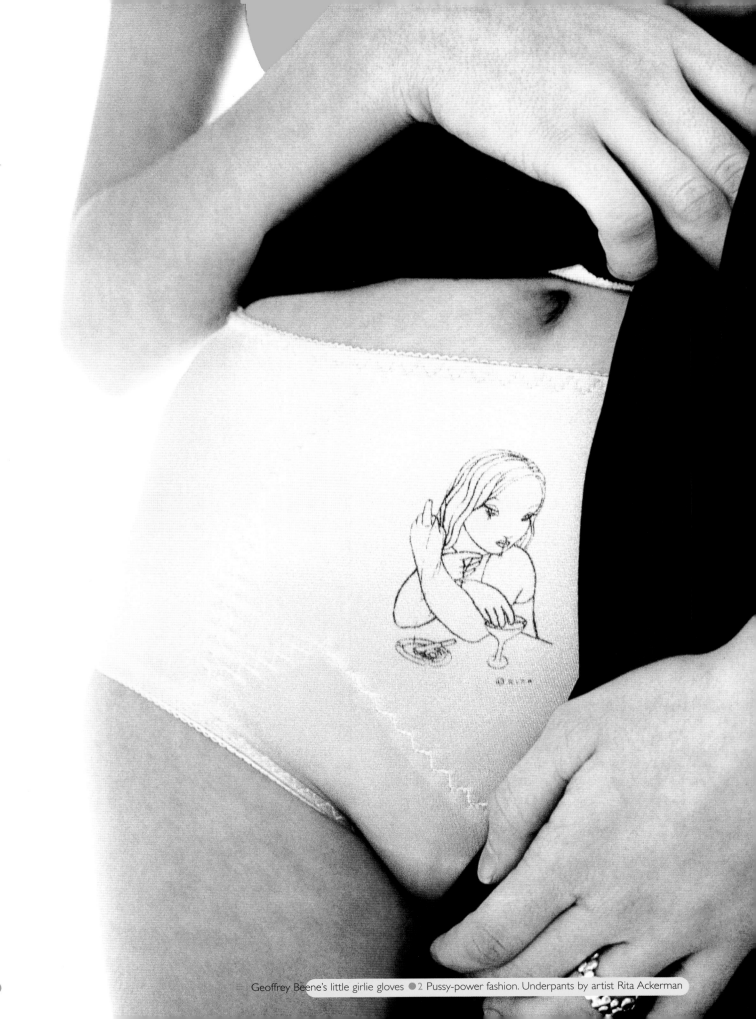

Geoffrey Beene's little girlie gloves ● 2 Pussy-power fashion. Underpants by artist Rita Ackerman

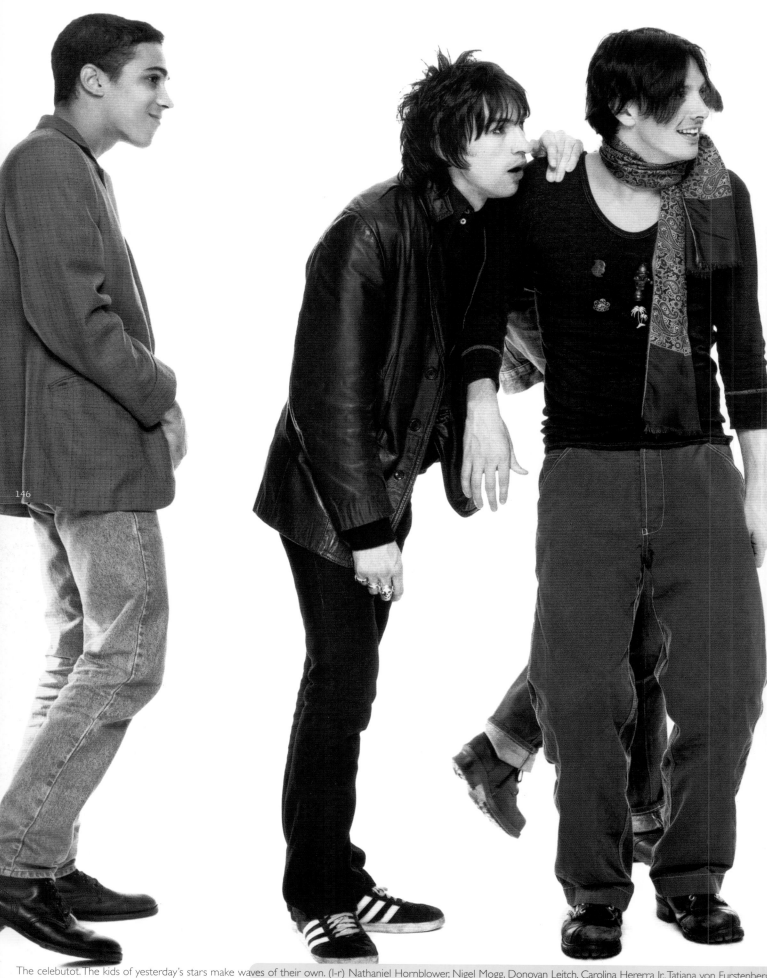

146

The celebutot. The kids of yesterday's stars make waves of their own. (l-r) Nathaniel Hornblower, Nigel Mogg, Donovan Leitch, Carolina Hererra Jr., Tatiana von Furstenberg

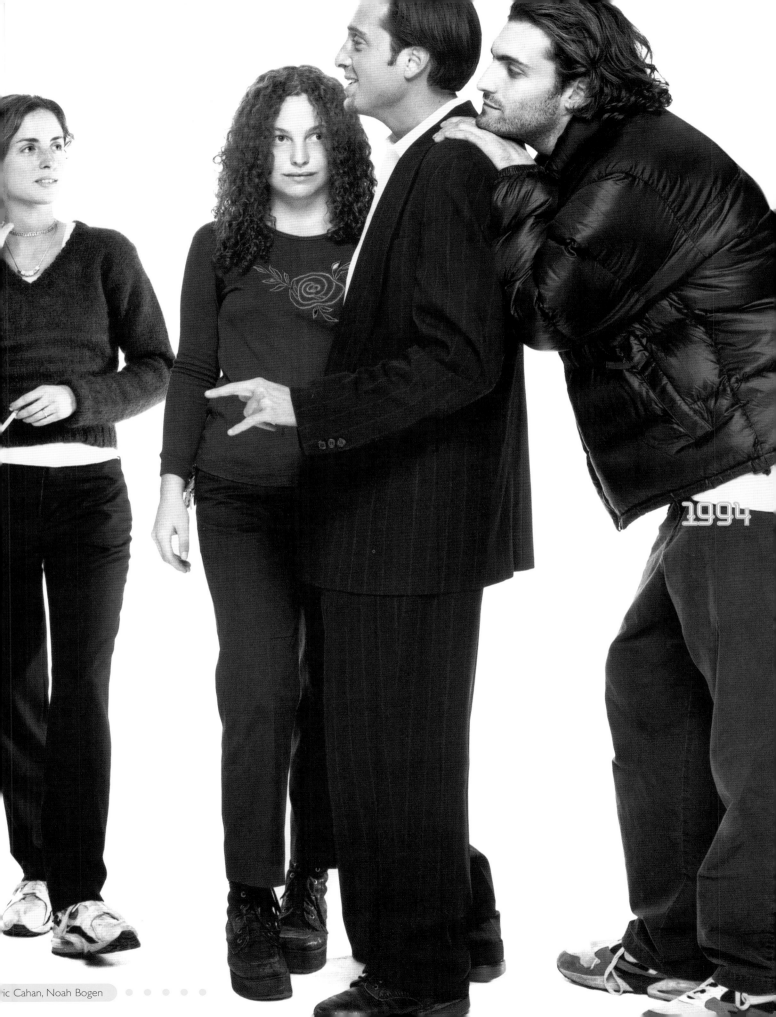

1994

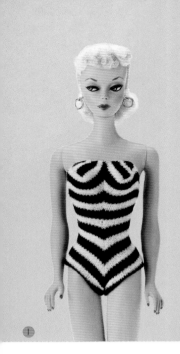

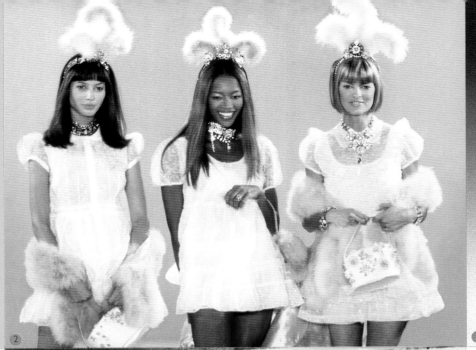

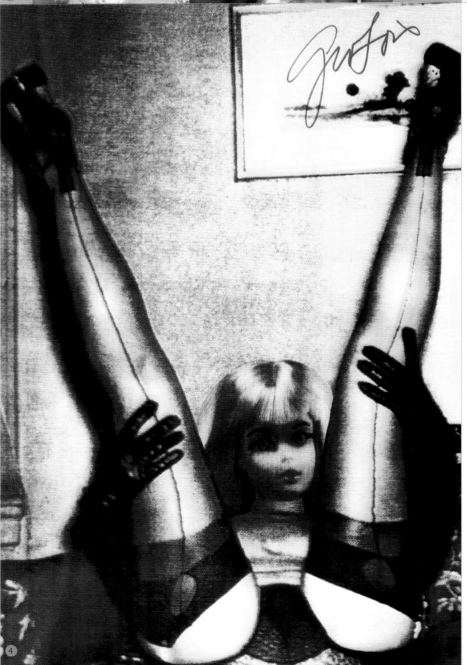

148

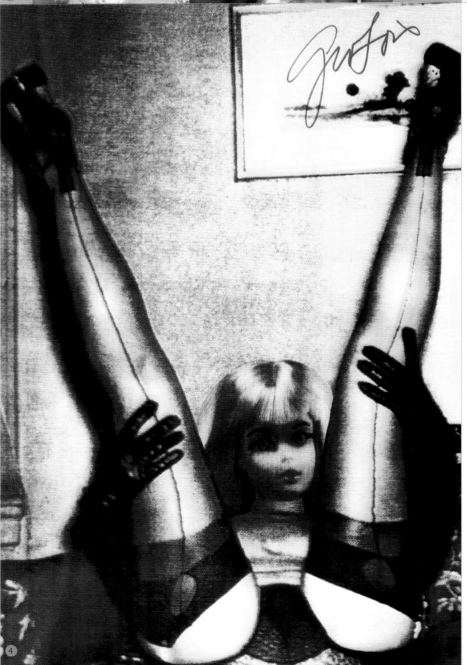

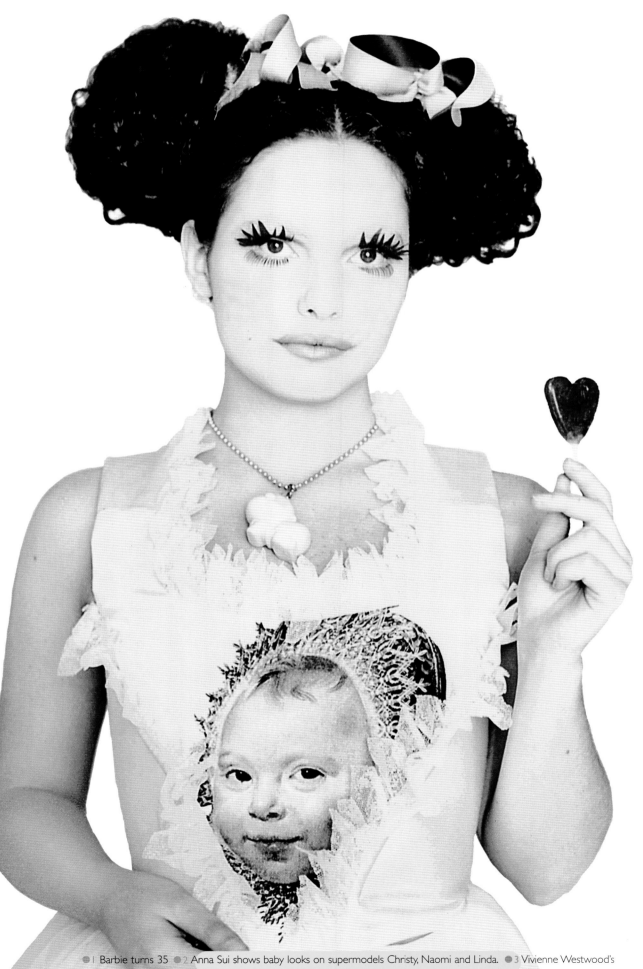

1994

1 Barbie turns 35 2 Anna Sui shows baby looks on supermodels Christy, Naomi and Linda. 3 Vivienne Westwood's fetish chic 4 Barbie as Bettie Page by ad-guru George Lois 5 Celebutot Tatiana von Furstenberg models the baby moment.

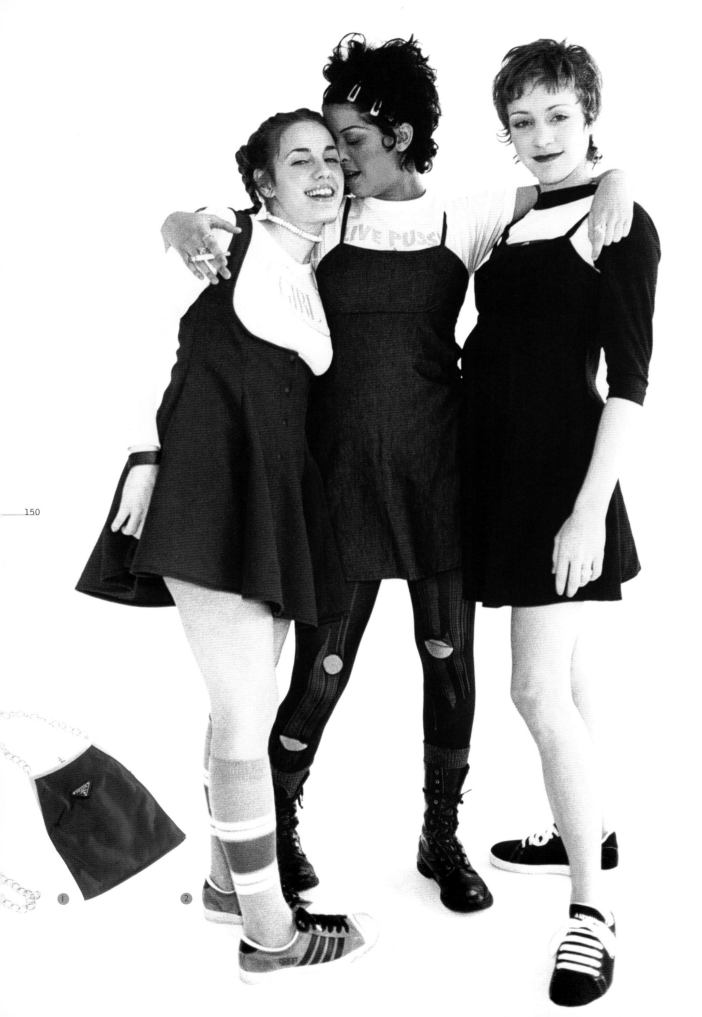

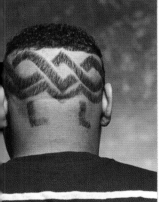

1994

●1 Miuccia Prada designs bag for Pina Bausch. ●2 Chloë Sevigny models for PAPER.
●3 Live pussy hat ●4 Artist Shepard Fairey snipes Andre the Giant posters everywhere. ●5 Vinyl is big again.
●6 Hair as art ●7 Music producer Sean "Puffy" Combs ●8 Rita Ackerman's art as fashion

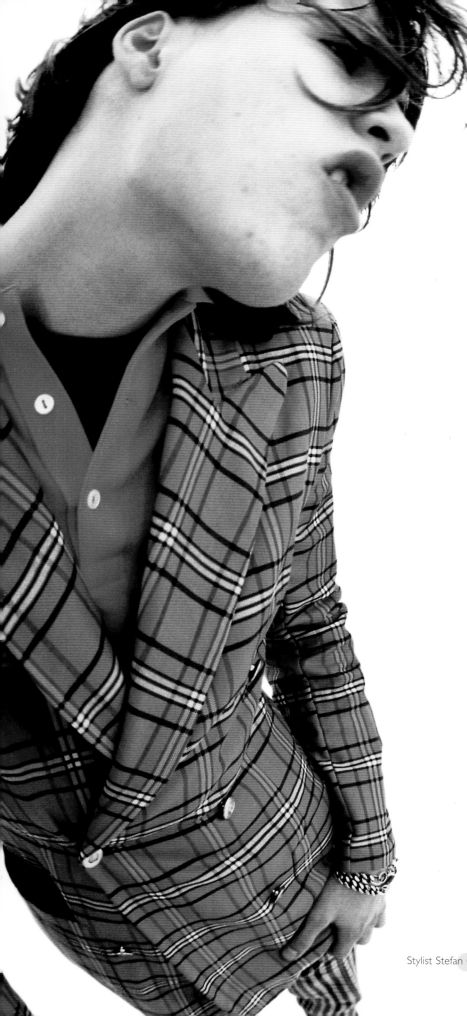

PAPER WANDERED THE CITY THIS YEAR searching for style—and we hit the jackpot in both Harlem and Chinatown. The hybrid look of the day was the punk yuppie (or the puppy, as we called it). Hardcore kids wore IZOD shirts and plaid pants, while suburban punks rocked combat boots and camouflage colors. The newspapers reported on OJ's acquittal, and the Oklahoma City federal building bombing. On the fashion tip, plenty of news came from Europe: Photographer Mario Testino and stylist Carine Roitfeld collaborated on their first Gucci campaign; Stella McCartney's graduation show from St. Martin's College of Art and Design got worldwide press coverage; and Comme des Garçons showed a collection seemingly inspired by Bozo the Clown. In Paris, Belgian designer Walter Van Beirendonck showed gay-bears-gone-cyber fashions for Wild and Lethal Trash. Sony introduced PlayStation to the U.S., and it was an instant sensation. Dial-up Internet service hit the market too. Tyson Beckford was the male supermodel of the moment and proved big muscles are always in style. Also back in style were Hush Puppies, plucked out of obscurity and back onto the feet of the hip and cool.

Stylist Stefan Campbell's look, which he calls "puppys"—punk yuppies

1995

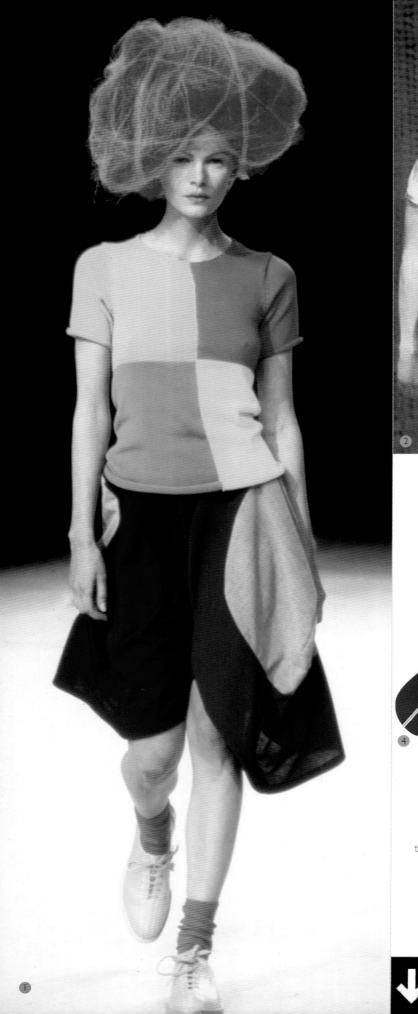

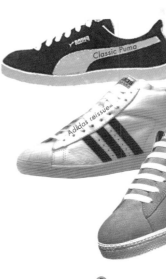

● 1 ● 2 ● 3 Cyber fashion: Comme des Garçons and
Walter Van Beirendonck looks inspired by the worldwide Web
● 4 Model Tyson Beckford is on PAPER's cover.
● 5 Old-school sneakers are resurrected. ● 6 Stickers become
the new graffiti with the skater kids. ● 7 A cyber swimmer

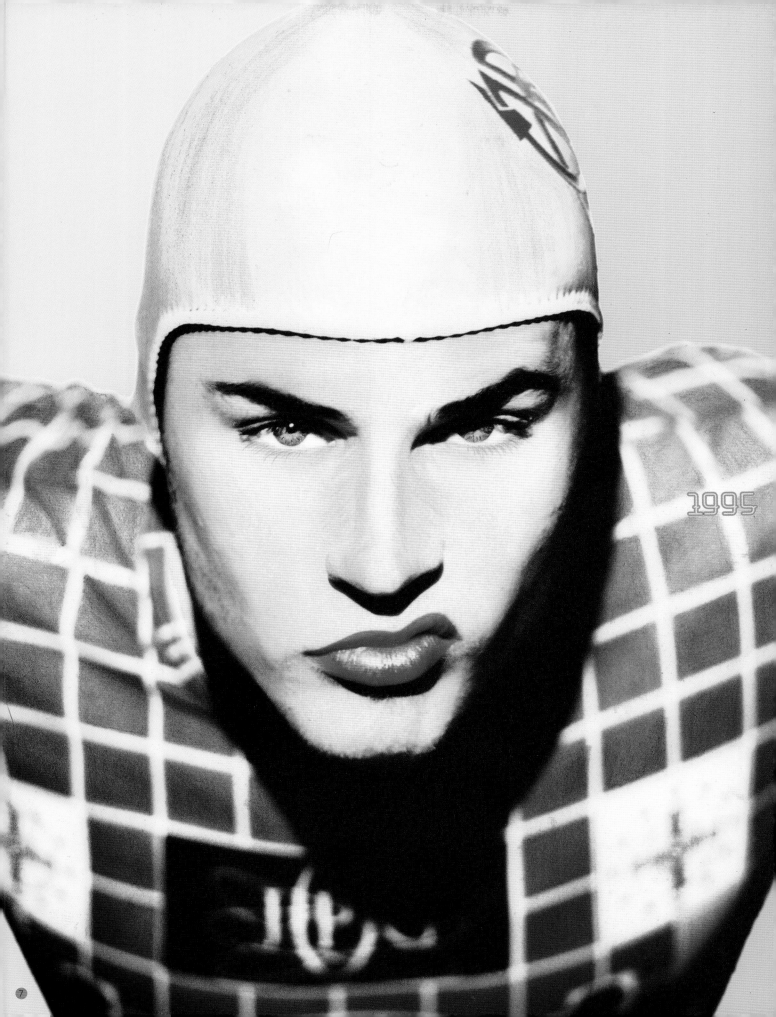

1995

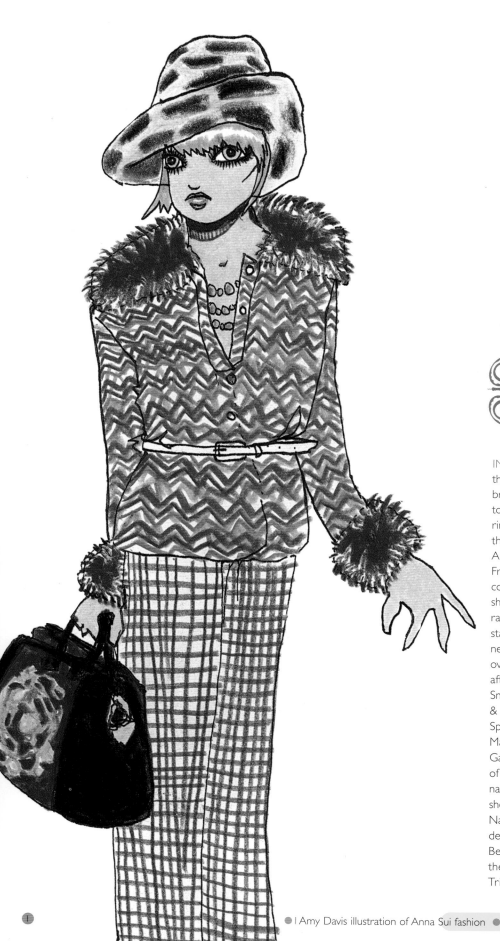

IN 1996, BANJEE QUEENS DOMINATED the streets—and the pages of PAPER. They embraced talk show host Ricki Lake, so we photographed her in a pink wig and bamboo earrings. Go, Ricki! Go, Ricki! It was also the year that we developed a jones for African-American hair and nail art. Makeup genius François Nars, who created a gorgeous line of cosmetics that all the fashionistas coveted, also showed the world he was a brilliant photographer. He shot the newest modeling superstar, Alek Wek, for PAPER. In other culture news, the music industry was heartbroken over the murder of Tupac Shakur (and, shortly afterward, the shooting death of Biggie Smalls). But the songs kept on coming: Dolce & Gabbana recorded a techno record, the Spice Girls shot up the charts, and the Macarena invaded the suburbs. Designer John Galliano took over at Dior, changing the face of couture forever, and a 14-year-old model named Gisele Bundchen was discovered while she was eating a hamburger in Rio de Janeiro. Narciso Rodriguez leaped to stardom after designing the wedding dress for Carolyn Bessette—who married John Kennedy Jr., the sexiest man alive. The couple moved to Tribeca, just a few blocks from our office.

1 Amy Davis illustration of Anna Sui fashion 2 François Nars photographs model Alek Wek wearing Prac

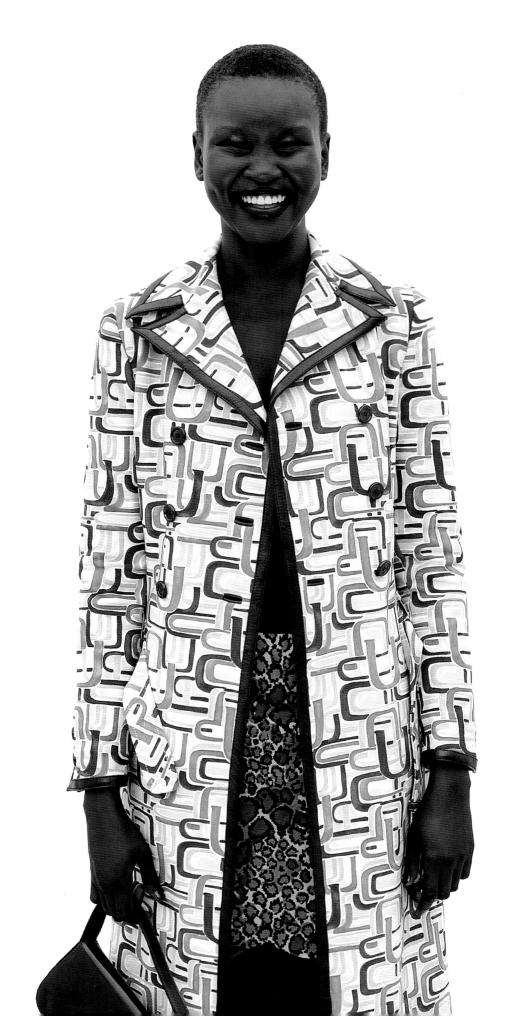

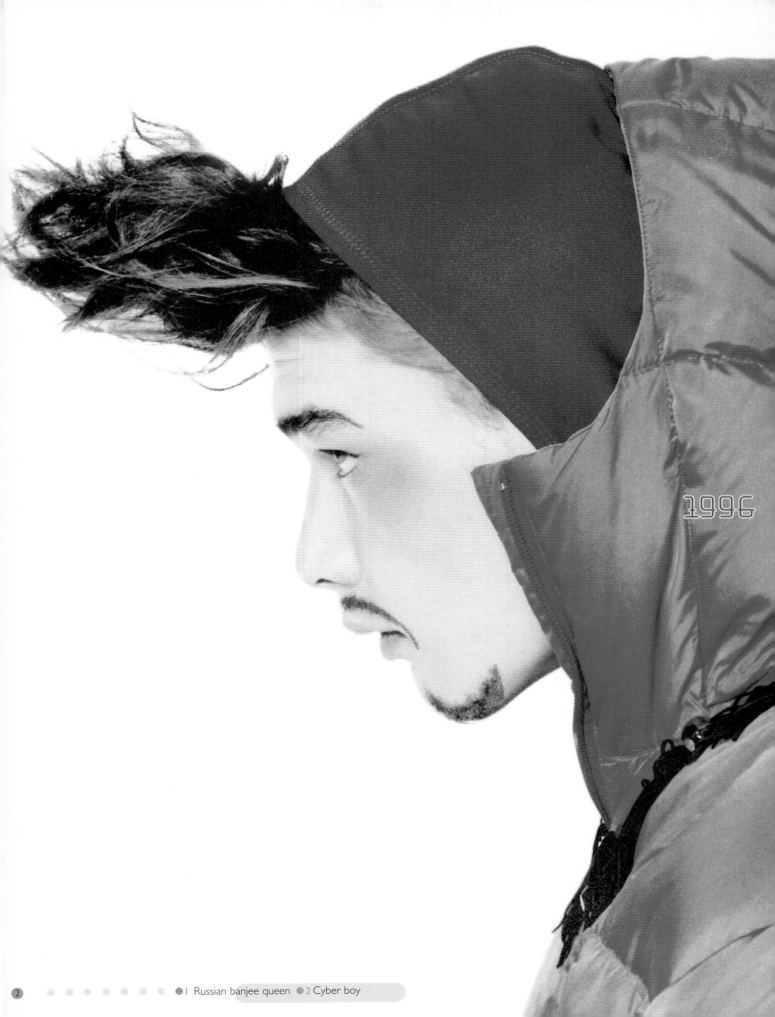

1996

●1 Russian banjee queen ●2 Cyber boy

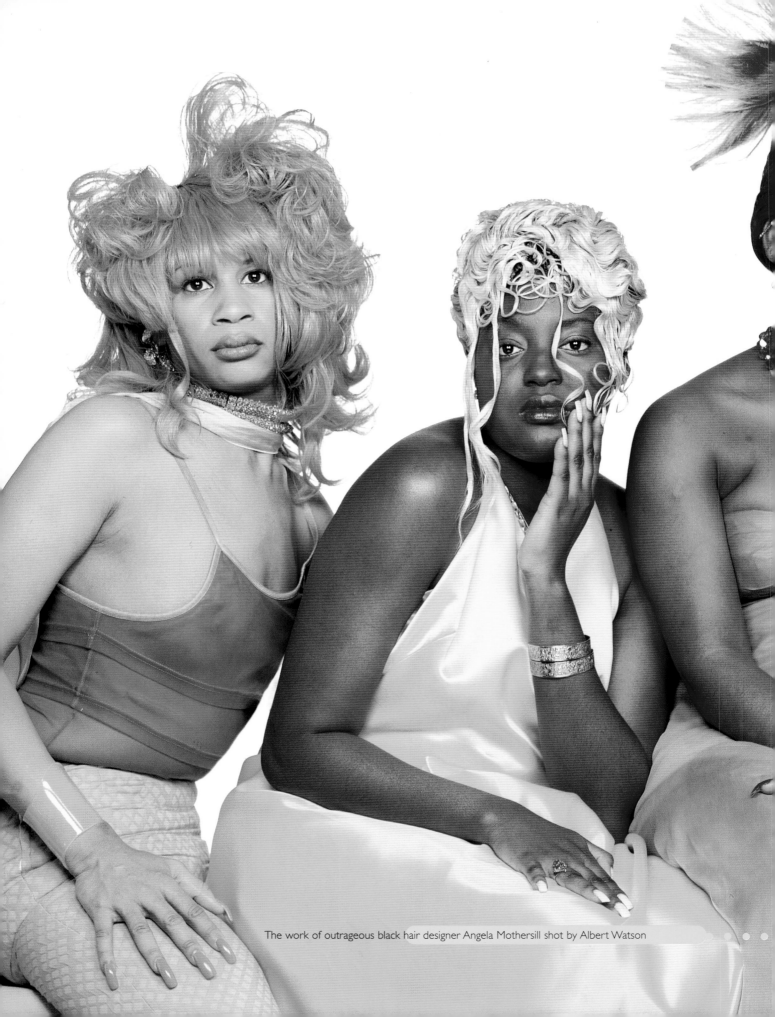

The work of outrageous black hair designer Angela Mothersill shot by Albert Watson

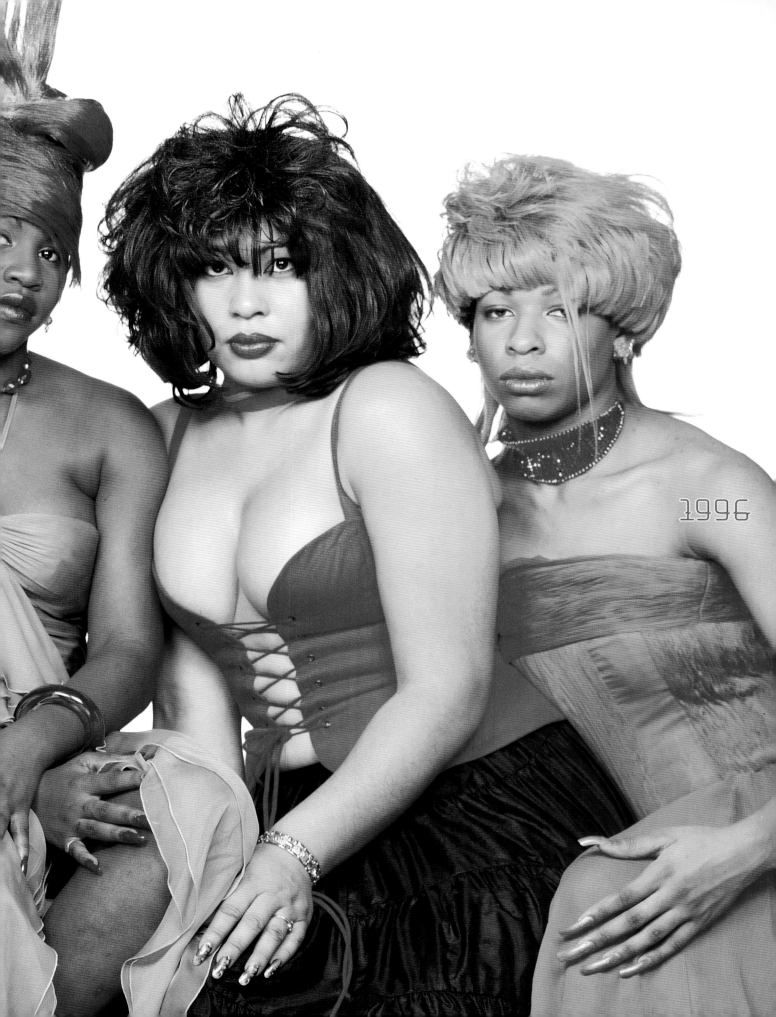
1996

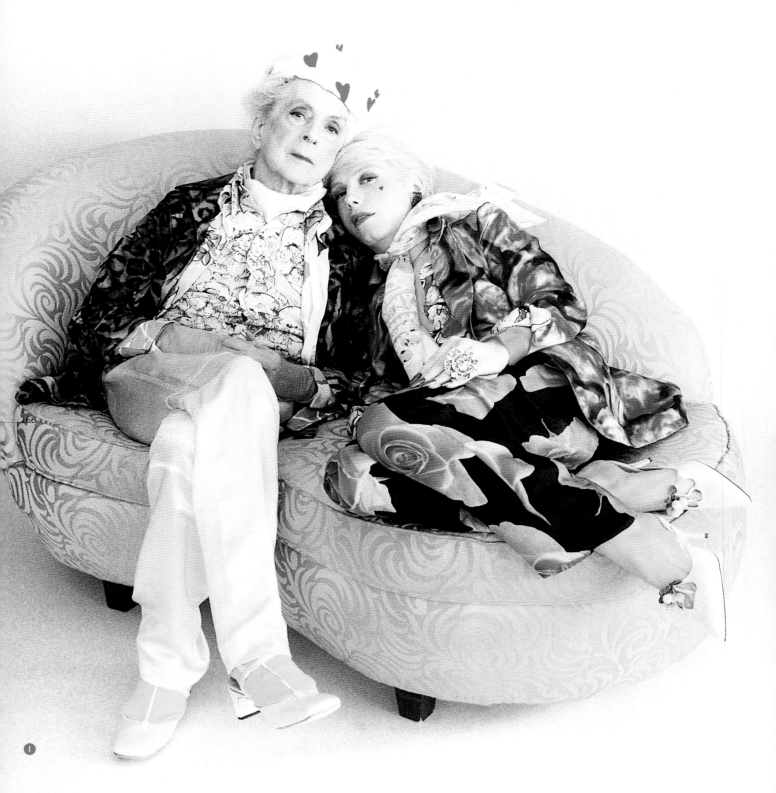

●1 Quentin Crisp poses. ●2 Isaac Mizrahi's fashion show ●3 Fashion's backstage documentarian photographer Roxanne Lowit ●4 Nail art takes off. ●5 Donatella Versace epitomizes glam.

●6 Artist/designer Susan Cianciolo's handmade clothes react against mainstream fashion.

●7 You go, girl! Ricki Lake as banjee queen for PAPER's cover

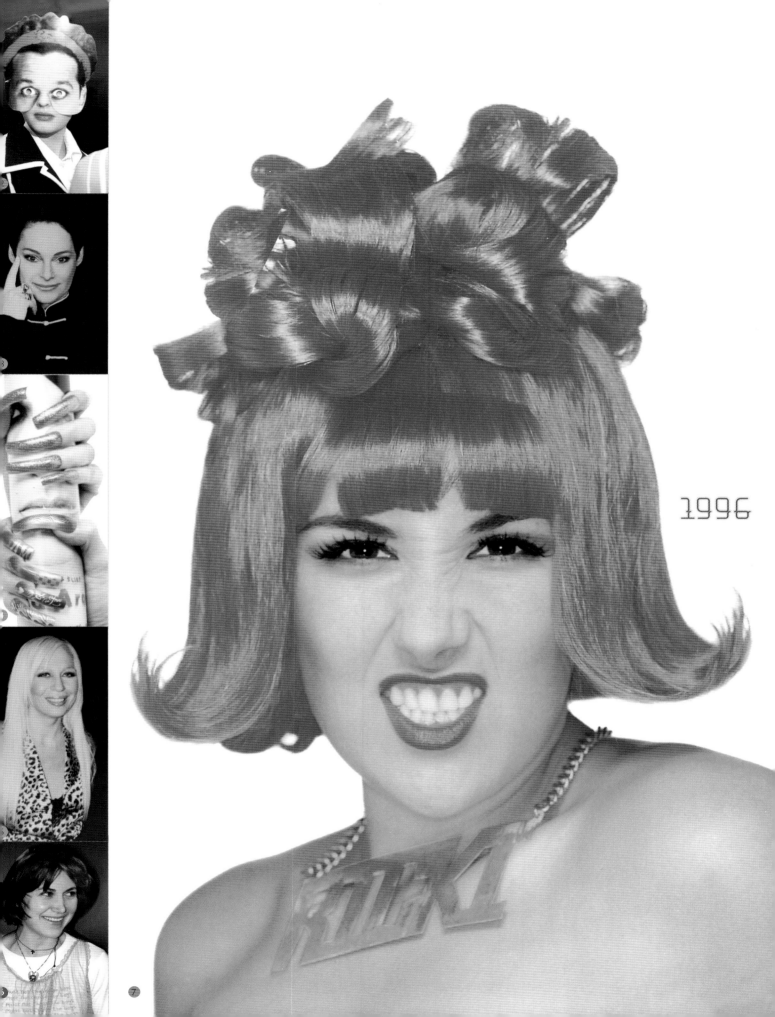

1996

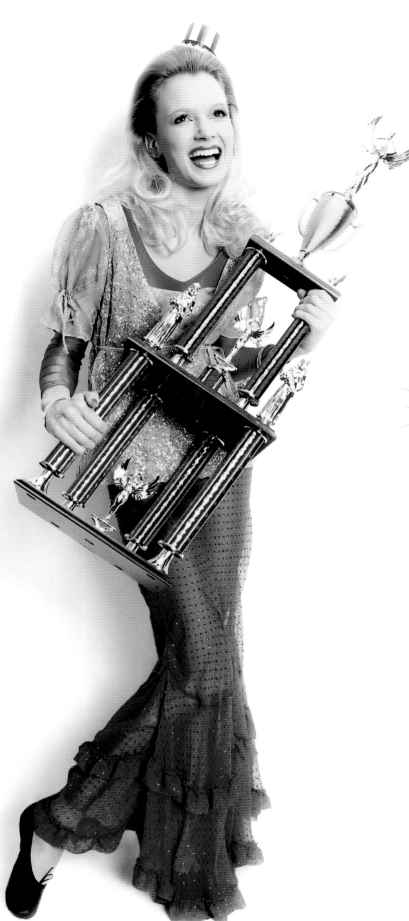

THE STYLE WORLD WAS STUNNED BY the 1997 murder of Gianni Versace and took flak from critics who alleged that the fashion industry was promoting heroin chic by idealizing hyper-thin, sickly looking models. PAPER, however, celebrated two robust goddesses: Lil' Kim, who emerged as hip-hop's sexiest label lover, and Dolly Parton, shot for us on a shelf of giant teddy bears by David LaChapelle. On the male side, we paid homage to studly Burt Reynolds (who made a comeback playing a porn king in Paul Thomas Anderson's *Boogie Nights*). Dolly the sheep was cloned, causing an uproar in the scientific community, and beefcake Bill Clinton began his second term as commander-in-chief, appointing Madeleine Albright the highest-ranking woman in the U.S. government. Back on the streets, pierced navels hit suburbia, and the mall girls went crazy for henna tattoos. In Paris, a trio of red-hot designers got new gigs: Marc Jacobs at Louis Vuitton, Nicolas Ghesquière at Balenciaga and Stella McCartney at Chloé. Everyone's fashion obsession Princess Diana was photographed by Mario Testino for *Vanity Fair*'s cover. Sadly, she died in a car crash late that August.

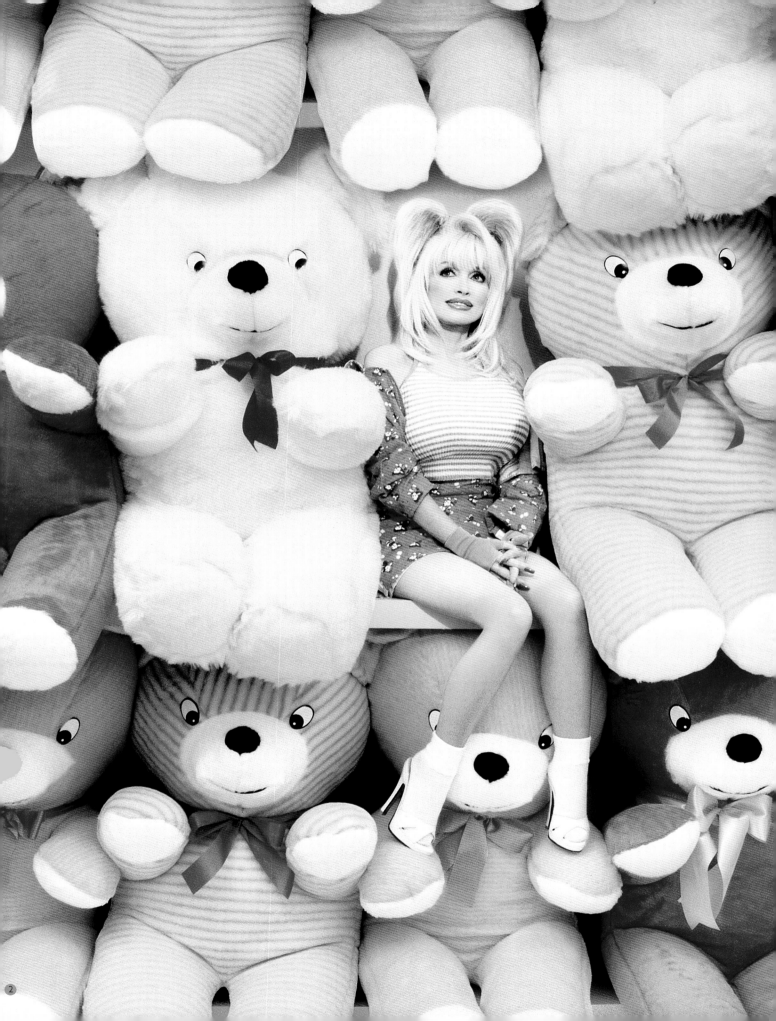

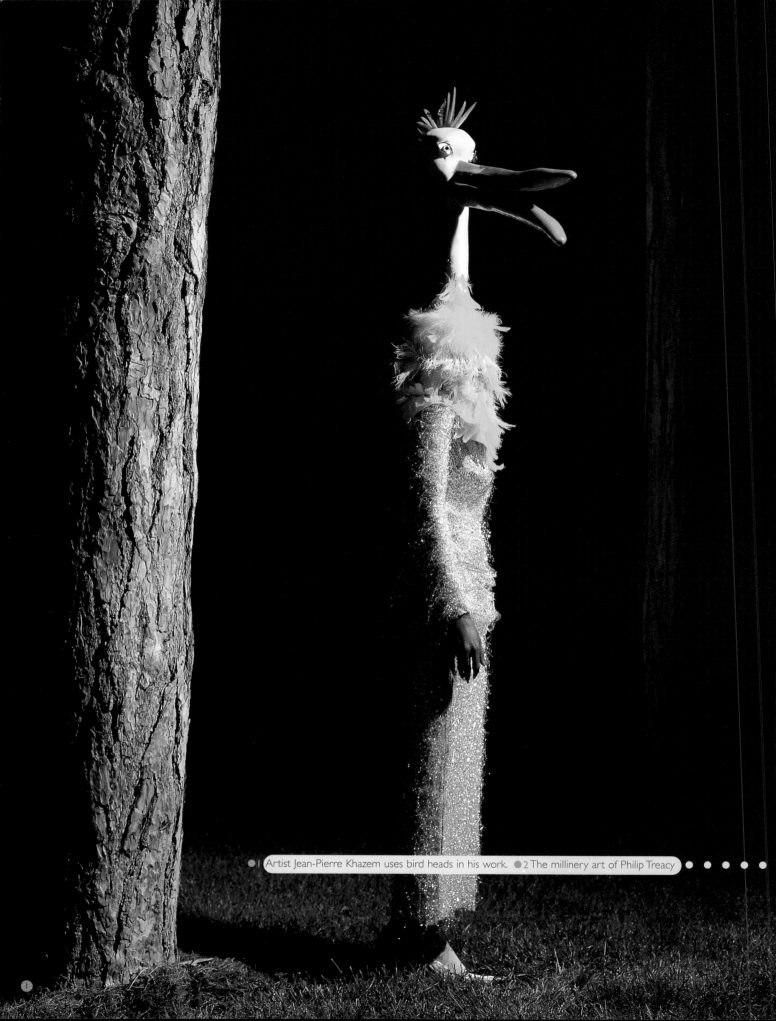

1 Artist Jean-Pierre Khazem uses bird heads in his work. ● 2 The millinery art of Philip Treacy

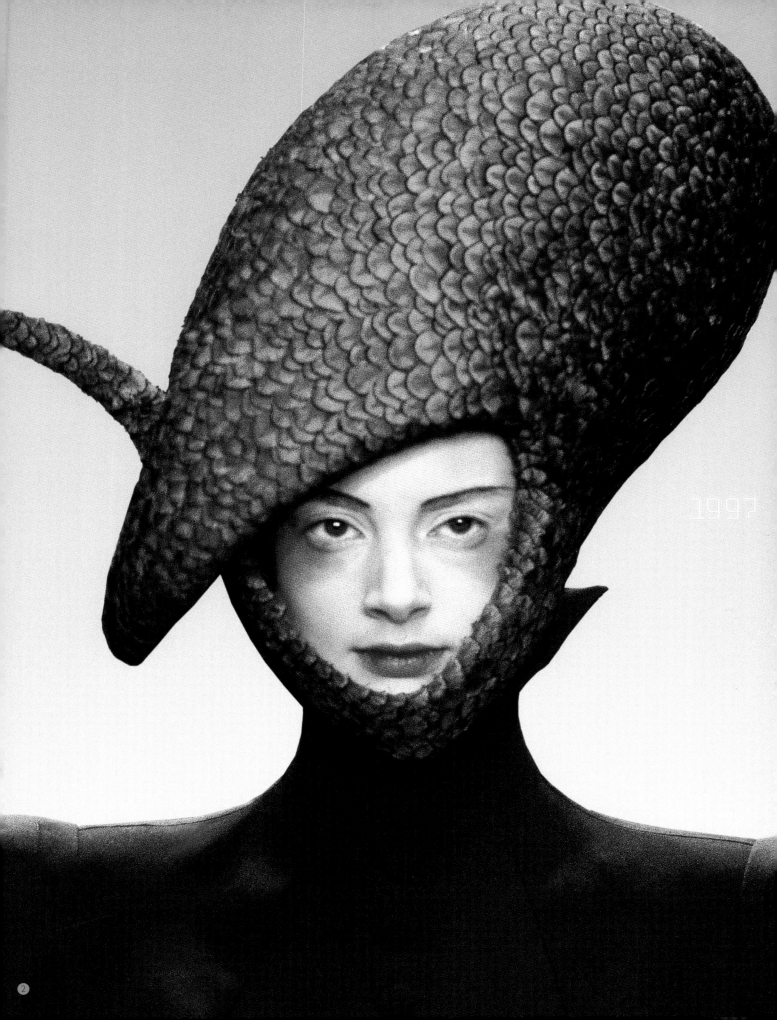

1997

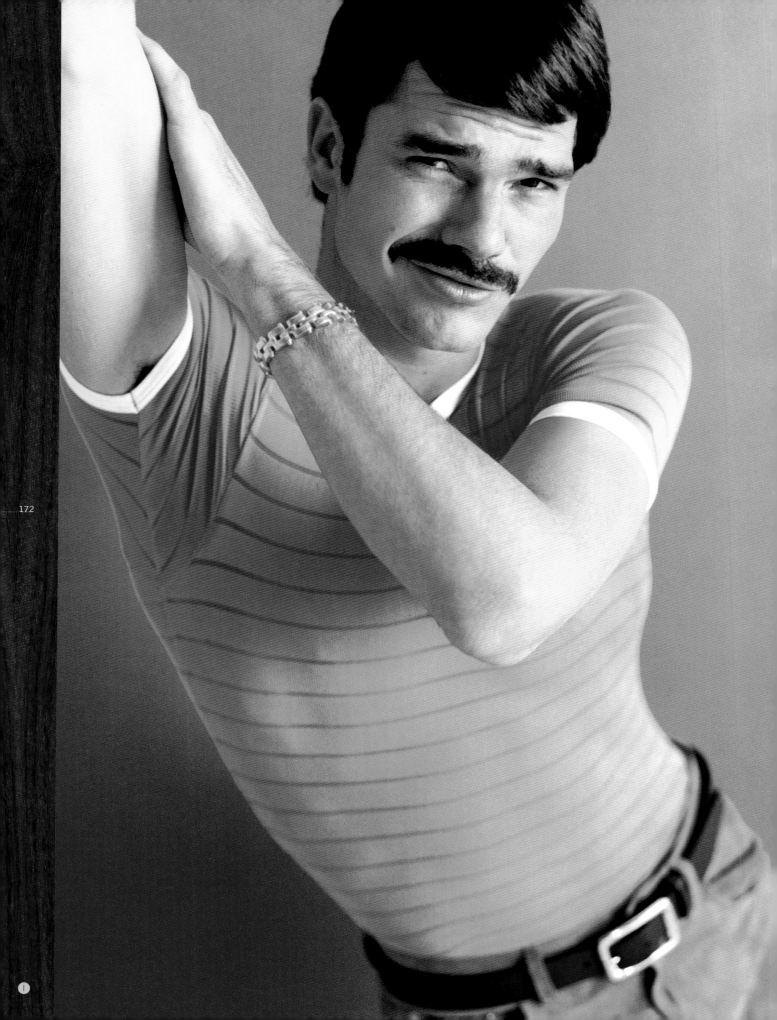

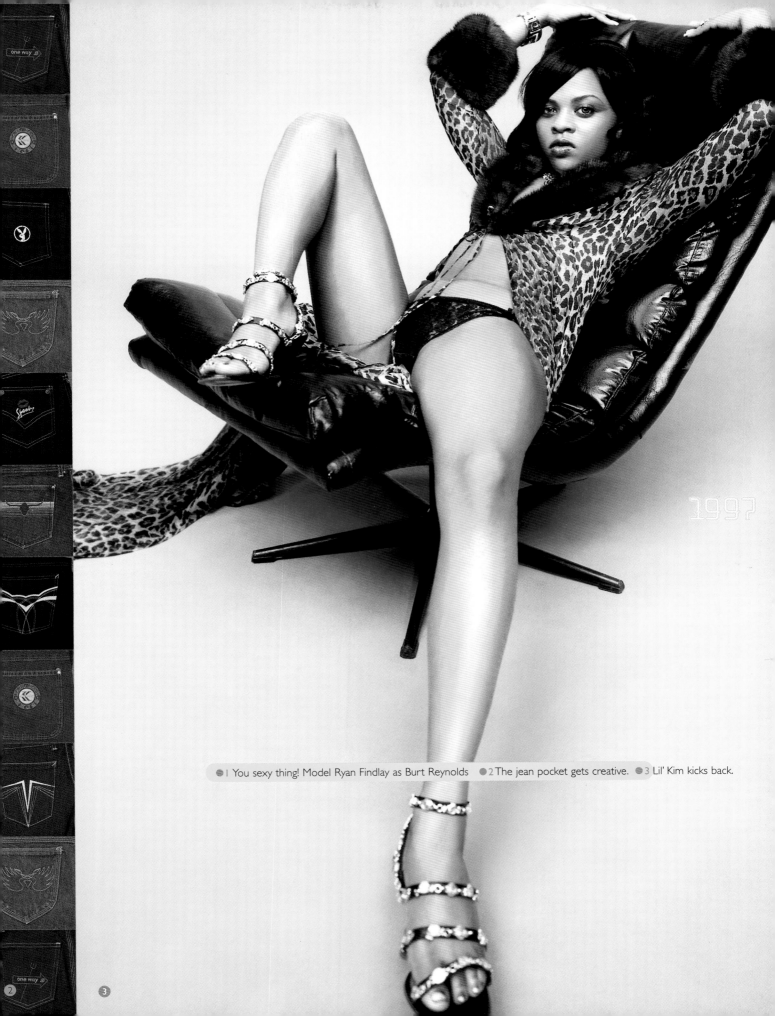

1997

●1 You sexy thing! Model Ryan Findlay as Burt Reynolds ●2 The jean pocket gets creative. ●3 Lil' Kim kicks back.

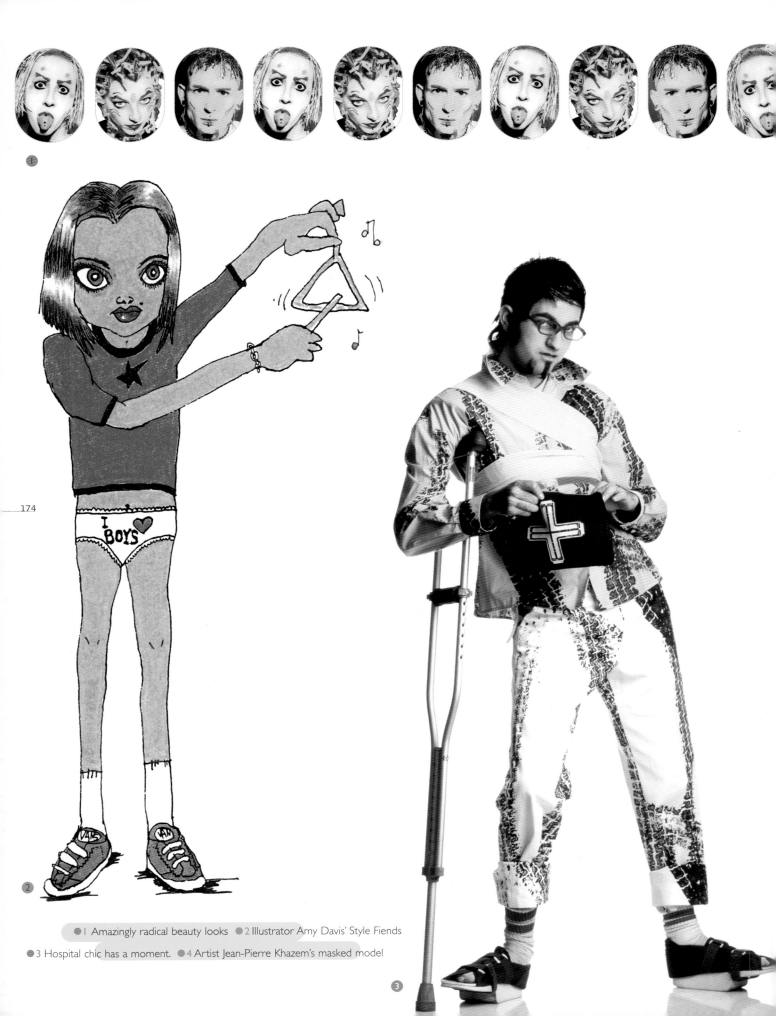

174

●1 Amazingly radical beauty looks ●2 Illustrator Amy Davis' Style Fiends
●3 Hospital chic has a moment. ●4 Artist Jean-Pierre Khazem's masked model

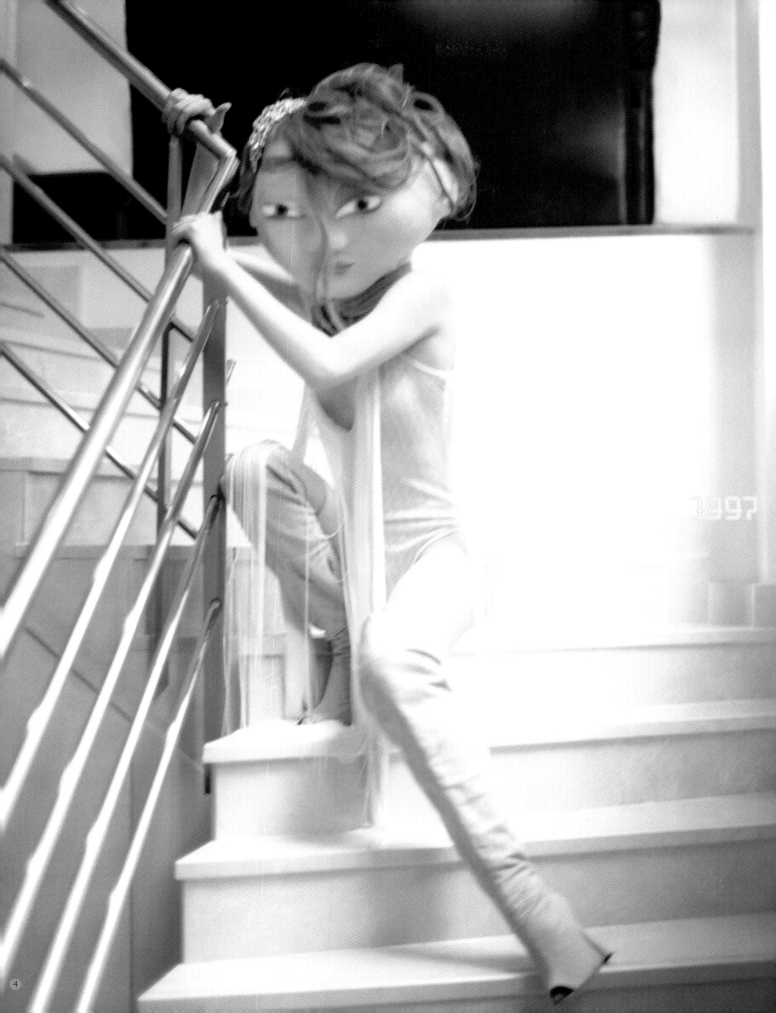

1997

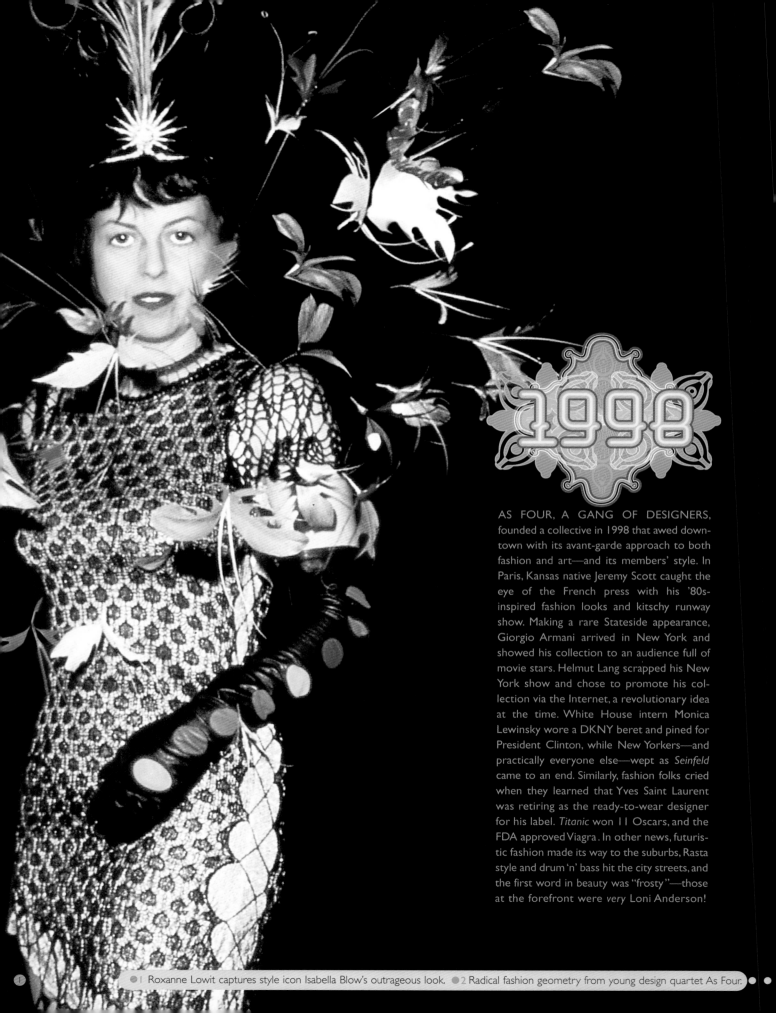

1998

AS FOUR, A GANG OF DESIGNERS, founded a collective in 1998 that awed downtown with its avant-garde approach to both fashion and art—and its members' style. In Paris, Kansas native Jeremy Scott caught the eye of the French press with his '80s-inspired fashion looks and kitschy runway show. Making a rare Stateside appearance, Giorgio Armani arrived in New York and showed his collection to an audience full of movie stars. Helmut Lang scrapped his New York show and chose to promote his collection via the Internet, a revolutionary idea at the time. White House intern Monica Lewinsky wore a DKNY beret and pined for President Clinton, while New Yorkers—and practically everyone else—wept as *Seinfeld* came to an end. Similarly, fashion folks cried when they learned that Yves Saint Laurent was retiring as the ready-to-wear designer for his label. *Titanic* won 11 Oscars, and the FDA approved Viagra. In other news, futuristic fashion made its way to the suburbs, Rasta style and drum 'n' bass hit the city streets, and the first word in beauty was "frosty"—those at the forefront were *very* Loni Anderson!

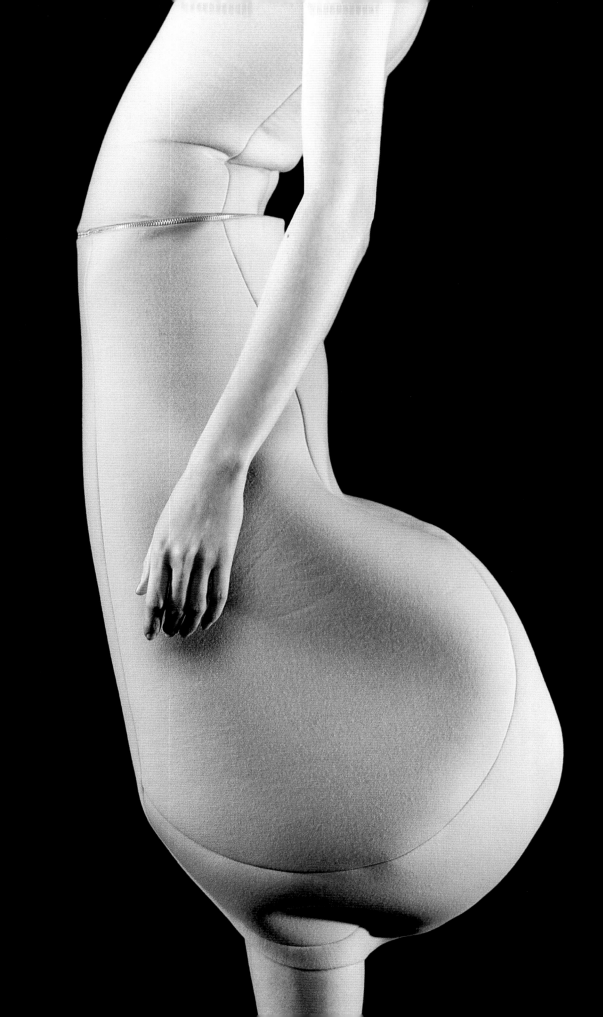

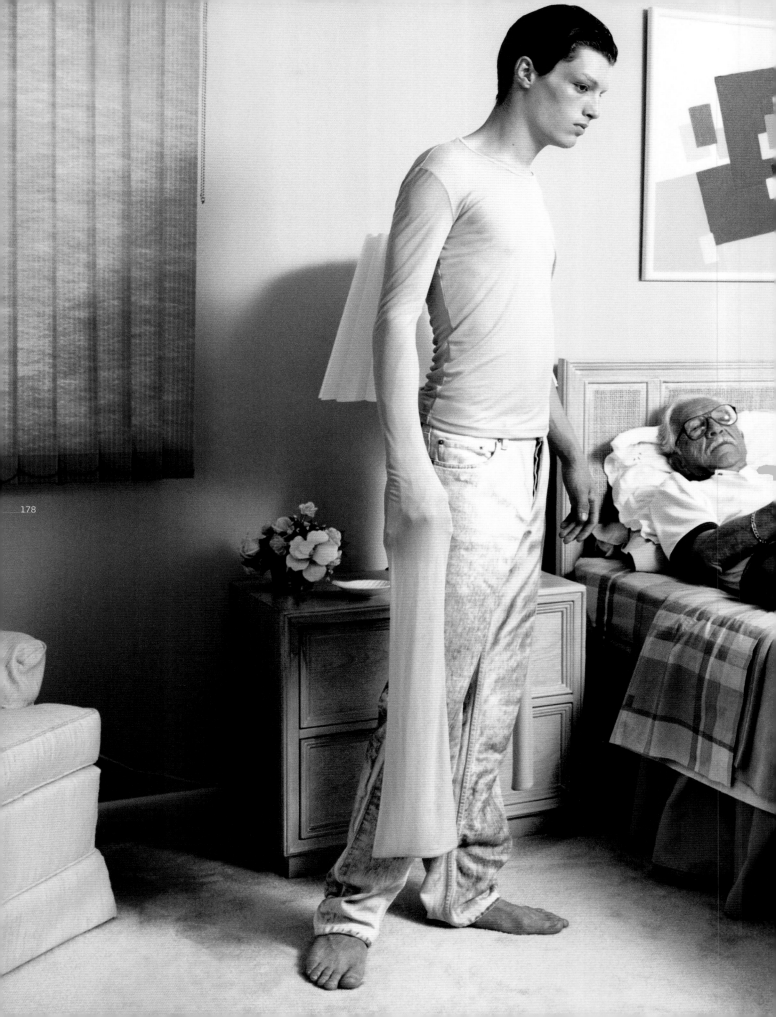

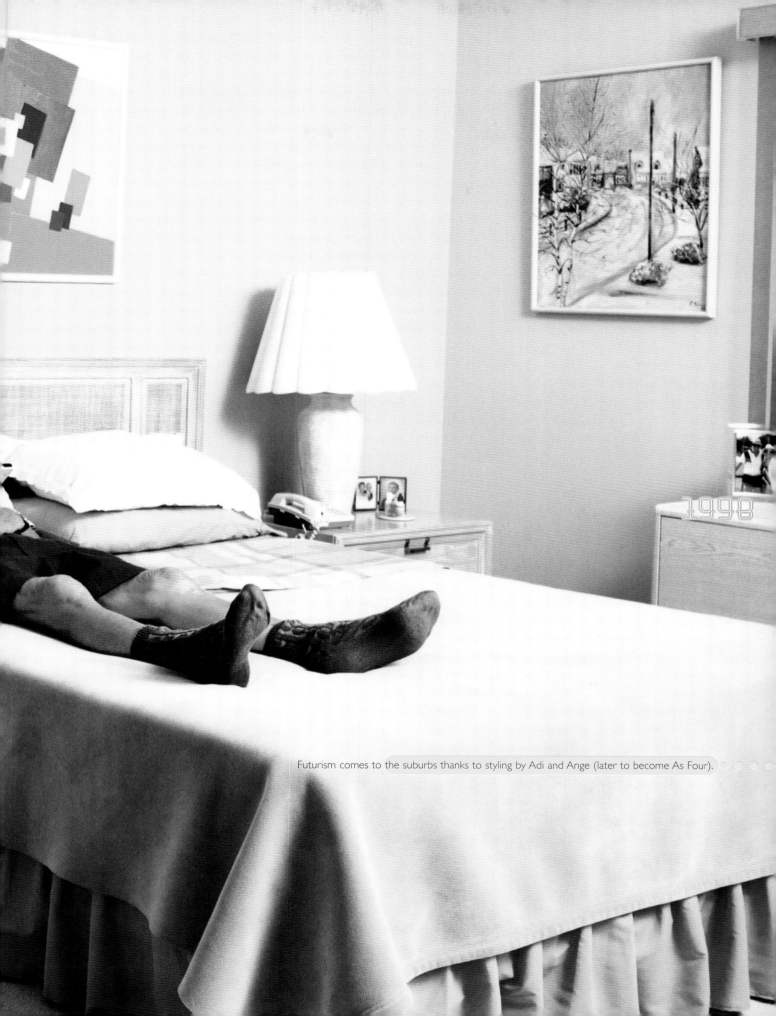

1998

Futurism comes to the suburbs thanks to styling by Adi and Ange (later to become As Four).

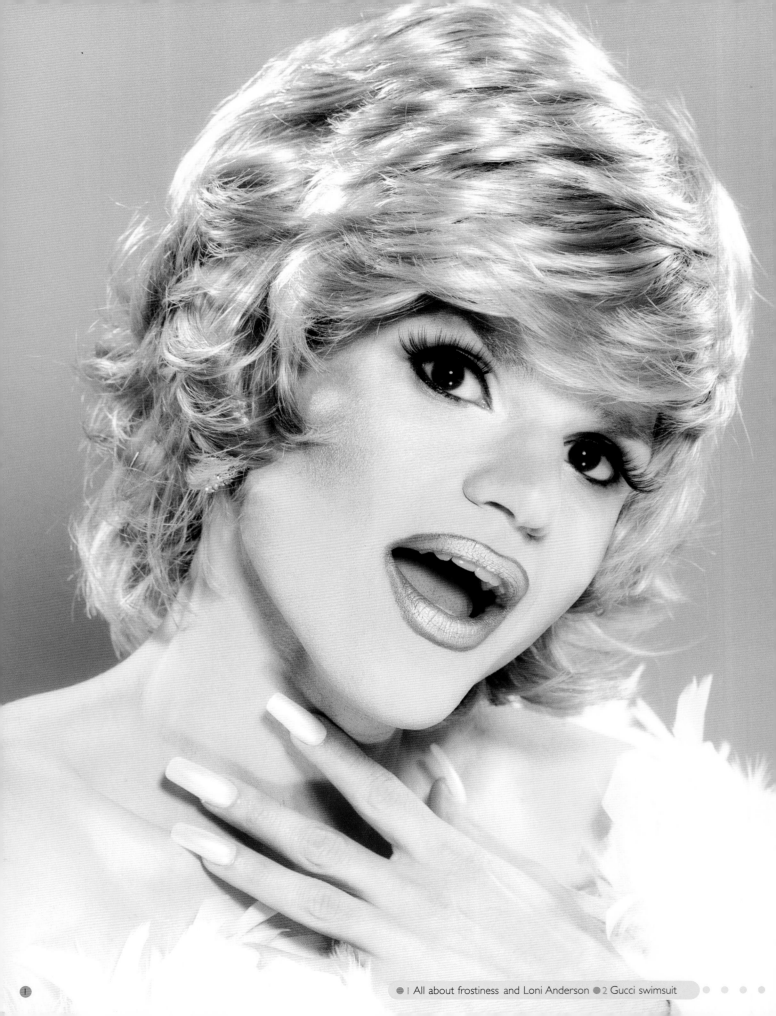

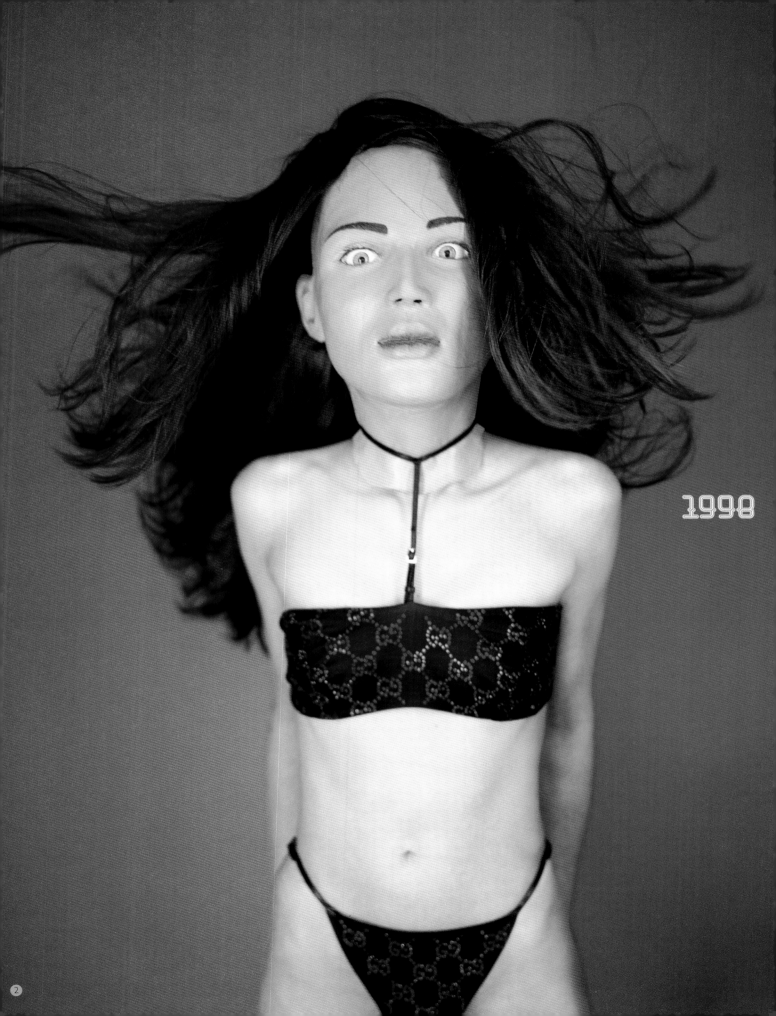

1998

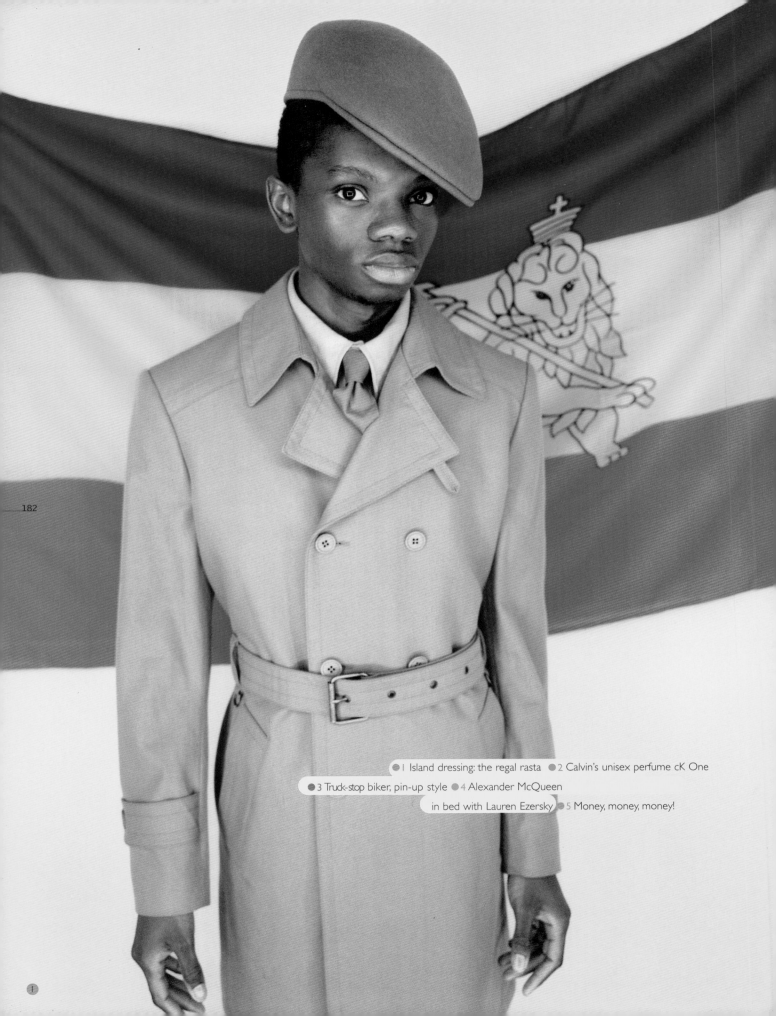

182

1 Island dressing: the regal rasta ● 2 Calvin's unisex perfume cK One
3 Truck-stop biker, pin-up style ● 4 Alexander McQueen
in bed with Lauren Ezersky ● 5 Money, money, money!

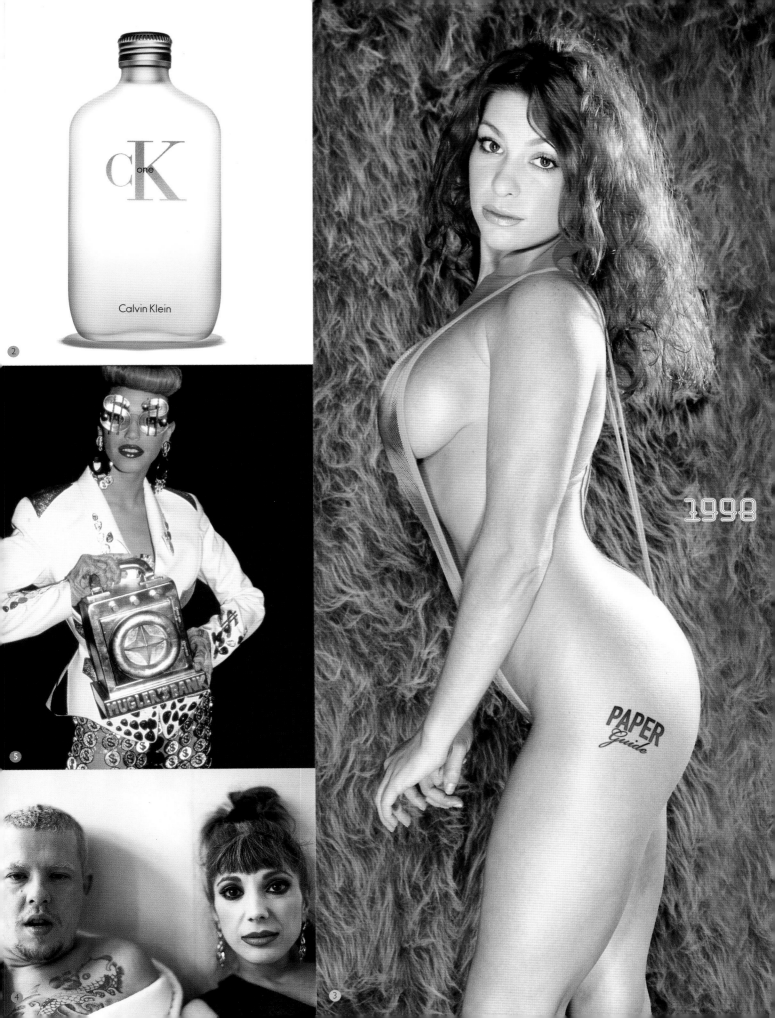

1998

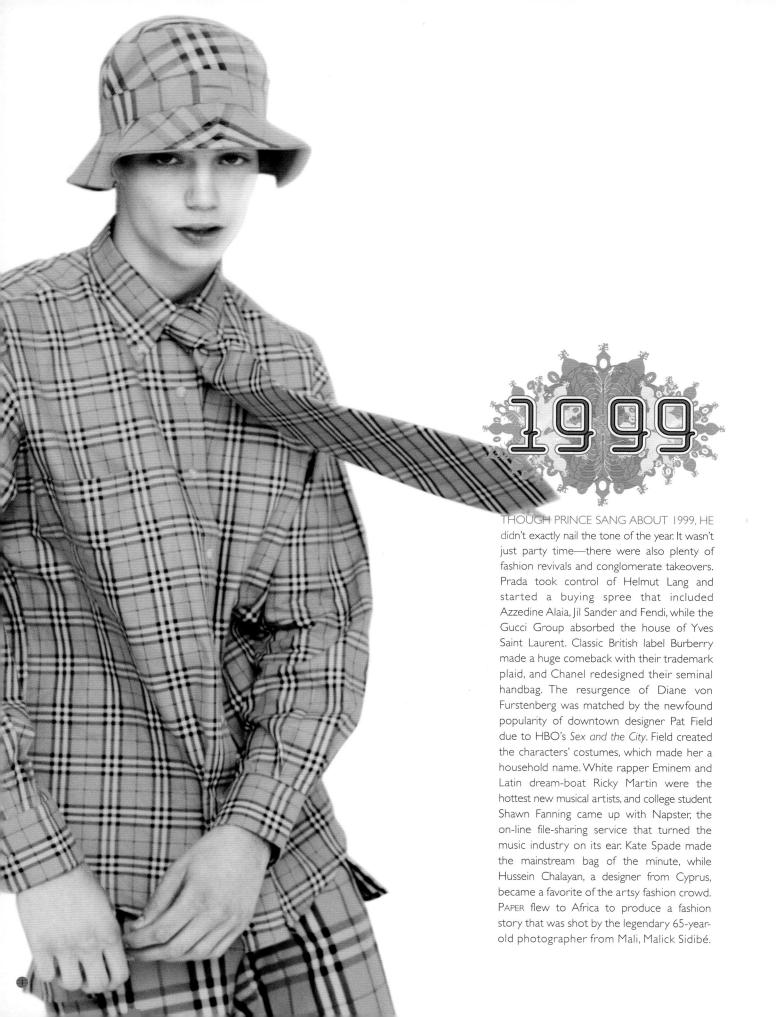

1999

THOUGH PRINCE SANG ABOUT 1999, HE didn't exactly nail the tone of the year. It wasn't just party time—there were also plenty of fashion revivals and conglomerate takeovers. Prada took control of Helmut Lang and started a buying spree that included Azzedine Alaia, Jil Sander and Fendi, while the Gucci Group absorbed the house of Yves Saint Laurent. Classic British label Burberry made a huge comeback with their trademark plaid, and Chanel redesigned their seminal handbag. The resurgence of Diane von Furstenberg was matched by the newfound popularity of downtown designer Pat Field due to HBO's *Sex and the City*. Field created the characters' costumes, which made her a household name. White rapper Eminem and Latin dream-boat Ricky Martin were the hottest new musical artists, and college student Shawn Fanning came up with Napster, the on-line file-sharing service that turned the music industry on its ear. Kate Spade made the mainstream bag of the minute, while Hussein Chalayan, a designer from Cyprus, became a favorite of the artsy fashion crowd. PAPER flew to Africa to produce a fashion story that was shot by the legendary 65-year-old photographer from Mali, Malick Sidibé.

● 1 The kids are loving Burberry. ● 2 Skate + rave = baggy, baggy pants

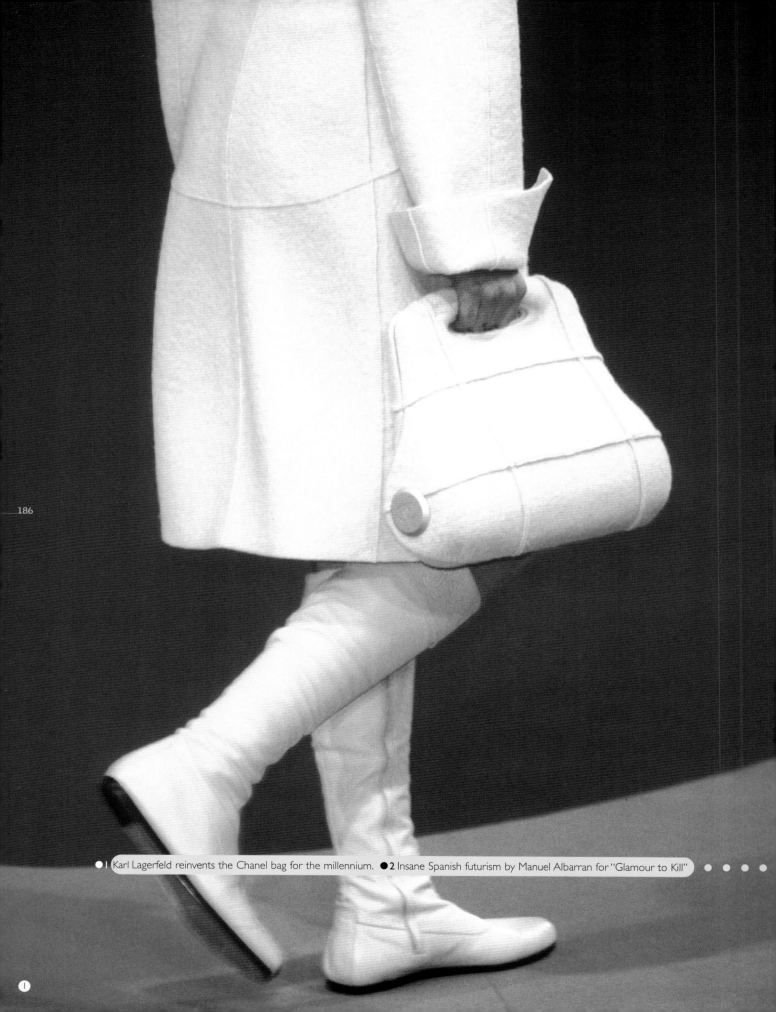

●1 Karl Lagerfeld reinvents the Chanel bag for the millennium. ●2 Insane Spanish futurism by Manuel Albarran for "Glamour to Kill" ● ● ● ● ●

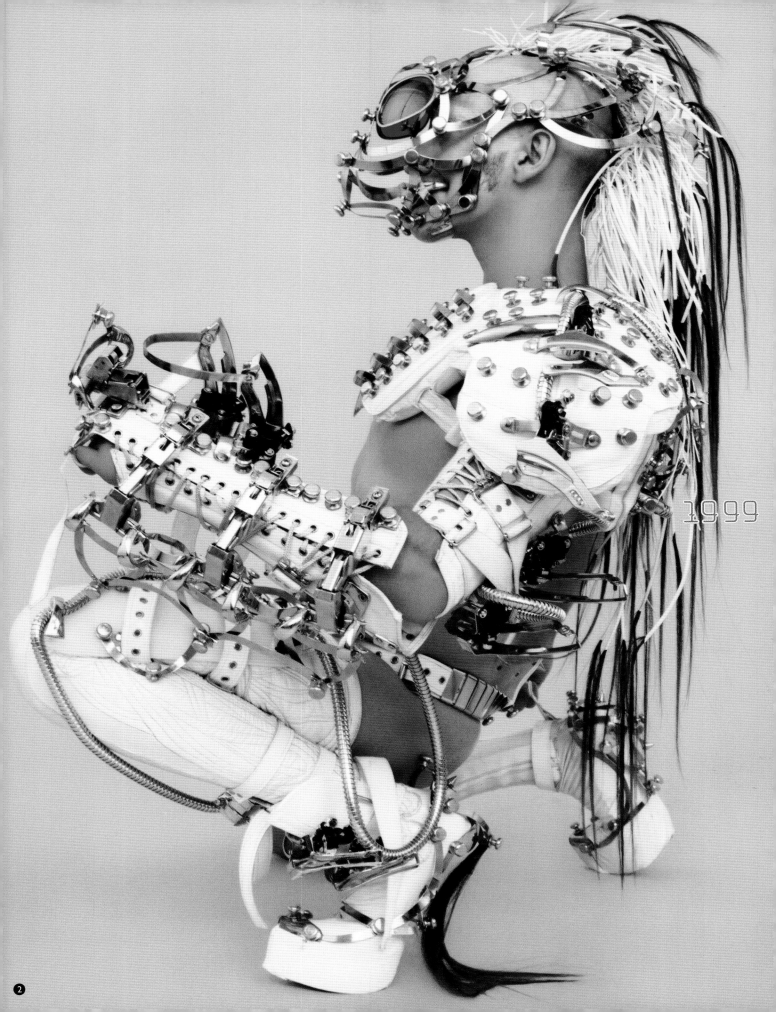

1999

2

●1 Yves Saint Laurent retires. ●2 Kate Spade becomes a household name. ●3 Design guru Murray Moss raises the bar for retail with his Soho shop. ●4 Martha Stewart is a good thing. ●5 Hussein Chalayan designs amazing architectural fashion. ●6 Diane von Furstenberg comes back big. ●7 Plain-clothes man ●8 Celebrated African photographer Malick Sidibé shoots in Mali for PAPER.

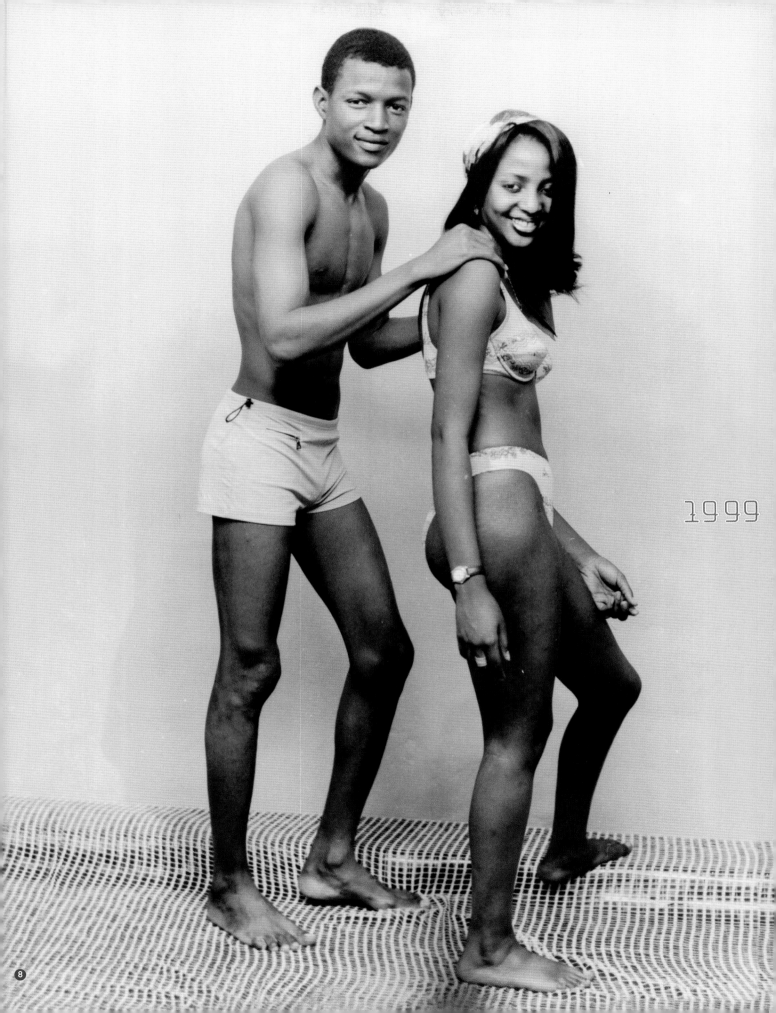

1999

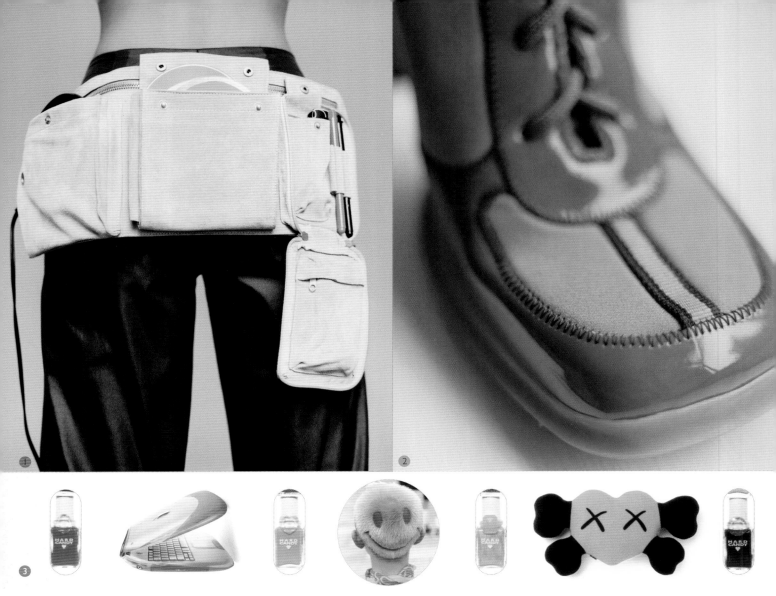

●1 Utilitarian chic meets Prada Sport. ●2 Miu Miu marches to the future. ●3 Indie cosmetics maverick Hard Candy; Apple's iBook becomes a fashion accessory; smiley face hairdo from Tokyo; KAWS makes products. ●4 Hussein Chalayan's fashion performance

●5 Artist Ruben Toledo depicts a Y2K future fantasy for PAPER, in this case a Helmut Lang survival helmet!

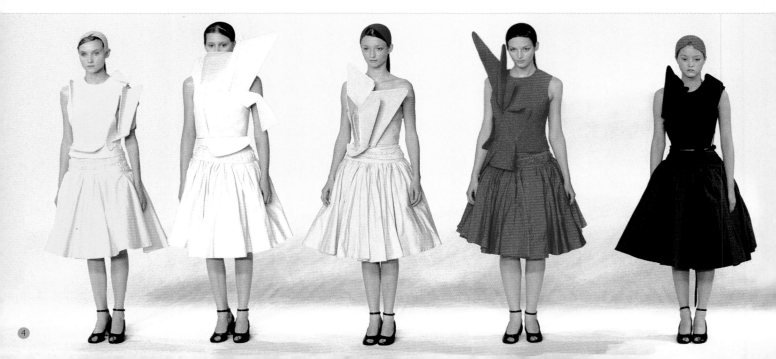

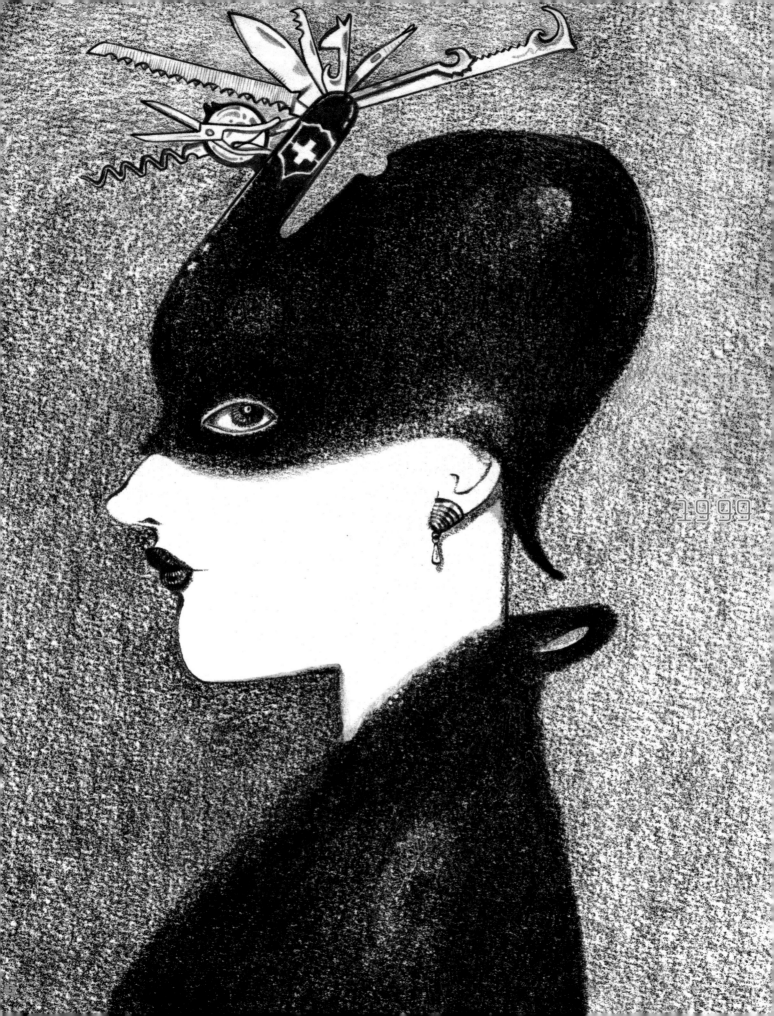

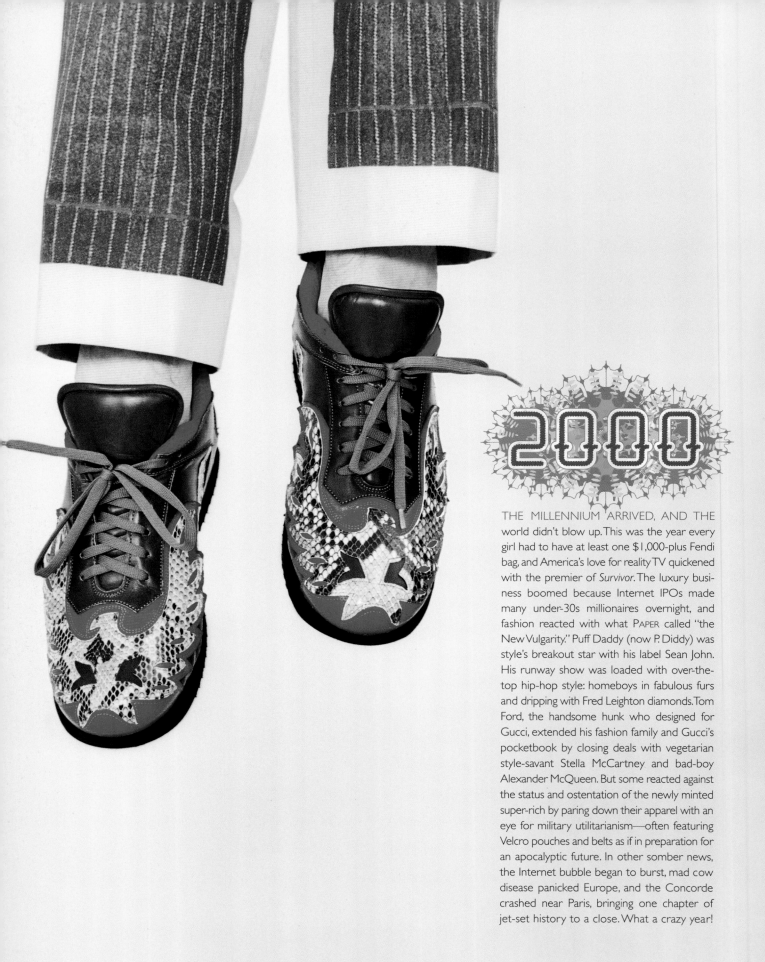

2000

THE MILLENNIUM ARRIVED, AND THE world didn't blow up. This was the year every girl had to have at least one $1,000-plus Fendi bag, and America's love for reality TV quickened with the premier of *Survivor*. The luxury business boomed because Internet IPOs made many under-30s millionaires overnight, and fashion reacted with what PAPER called "the New Vulgarity." Puff Daddy (now P. Diddy) was style's breakout star with his label Sean John. His runway show was loaded with over-the-top hip-hop style: homeboys in fabulous furs and dripping with Fred Leighton diamonds. Tom Ford, the handsome hunk who designed for Gucci, extended his fashion family and Gucci's pocketbook by closing deals with vegetarian style-savant Stella McCartney and bad-boy Alexander McQueen. But some reacted against the status and ostentation of the newly minted super-rich by paring down their apparel with an eye for military utilitarianism—often featuring Velcro pouches and belts as if in preparation for an apocalyptic future. In other somber news, the Internet bubble began to burst, mad cow disease panicked Europe, and the Concorde crashed near Paris, bringing one chapter of jet-set history to a close. What a crazy year!

●1 Jump for joy—it's 2000! ●2 Young, cute and animal-loving, West Coast style

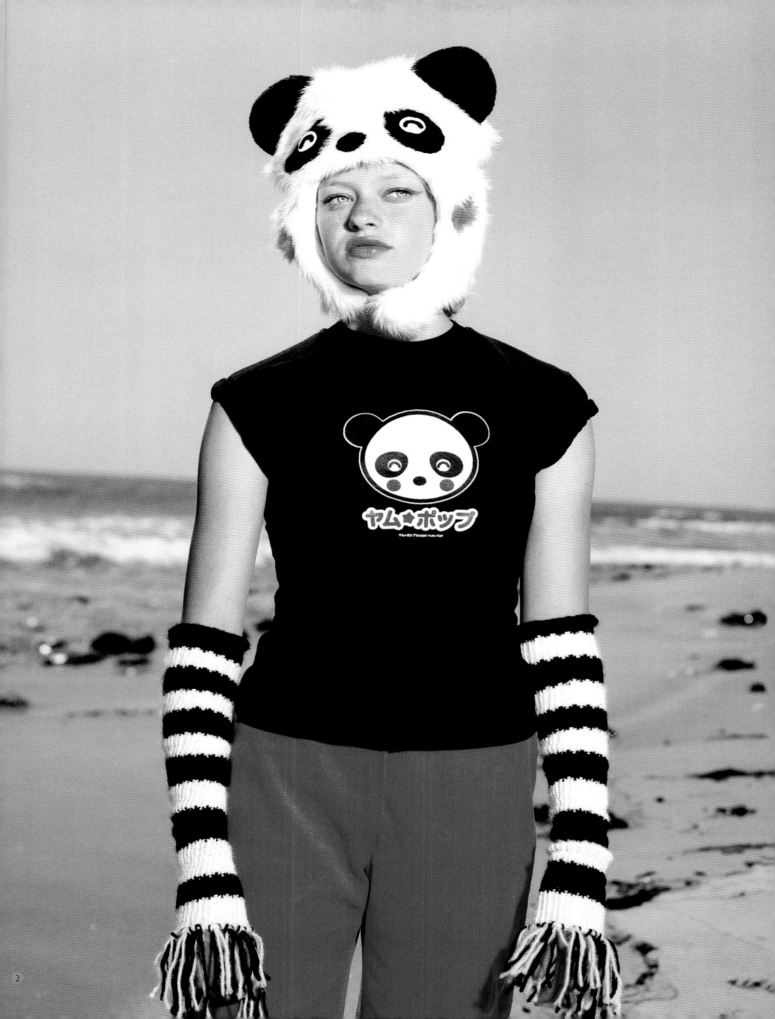

①

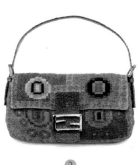

②

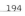 1 Old-fashioned is still pretty at Coney Island. ● 2 The $1,000-plus Fendi Baguette is the rage. ● 3 Futuristic Big Bird by Alexander McQueen

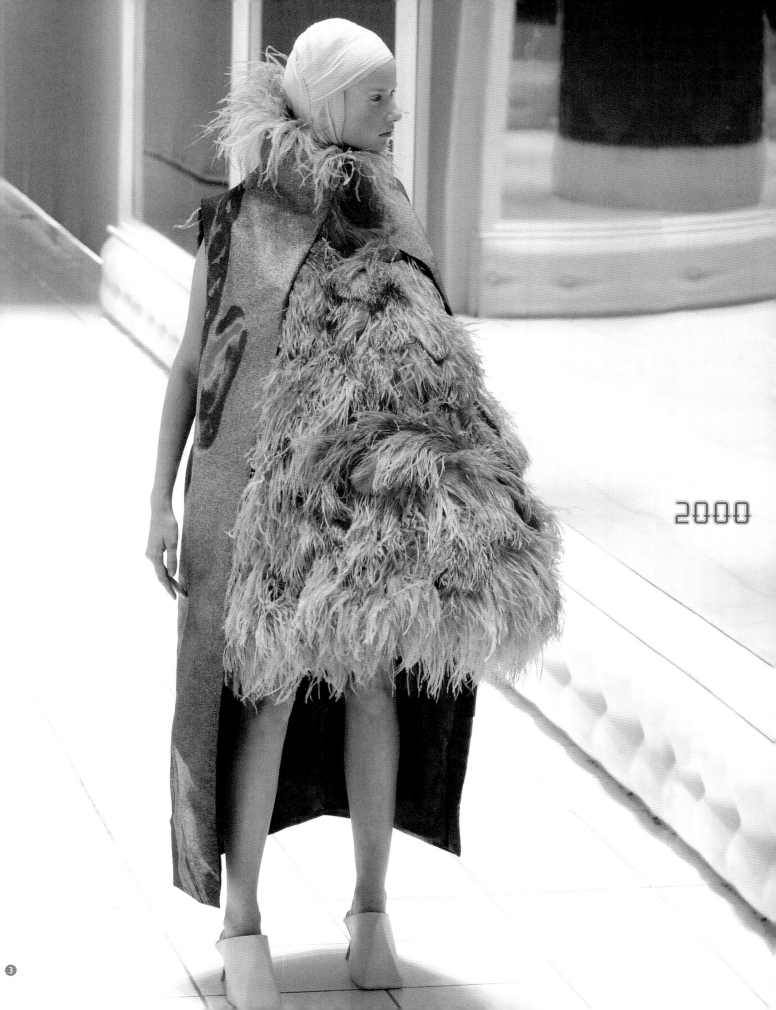

2000

3

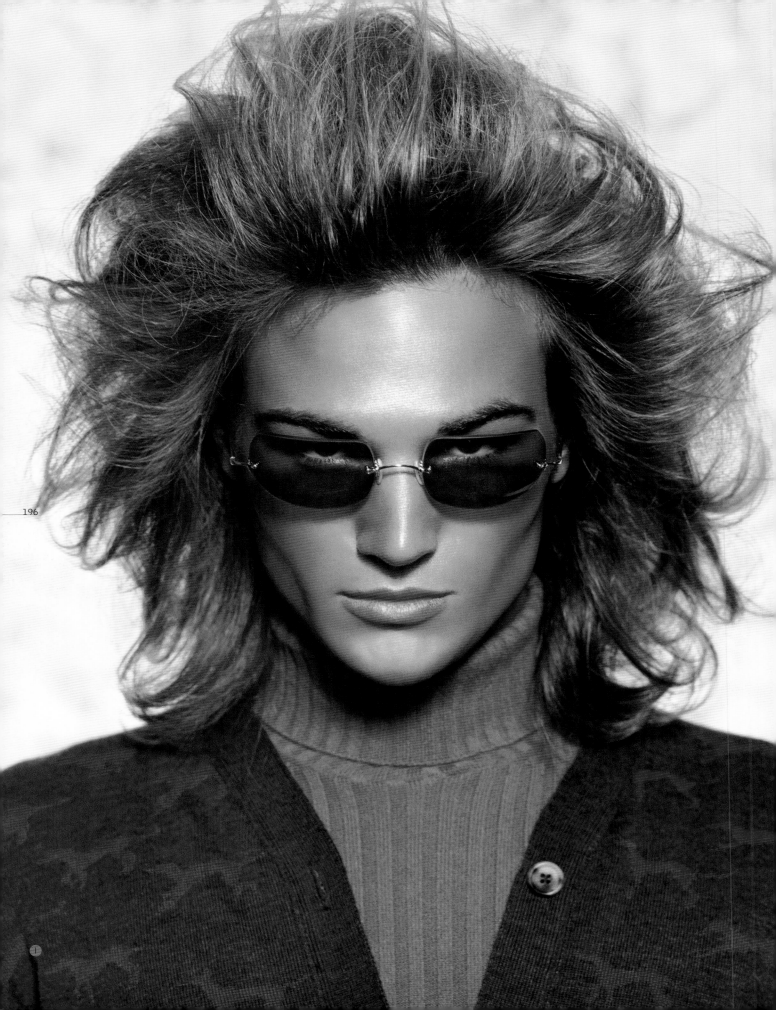

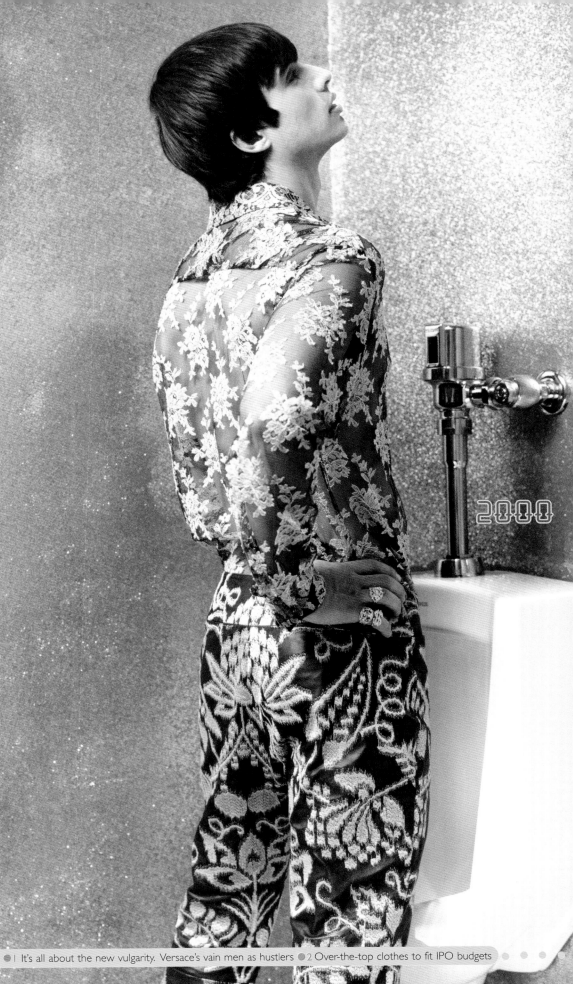

2000

● 1 It's all about the new vulgarity. Versace's vain men as hustlers ● 2 Over-the-top clothes to fit IPO budgets ● ● ● ●

●1 The millennium white trend ●2 ●3 Founder of the
International Best-Dressed List, the late Eleanor Lambert invites
PAPER's Mr. Mickey to judge. ●4 M.A.C Cosmetics' John Dempsey
with spokeswoman Lil' Kim ●5 Patricia Field wins a costumer
Emmy for *Sex and the City*. ●6 Tom Ford's muse and Gucci stylist
Carine Roitfeld . ●7 The luxe for nighttime

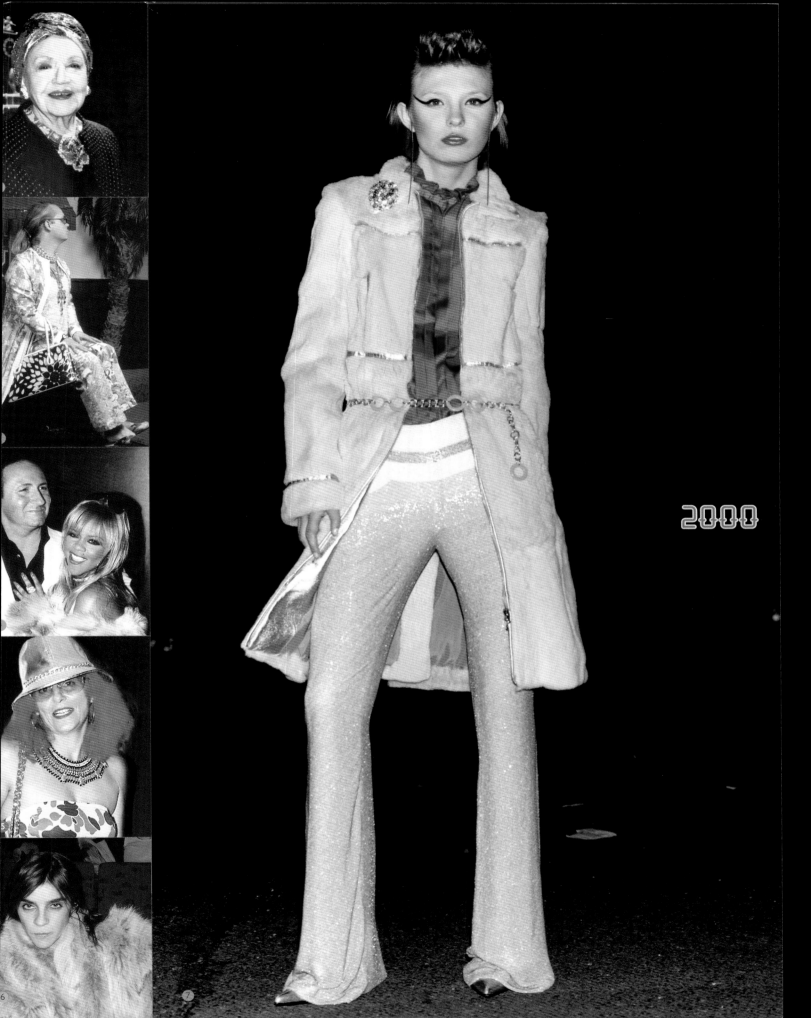

2000

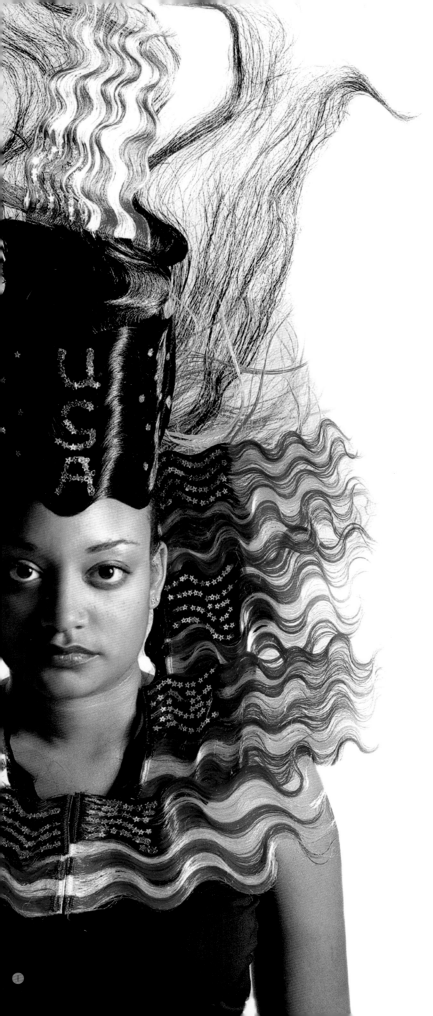

ON SEPTEMBER 11, 2001, EVERYTHING changed, and art and culture were no exceptions. Fashion responded immediately. Humble, handmade looks flourished. New Yorkers forgot about their diets and started eating comfort foods like mashed potatoes. Anti-depressants were *de rigueur*, and the style world deserted the cold-and-coiffed-bitch look in favor of warmth and sincerity. In Paris, the wonderfully talented Carine Roitfeld took over at French *Vogue*, and Alexander McQueen explored clownish beauty. Meanwhile, in Manhattan, Miguel Adrover showed lesbian looks with a distinctly Middle Eastern flair. Stephen Sprouse teamed up with the venerable house of Louis Vuitton to produce graffiti bags, and the high cost of living in Manhattan forced many kids to Brooklyn, making Williamsburg the neighborhood of choice for hipsters. The cool girls all wanted to wear jeans by Marc Jacobs, and the skate-sneaker company Gravis hired artists like Phil Frost to design the insides of their shoes. *Saturday Night Live*'s Jimmy Fallon became TV's funniest sex symbol, and model-turned-rock-star-turned-movie-star Milla Jovovich became PAPER's most beloved multitasker.

September 11 inspires patriotic hairstyles. ● 2 *Saturday Night Live*'s Jimmy Fallon is shot for the cover of PAPER the week after the terror attacks.

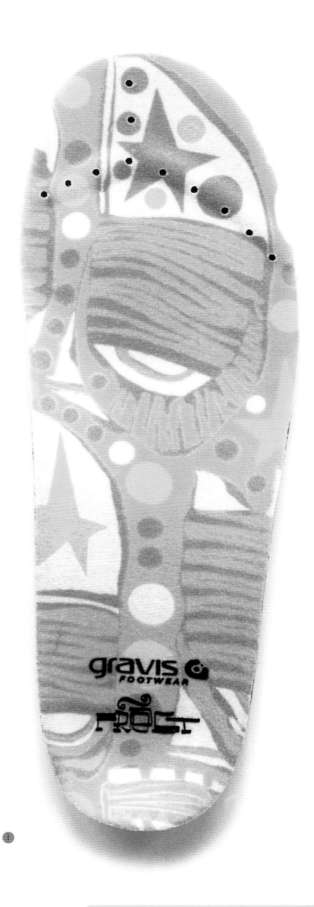

●1 Phil Frost and other artists create foot beds for sneakers by Gravis. ●2 The Stüssy skater jean ● ● ● ● ● ● ● ● ●

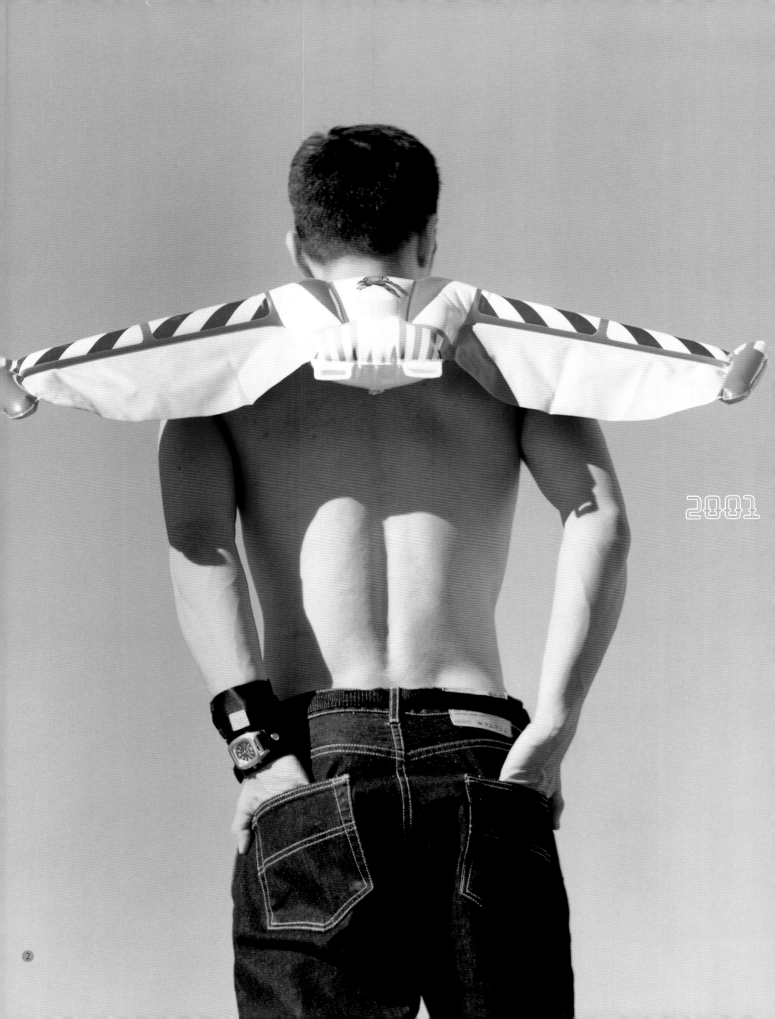

2001

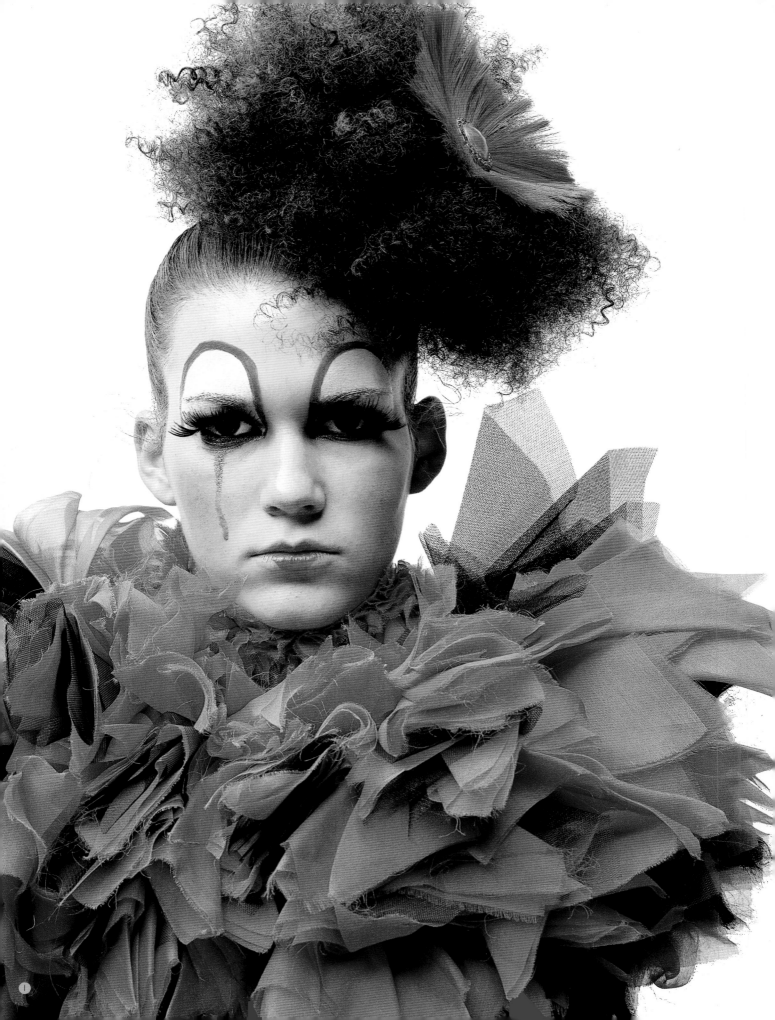

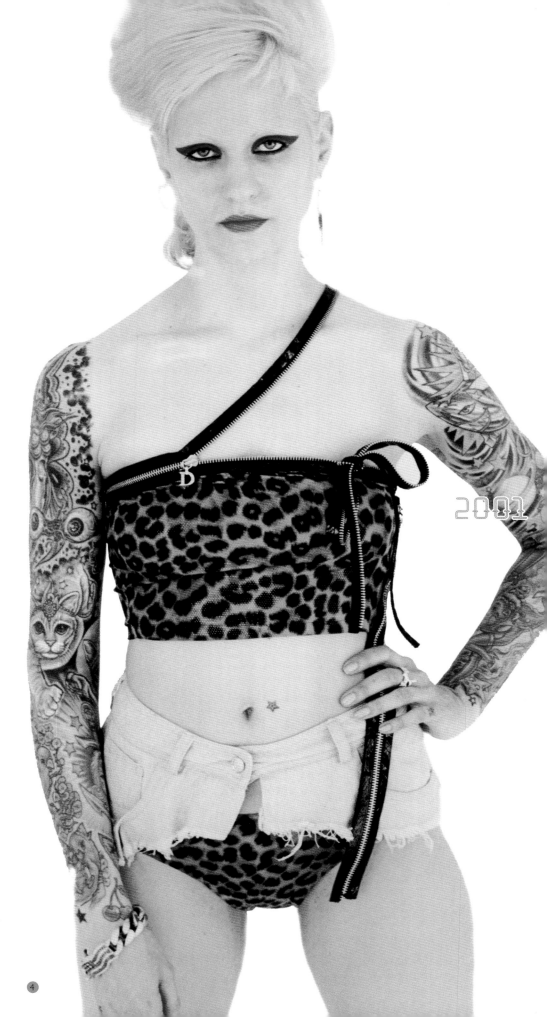

● 1 High-fashion clown photographed for PAPER by Walter Chin ● 2 ● 3 Clowns from Alexander McQueen's runway

● 4 Tattooed rocker beauty Theo Kogan wears leopard-print Dior.

2001

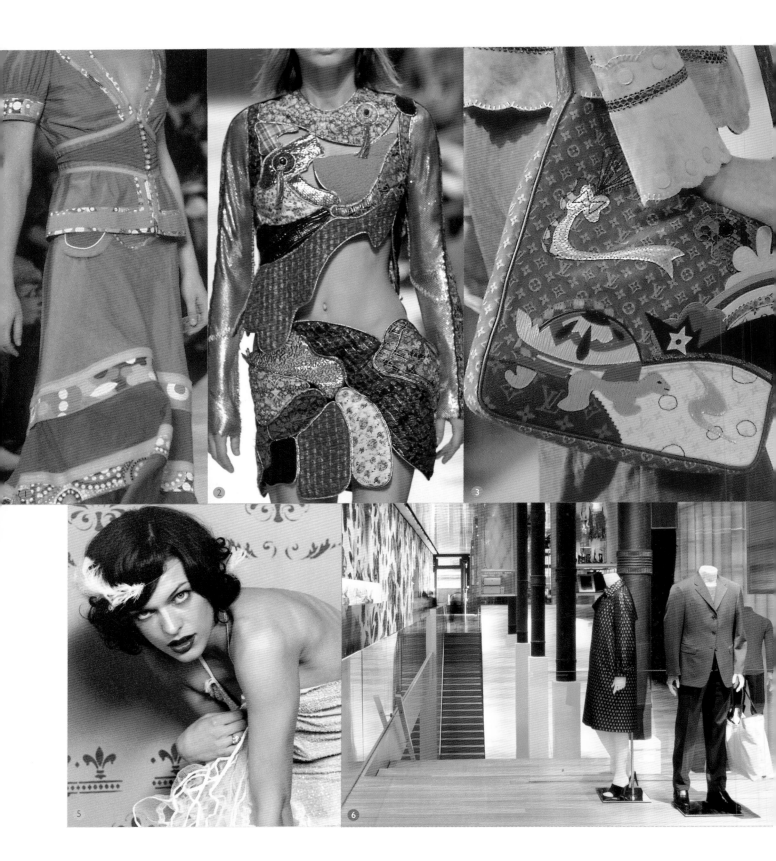

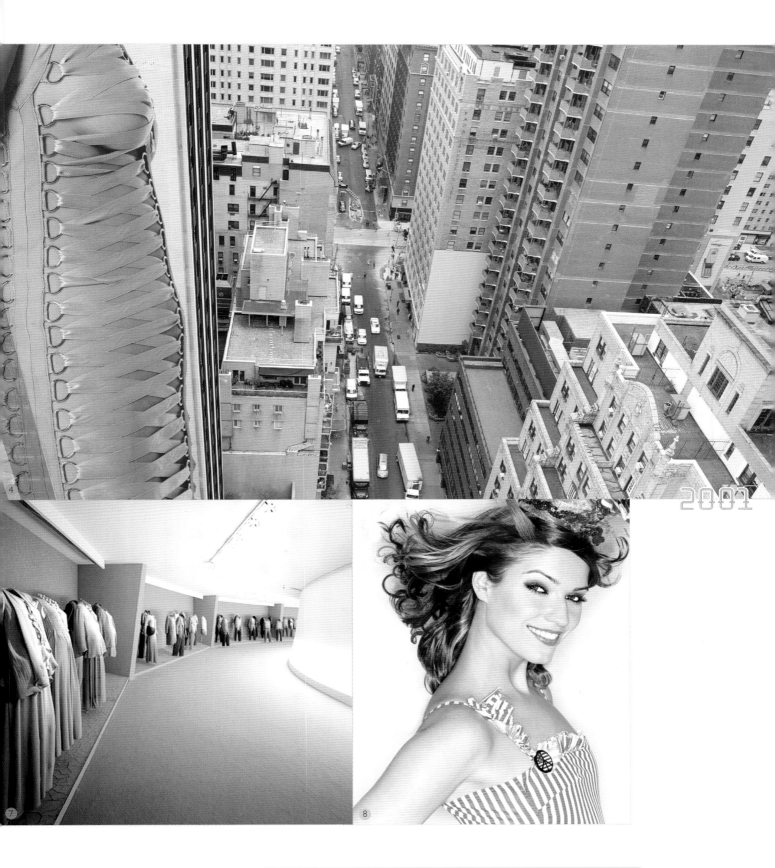

● 1 ● 2 ● 3 Marc Jacobs, Balenciaga and Louis Vuitton's crazy quilting ● 4 PAPER's defiant architectural photo shoot, post-9/11

● 5 Milla Jovovich becomes a movie star. ● 6 ● 7 Architecture and art meet fashion: Rem Koolhaas designs the new Prada store

in Soho, and Giorgio Armani has a retrospective at the Guggenheim. ● 8 Positive energy from Ivana Milicevic ● ● ● ●

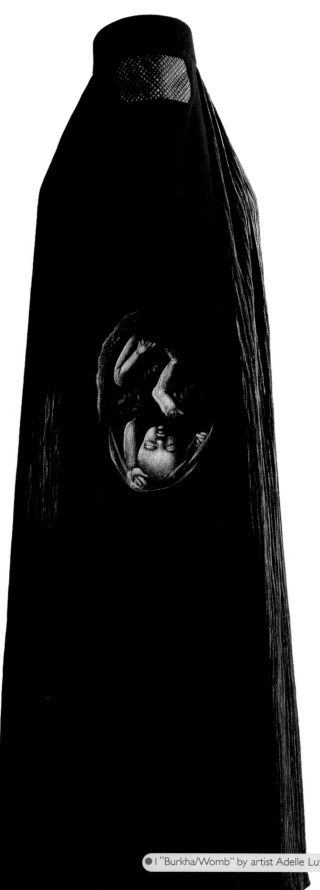

THIS WAS THE YEAR THAT FASHION FELL in love with mass-market, as retail chain Target broke from its usual low-end mold and collaborated with icons like Todd Oldham, Cynthia Rowley, Stephen Sprouse and Isaac Mizrahi on affordable but brilliantly designed clothing and items for the home. At Louis Vuitton, Marc Jacobs hooked up with Japanese artist Takashi Murakami, whose cartoons became the signature style of the year's must-have handbag. Dutch design duo Viktor & Rolf made history with Yohji Yamamoto for their Y-3 collection. Frank Gehry's Issey Miyake store opened in New York, while artist Vito Acconci designed the United Bamboo location in Tokyo. Fashion went artsy and vice-versa at the Spring/Summer New York Collections, when Imitation of Christ presented topless models vacuuming a furniture store, and artist Adelle Lutz showed a piece called "Burkha/Womb," which reflected the plight of Middle Eastern women. No Doubt's Gwen Stefani became Gavin Rossdale's blushing bride, wearing Dior as she marched down the aisle.

● 1 "Burkha/Womb" by artist Adelle Lutz ● 2 Actress Tara Subkoff's fashion collection, Imitation of Christ ● ● ● ● ●

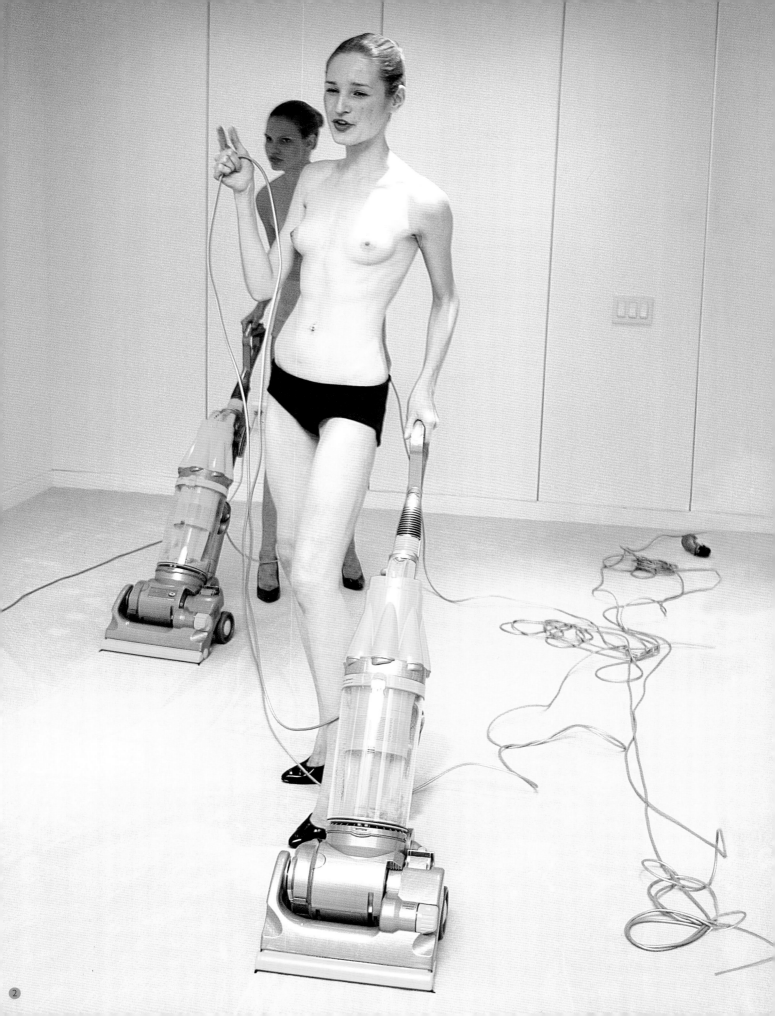

●1 ●3 Toys are huge with the kids. ●2 Issey Miyake's latest idea is a new fabric technology, APOC. ●4 Marc Jacobs commissions Takashi Murakami to play with the traditional Louis Vuitton logo and products. ●5 An inspired Cadillac Escalade, spotted on 57th Street ● ● ●

❶ 　 ❷ 　 ❸

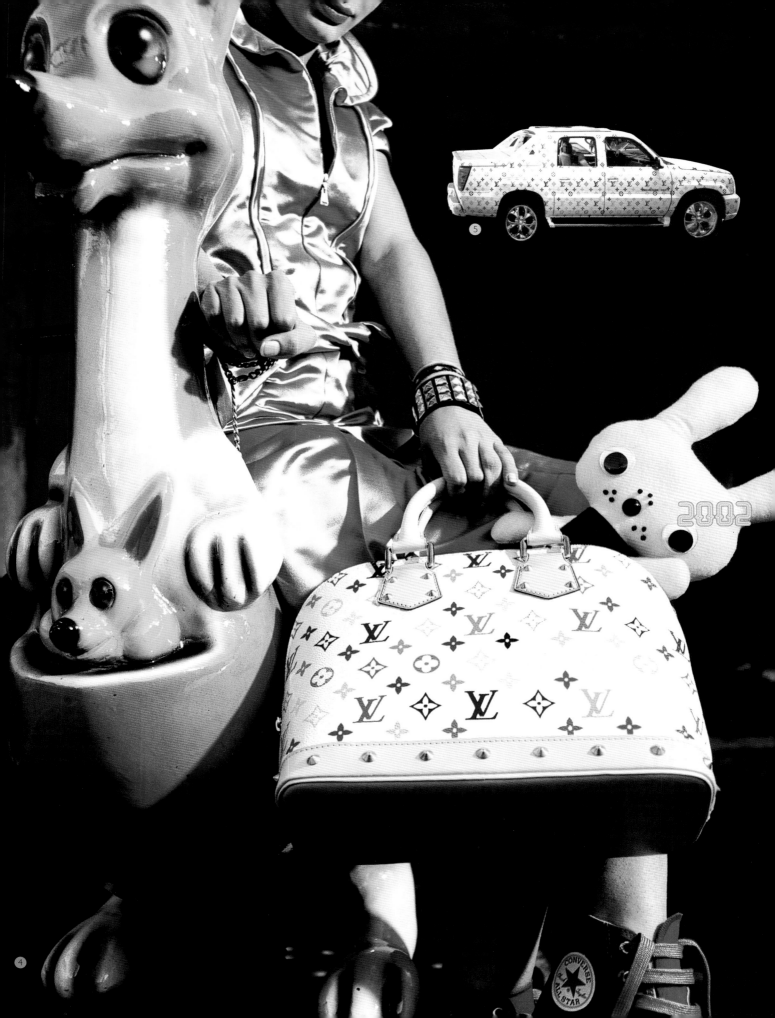

2002

1 Style visionary, writer Lynn Yaeger 2 Barely legal boy-toy style is found in the clubs.

2002

●1 ●2 A surreal layered collection (l) is designed by Dutch duo Viktor & Rolf (r). ●3 Stephen Sprouse and other hipsters design for Target.
●4 A Sprouse blow-up raft from Target ●5 Designer Paul Frank's monkey logo ●6 Toland Grinnell designs purses as art.
●7 Jeremy Scott designs "money sneakers" for Adidas. ●8 Country-club looks are big in L.A. ● ● ●

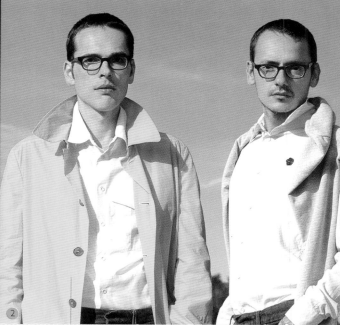

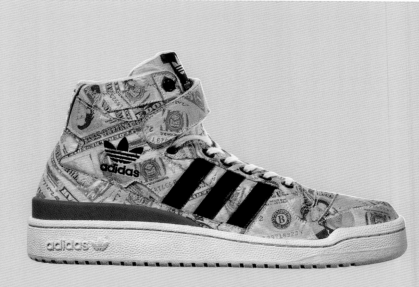

2002

2003

IT WAS A VERY GAY YEAR AS AMERICA embraced TV's *Queer Eye for the Straight Guy*. The life of late performance artist and fashion visionary Leigh Bowery was transformed into a Broadway musical starring Boy George. Tom Ford and Domenico De Sole shocked fashionistas by departing from the Gucci Group, and Geoffrey Beene declared he would no longer show his collections seasonally, instead devoting himself to designing every day. The fashion world lost Eleanor Lambert, who created the International Best-Dressed List. In downtown New York, hairstylist Danilo introduced a line of wigs, and rocker Kembra Pfahler unveiled a fashion collection. Text-messaging was the new thing for kids, and designer cellphones were all the rage. Barney's creative director Simon Doonan celebrated girls with offbeat style in his book *Wacky Chicks*. In Las Vegas, Parisian couturier Thierry Mugler designed costumes for Cirque du Soleil's new adult review *Zumanity*, which featured Joey Arias, one of PAPER's best friends. Meanwhile, hotel heiress Paris Hilton became a celebrity after a sex tape she'd made was distributed on the Internet.

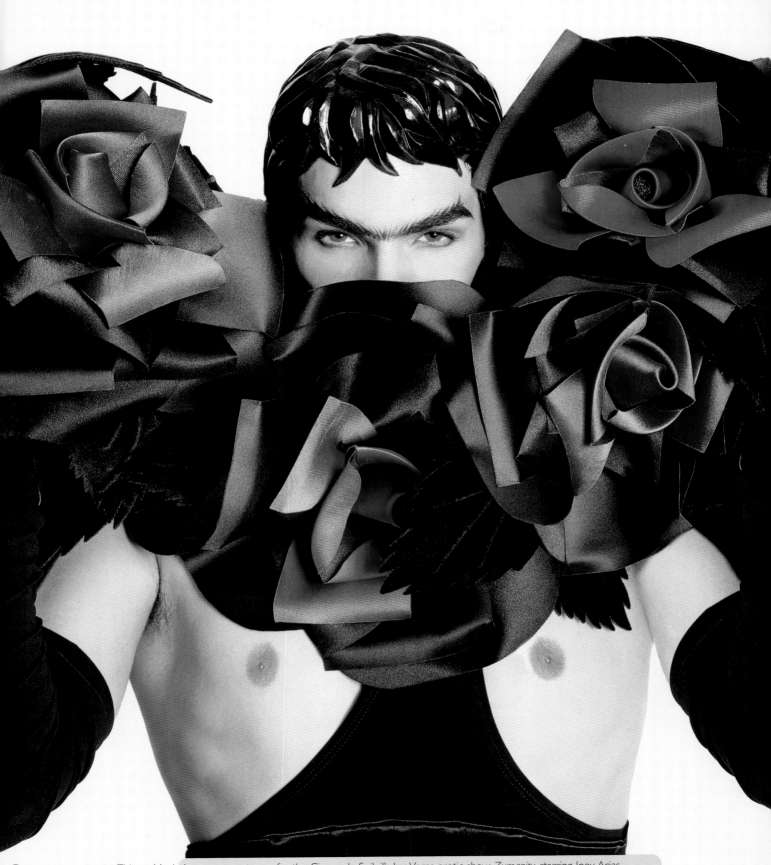

● I ● 2 Thierry Mugler's couture costumes for the Cirque du Soileil's Las Vegas erotic show, *Zumanity*, starring Joey Arias

218

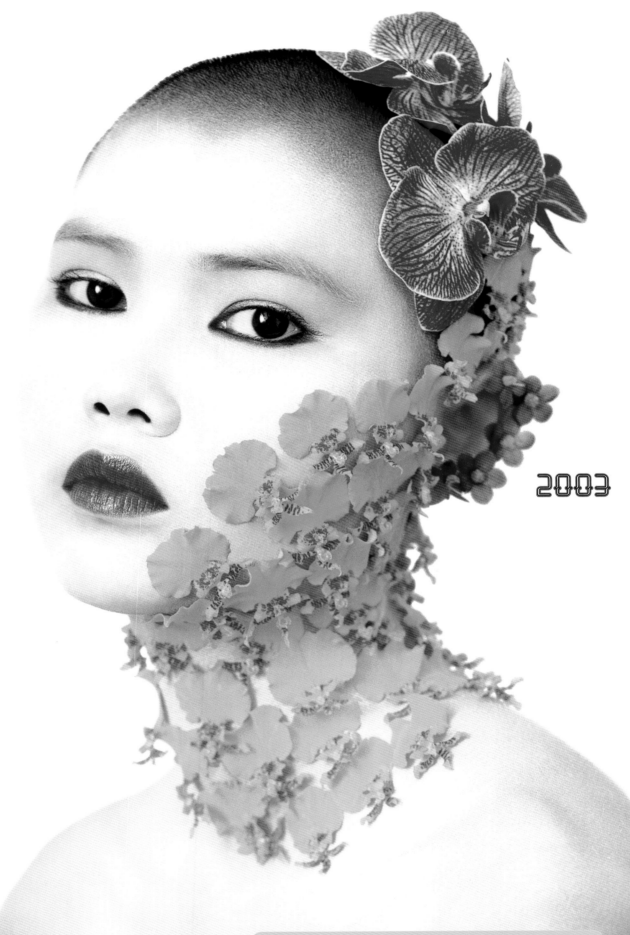

2003

●1 Cult artist Coop illustrates fashion. ●2 *Taboo*, the play about Leigh Bowery, hits Broadway thanks to producer Rosie O'Donnell. ●3 ●4 Clowns are big and so is Diane Keaton's clown book. ●5 Artist Dietmar Busse's flower power

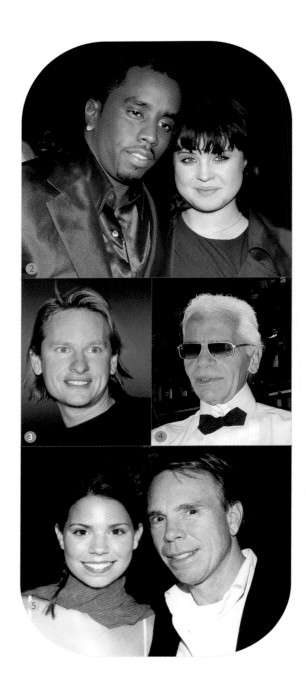

●1 Designer Miguel Adrover goes butch. ●2 Kelly Osbourne falls for P. Diddy. ●3 Carson Kressley from *Queer Eye for the Straight Guy* shows gays on TV giving makeovers to slovenly straight men. ●4 Karl Lagerfeld goes on a diet and loses 60 pounds. ●5 Tommy Hilfiger's daughter's reality show *Rich Girls* is a hit. ●6 Simon Doonan's book *Wacky Chicks* inspires fashion looks. ●7 Baby Phat designs cellphones.

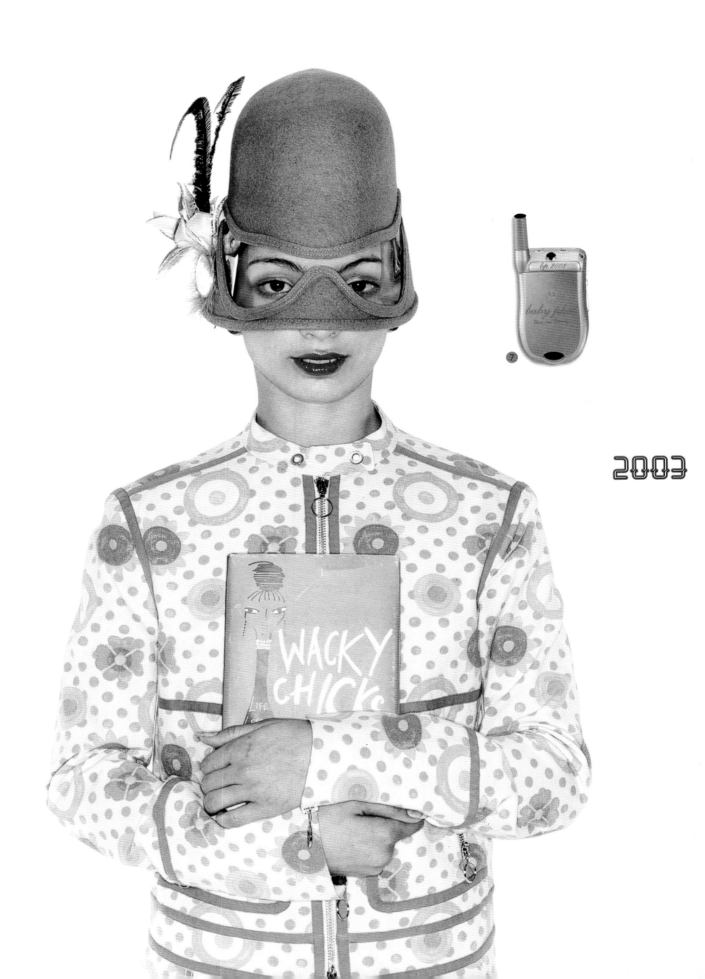

2003

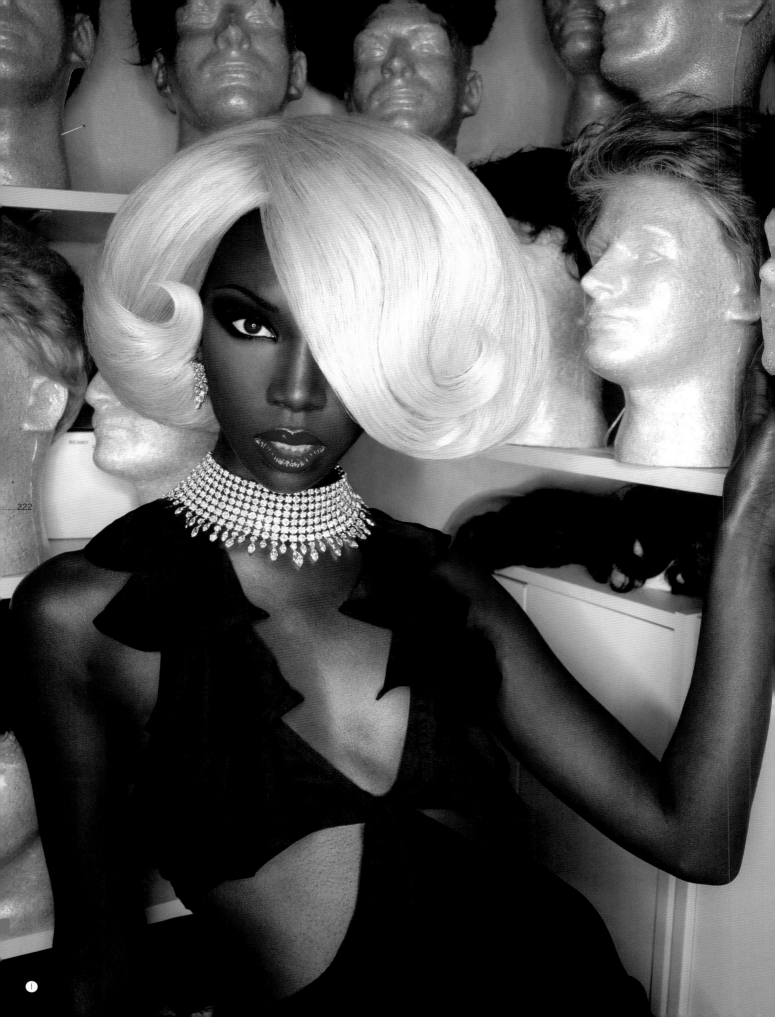

222

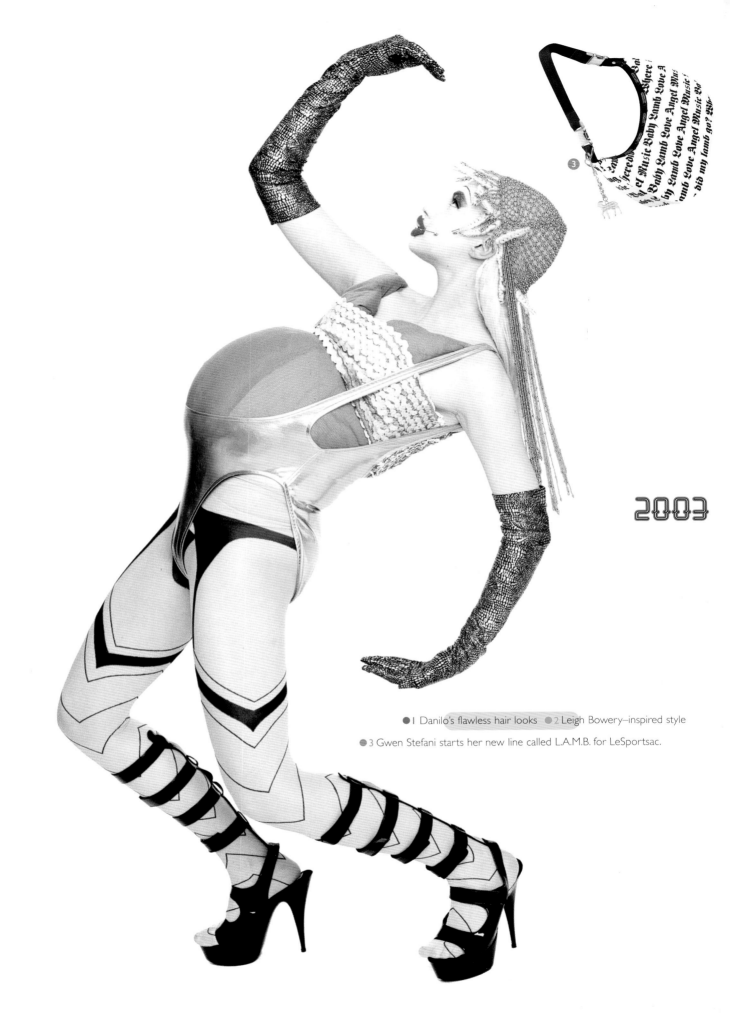

2003

●1 Danilo's flawless hair looks ●2 Leigh Bowery–inspired style

●3 Gwen Stefani starts her new line called L.A.M.B. for LeSportsac.

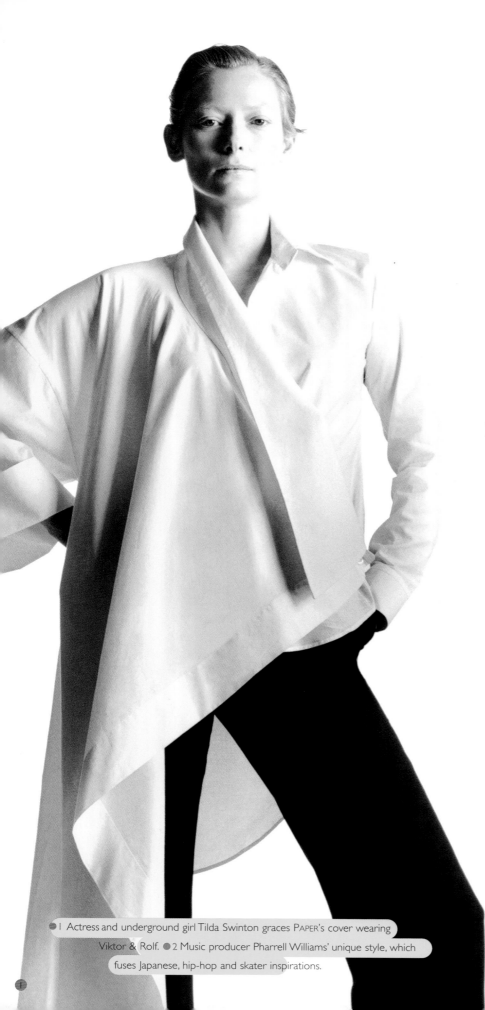

2004

FOR US, THE BIGGEST NEWS OF 2004 was that PAPER turned 20—and we at the magazine couldn't be prouder! On the fashion front, we were shocked and saddened by the death of radical designer Stephen Sprouse. In Paris, designer Jean Paul Gaultier, one of Sprouse's biggest fans, took over the prestigious house of Hermès. Gay marriage controversy became a political and cultural wedge issue, while on a superficial level, Janet Jackson distracted the press from her brother Michael's child-sex-abuse charges by showing her naked boob at the Super Bowl. Convicted felon Martha Stewart's daily courtroom display of her *very* expensive Hermès Birkin and carryall did her no good. In new hip-hop trends, homeboys started dressing in slick, Wall Street–style suits, while in the outskirts of Los Angeles, both homegirls and boys were busy painting their faces like clowns for a new dance craze called "Krumping," which was discovered by photographer David LaChapelle. He directed a short documentary on this art form. Duo Proenza Schouler caused a cyber riot when they put their Fall 2004 samples up on eBay immediately following their show. As usual, the year shaped up in outrageous PAPER style. If you want to know more about 2004—and the years beyond—pick up a magazine subscription at *www.papermag.com*.

1 Actress and underground girl Tilda Swinton graces PAPER's cover wearing Viktor & Rolf. 2 Music producer Pharrell Williams' unique style, which fuses Japanese, hip-hop and skater inspirations.

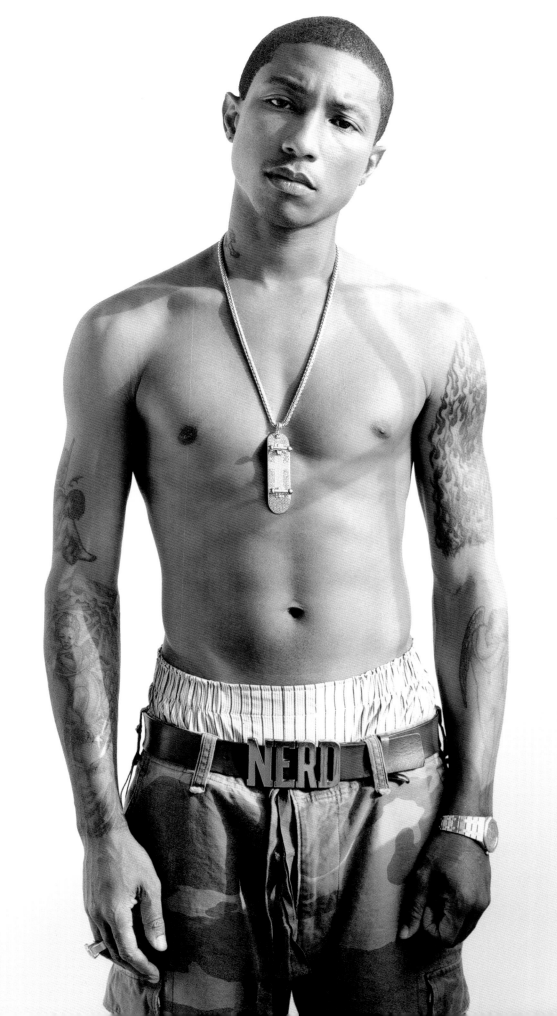

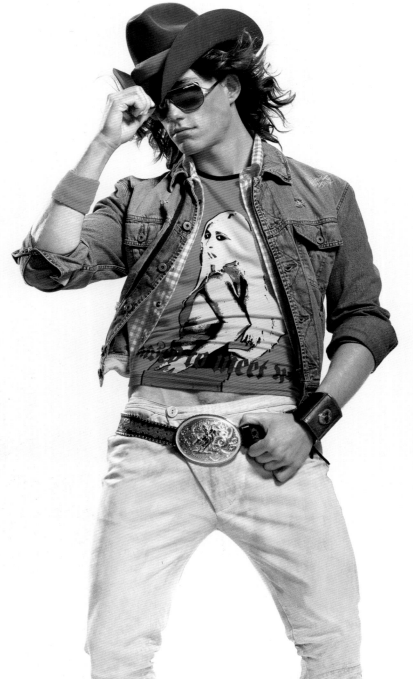

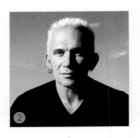

●1 Fashion cowboys are everywhere. ●2 Jean Paul Gaultier shows
his first collection for Hermès. ●3 Designer It Boys Proenza Schouler sell their 2004 collection samples on eBay.

●4 The men of hip-hop trade in their track suits for Wall Street looks.

●5 A still from David LaChapelle's *Krumped*, a film about the West Coast dance craze.

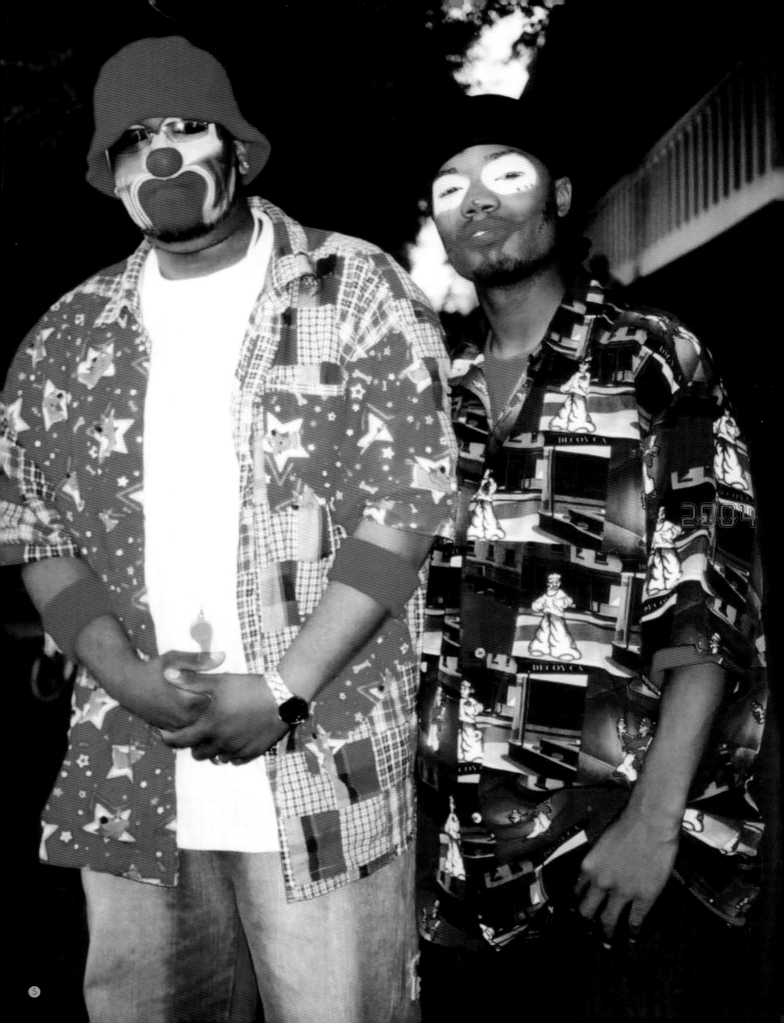

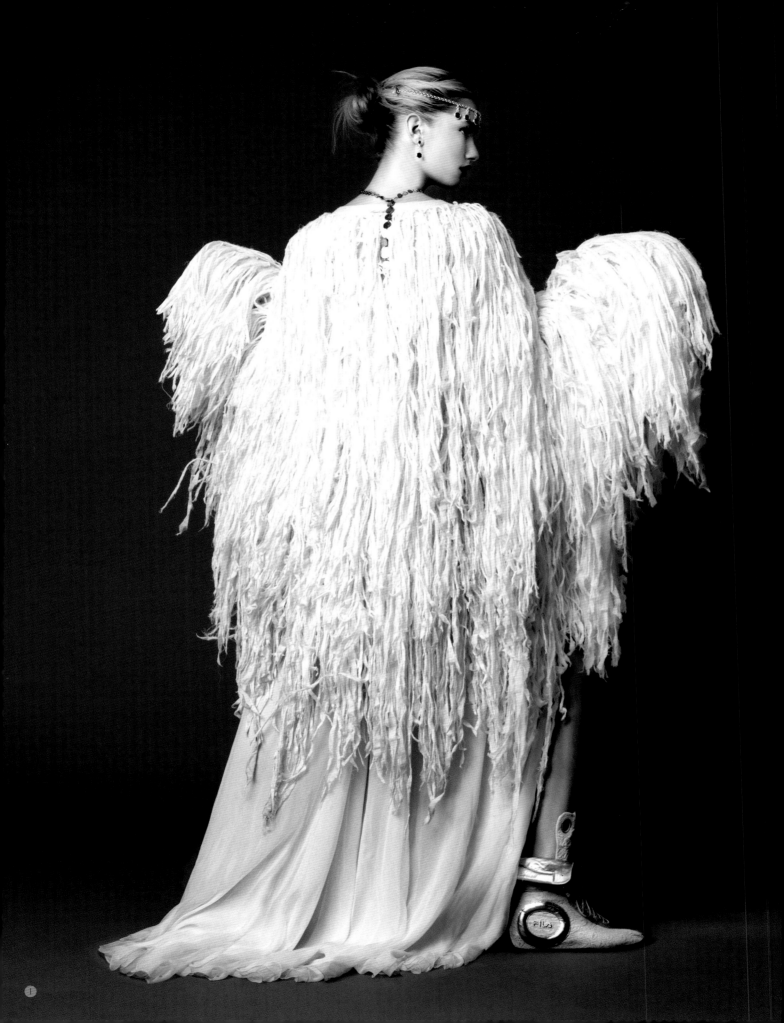

● 1 Miguel Adrover's "Big Bird" cape, paired with Fila shoes

● 2 Gay weddings are big, but still swirled in controversy. Here a hip

Australian sheet company called No One You Know offers some support. ● ● ● ● ● ● ● ● ●

2004

2004

PAPER promotes positive energy and love in 2004. • • • • • • •

20 YEARS OF STYLE IS THE RESULT OF THE COLLABORATION OF AN INCREDIBLE TEAM OF TALENTED PEOPLE. WE WANT TO THANK ALL THE CONTRIBUTORS TO THIS BOOK BECAUSE IT'S ABOUT YOU. YOU ARE THE CREATIVE PEOPLE WHO LEAD THE WAY, AND YOUR GENEROSITY AS CONTRIBUTORS TO *PAPER* AND TO THE DOWNTOWN SCENE OVER THE YEARS HAS PAVED THE WAY FOR CULTURAL CHANGE. WE ARE HONORED TO HAVE SUCH AMAZING TALENT AMONG OUR RANKS.

SPECIAL THANKS

THE PHOTOGRAPHY • WE WANT TO SEND OUT A HUGE THANK YOU TO ALL THE GENEROUS PHOTOGRAPHERS WHO SHOT FOR *PAPER* OVER THE YEARS AND HAVE ALLOWED US TO USE THEIR WORK IN THIS DELICIOUSLY BEAUTIFUL BOOK. THERE ARE TOO MANY TO NAME, BUT MAKE SURE YOU LOOK AT WHO THEY ALL ARE ON THE FOLLOWING PAGES. YOUR WORK MAKES *PAPER* BEAUTIFUL, AND THIS BOOK SHOWS IT TO THE WORLD. • THE WORDS • WE ARE *SO* GRATEFUL TO OUR TALENTED FRIENDS WHOSE WORDS GAVE US SO MUCH INSIGHT ON THESE PAGES. THESE FOLKS ARE SEMINAL IN DOWNTOWN'S HISTORY, AND THE LIST IS STELLAR: MICHAEL MUSTO, CARLO McCORMICK, MOBY, FAB 5 FREDDY, TODD OLDHAM, HAROLD KODA, CHARLIE AHEARN, AARON ROSE, KIM GORDON, RUPAUL, JEFFREY DEITCH, ANNA SUI, PEDRO ALMODÓVAR, ISAAC MIZRAHI, SANDRA BERNHARD, JOHN WATERS AND PATRICK McMULLAN. • THE PAPER THREE • THERE WERE THREE CAPTAINS AND *PAPER* VETERANS AT THE HELM OF THIS BOOK WHO LED THE MADNESS: BRIDGET DE SOCIO, MICKEY BOARDMAN AND SCOTT ASHWELL. • THE

DESIGN AND ART DIRECTION • A BOW TO THE BRILLIANT BRIDGET DE SOCIO, WHO HAS BEEN THE CREATIVE DIRECTOR OF *PAPER* FOR 14 YEARS. HER KEEN EYE, ASTOUNDING DESIGN TALENT AND INTELLIGENCE HAS TAKEN THIS BOOK TO A NEW LEVEL. SHE MADE EVERY PAGE SPARKLE, AND WE LOVE AND THANK HER FOR THAT. • PHOTO EDITING AND COPYWRITING • WE ALSO PAY HOMAGE TO OUR DEPUTY EDITORIAL DIRECTOR MR. MICKEY BOARDMAN, WHOSE BRILLIANT AND HILARIOUS WORDS INTRODUCE EACH YEAR IN THE BOOK AND WHOSE PHOTOGRAPHIC MEMORY SERVED HIM WELL IN THIS TASK. MICKEY'S GENEROSITY OF SPIRIT HAS BLOWN US AWAY AND HE HAS KEPT US LAUGHING FOR THE 12 YEARS HE'S BEEN AT *PAPER*. • THE PRODUCTION • WE ALSO WANT TO THANK SCOTT ASHWELL, WHO TOOK CHARGE OF THIS PROJECT, DOGGEDLY WHIPPING EVERYONE INTO SHAPE AND COMMANDING AND WRANGLING THE CREATIVE TYPES SO THAT THE DEADLINE COULD BE MET. SCOTT IS OUR PRODUCTION DIRECTOR AND HAS BEEN AT *PAPER* FOR 10 YEARS. • THEN THERE'S OUR CREW •

THEY WORKED DAYS, NIGHTS, WEEKENDS AND HOLIDAYS TO GET THIS BOOK PRODUCED. IN OUR DESIGN DEPARTMENT: THANK YOU TO AGNIESZKA STACHOWICZ, WHO WAS HEAD DESIGNER FOR THE BOOK AND WHO ADDED HER FABULOUS DECORATION TO ANDREA TINNES' WONDERFUL TYPEFACE. THANKS TO DESIGNER SUNG HEE HAM, WHO ALSO HELPED TREMENDOUSLY, AND TO YAEL GAVISH, WHO DID THE IMAGING FOR THESE PAGES. ON THE TEXT END OF THINGS, WE TIP OUR HAT TO *PAPER*'S WONDERFUL TEAM: MANAGING EDITOR JONATHAN DURBIN, WHO EDITED ALL THE WORDS, ASSISTANT EDITOR ALEX ZAFIRIS, WHO DILIGENTLY FACT-CHECKED THEM, AND COPY CHIEF HENRY FLESH, WHO MADE THEM SHINE. WE WANT TO GIVE A HUGE THANKS TO KARLA ARRIA-DEVOE, WHO WORKED SO HARD TRACKING DOWN MANY OF THE PHOTOS AND ALL THE PERMISSIONS FOR THEM. WE WOULD ALSO LIKE TO THANK SARI BECKER, WHO HELPED CREATE THE INDEX FOR THIS FABULOUS BOOK, EUNICE GOMES, WHO HELPED WITH THE IMAGING, AND OUR INTERN KRISTEN SCHEER. • OUR PUBLISHER • WE ARE GRATEFUL TO THE FEARLESS AND OPEN-MINDED FOLKS AT HARPER DESIGN, ESPECIALLY ROLAND ALGRANT, WHO GLEEFULLY GAVE US THE GREEN LIGHT FOR THE BOOK WITHIN THE FIRST FIVE MINUTES OF OUR MEETING WITH HIM. WE ALSO WANT TO THANK HARRIET PIERCE AND MARTA SCHOOLER AT HARPER DESIGN FOR ALL THEIR HELP AND SUPPORT, AND LAURIE RIPPON FOR BRINGING US TO HARPER DESIGN IN THE FIRST PLACE. • OUR FAMILIES • WE WOULD LIKE TO DEDICATE THIS BOOK TO OUR *PAPER* FAMILY, THE GREATEST GROUP OF PEOPLE WE COULD EVER HOPE TO WORK WITH. WE ESPECIALLY WANT TO THANK SHARON PHAIR, HUNTER HILL AND DREW ELLIOTT FOR ALL THEIR OVER THE TOP EFFORTS, ESPECIALLY IN MARKETING THIS BOOK. WE WOULD ALSO LIKE TO DEDICATE THIS BOOK TO OUR PERSONAL FAMILIES. THEIR SUPPORT AND BELIEF IN US OVER THE PAST 20 YEARS HAS KEPT US GOING: GLORIA AND WALTER HASTREITER, LAURIE HASTREITER RIPPON, SUSAN AND MORRIS HERSHKOVITS, BRIGITTE ENGLER, ESTHER LOUP HERSHKOVITS AND NISSIM HERSHKOVITS.

PAPER PAPER PAPER PAPER

Randy Brooke ✳ Renée Zellweger photo: Patrick McMullan ✳ Dolce & Gabbana photo: Caroline Torem Craig ✳ Sarah Jessica Parker photo: Patrick McMullan ✳ Gwyneth Paltrow at Calvin Klein photo: Randy Brooke ✳ Todd Oldham and Susan Sarandon photo: Maggie McCormick ✳ Zac Posen and Claire Danes photo: Patrick McMullan ✳ Hilton sisters and Patricia Field photo: Caroline Torem Craig ✳ Phillip Bloch and Lauren Holly photo: Caroline Torem Craig

✳ ✳ ✳ DAYLIFE ✳ ✳ ✳

p. 52 John Waters photo: Albert Watson ✳ pg. 53 Ange and Adi photo: Torkil Gudnason ✳ p. 54 (top) l-r ✳ Henny Garfunkel (bottom l–r) ✳ Courtesy of *Fruits* magazine ✳ Henny Garfunkel p. 55 (top) Cheryl Dunn ✳ Torkil Gudnason ✳ (bottom) l-r ✳ Werner Dick ✳ Henny Garfunkel ✳ Cheryl Dunn ✳ Cheryl Dunn ✳ Henny Garfunkel ✳ Henny Garfunkel ✳ Bill Cunningham photos: Roxanne Lowit

✳ ✳ ✳ NIGHTLIFE ✳ ✳ ✳

p. 56 Patrick McMullan photo: Caroline Torem Craig ✳ p. 57 Kenny Kenny photo: Paul Sunday ✳ p. 58–59 (top) l-r John John Martinez ✳ Eric McNatt ✳ Alexander Thompson ✳ Caroline Torem Craig ✳ Haim Ariav ✳ (bottom) l-r Jonathan B. Ragle ✳ Henny Garfunkel ✳ Tseng Kwong Chi 1984 © Muna Tseng Dance

Projects, Inc. New York. All Rights Reserved. ✳ Cheryl Dunn ✳ Haim Ariav ✳ Jonathan B. Ragle ✳ Cheryl Dunn

✳ ✳ ✳ ✳ ✳ 1984 ✳ ✳ ✳ ✳ ✳

p. 64 John Sex photo: Kiri ✳ p. 65 Suzan Pitt photo: Beth Baptiste ✳ p. 66 Claudia Skoda fashion photo: Edo ✳ Ann Magnuson as Edie Sedgwick and Joey Arias as Andy Warhol photo: Tseng Kwong Chi 1984 © Muna Tseng Dance Projects, Inc. New York. All Rights Reserved. ✳ p. 67 Snood fashion photo: Janette Beckman ✳ p. 68 Newlyweds Ruben and Isabel Toledo photo: Janette Beckman ✳ p. 69 Joan Vass photo: Beth Baptiste ✳ p. 70 Boom box photo: Janette Beckman ✳ Laura Wills and Biff Chandler photo: Henny Garfunkel ✳ Keith Haring and Mayor Koch photo: Tseng Kwong Chi 1984 © Muna Tseng Dance Projects, Inc. New York. All Rights Reserved. ✳ p. 71 Michael Jackson jacket photo: Jonathan Griffith

✳ ✳ ✳ ✳ ✳ 1985 ✳ ✳ ✳ ✳ ✳

p. 72 Louise Doktor photo: Janette Beckman ✳ p. 73 Black and white photo: Beth Baptiste ✳ p. 74 Zig-zag tie photo: Jon Ericson ✳ p. 75 André Walker "horsey pants" photo: Jon Ericson ✳ p. 76 Manolo Blahnik photo: Janette Beckman ✳ p. 77 Karl Lagerfeld pastry accessories photo: Janette Beckman ✳ p. 78 Corporate logo fashion photo: Tseng Kwong Chi 1985 © Muna Tseng Dance Projects, Inc. New

York. All Rights Reserved. ✳ Coochi not Gucci photo: Jon Ericson ✳ p. 79 High-fashion cyclist photo: Beth Baptiste

✳ ✳ ✳ ✳ ✳ 1986 ✳ ✳ ✳ ✳ ✳

p. 80 André Walker fashion photo: Janette Beckman ✳ p. 81 André Walker fashion photo: Richard Pandiscio ✳ p. 82 Marc Shaiman and menagerie photo: Jon Ericson ✳ p. 83 Billy Erb in Bodymap: Janette Beckman ✳ Tabboo! photo: Beth Baptiste ✳ p. 84 Darryl McDaniels of Run-DMC photo: Janette Beckman ✳ p. 85 Ann Magnuson photo: Tseng Kwong Chi 1986 © Muna Tseng Dance Projects, Inc. New York. All Rights Reserved. ✳ p. 86 Cindy Crawford photo courtesy of Willi Wear ✳ Willi Smith photo: Richard Pandiscio ✳ Gold-tooth girl rappers photo: Henny Garfunkel ✳ p. 87 Sports fashion photo: Beth Baptiste

✳ ✳ ✳ ✳ ✳ 1987 ✳ ✳ ✳ ✳ ✳

p. 88 Courtney Love photo: Harold Sweet ✳ p. 89 Punk graffiti: Richard Pandiscio ✳ p. 90 Tattooed girl photo: Henny Garfunkel ✳ p. 91 Stephen Sprouse photo: Richard Pandiscio ✳ p. 92 School teacher style photo: Janette Beckman ✳ Joey Arias as Salvador Dalí photo: Richard Pandiscio ✳ p. 93 Early skater style photo: Valerie Shaff ✳ p. 94 Hasidic fashion by John Walke for Gloria Superstein photo: Janette Beckman ✳ p. 95 Teen model Naomi Campbell photo: Roxanne Lowit ✳ Absolut Cameron ad courtesy of TBWA/

Chiat/Day ✳ Superfly '70s style photo: Jon Ericson

✳ ✳ ✳ ✳ ✳ 1988 ✳ ✳ ✳ ✳ ✳

p. 96 Leigh Bowery photo: Janette Beckman ✳ p. 97 Fabu-lash fashion photo: Bart Everly ✳ p. 98 Cecilia Dean photo: Jesse Frohman ✳ p. 99 Coney Island sideshow style photo: John Eder ✳ p. 100 Photo: Tseng Kwong Chi 1988 © Muna Tseng Dance Projects, Inc. New York. All Rights Reserved. ✳ p. 101 photo: Tseng Kwong Chi 1988 © Muna Tseng Dance Projects, Inc. New York. All Rights Reserved. ✳ p. 102–103 Men with purses fashion photo: Valerie Shaff ✳ Susanne Bartsch photo: Tseng Kwong Chi 1988 © Muna Tseng Dance Projects, Inc. New York. All Rights Reserved. ✳ Cyndi Lauper photo: Sergio Purtell ✳ Debbie Harry in *Hairspray* photo: Henny Garfunkel ✳ Lypsinka photo: Henny Garfunkel ✳ Wig genius Danilo photo: Sergio Purtell ✳ David Hockney photo: Greg Gorman © l.a. Eyeworks ✳ Ted Muehling earring photo: Don Freeman

✳ ✳ ✳ ✳ ✳ 1989 ✳ ✳ ✳ ✳ ✳

p. 104-105 Walter Cessna hodge-podge style photos: Kevin Hatt ✳ p. 106 Laurie Pike and John Bartlett photo: Sergio Purtell ✳ p. 107 Futura 2000 photo: David Hughes ✳ p. 108 Geoffrey Beene photo: Bart Everly ✳ p. 109 Panty girl photo: Dan Salzman ✳ p. 110–111 Before and after drag queen photos: Henny Garfunkel ✳ André

Walker and André Leon Talley photo: Peter Davis ✢ Bethann Hardison photo: Bart Everly ✢ Betsey Johnson photo: David Shea

✢ ✢ ✢ ✢ ✢ **1990** ✢ ✢ ✢ ✢ ✢
p. 112 Veronica Webb photo: Kevin Hatt ✢ p. 113 Isaac Hayes photo: Edward Maxey ✢ p. 114 Walter Cessna's Little Red Riding Hood style photo: Kevin Hatt ✢ p. 115 Debi Mazar photo: Edward Maxey ✢ p. 116 Brooke Shields photo: Henny Garfunkel ✢ p. 117 Naomi Campbell and Isaac Hayes photo: Edward Maxey ✢ p. 118 Gay banjees photo: John John Martinez ✢ Dorian Corey photo: David Hershkovits ✢ *House Party* hairdos photo: Sue Kwon ✢ Designer Franco Moschino photo: Maggie McCormick ✢ Michael Alig photo: Michael Fazakerley ✢ p. 119 Haircut with a message photo: Henny Garfunkel

✢ ✢ ✢ ✢ ✢ **1991** ✢ ✢ ✢ ✢ ✢
p. 120 Triple Five Soul multiculturalism photo: Michael Lavine ✢ p. 121 River Phoenix photo: Mark Contratto ✢ p. 122 Love Ball lovelies photo: Haim Ariav ✢ p. 123 Deconstruction photo: Caroll Van Amringe ✢ p. 124 Danilo's do photo: Haim Ariav ✢ Orlando's hair magic photo: Guzman ✢ Thierry Mugler plastic wig photo: Haim Ariav ✢ p. 125 Boys will be girls photo: Haim Ariav ✢ p. 126 André Balazs and Serge Becker photo: Jeffrey Kane

✢ Deee-Lite photo: Henry Wolf ✢ Oribe and Susanne Bartsch photo: Maggie McCormick ✢ Kevyn Aucoin and friend Don photo: Maggie McCormick ✢ Giving Face photo: Haim Ariav ✢ p. 127 House of PAPER photo: Haim Ariav

✢ ✢ ✢ ✢ ✢ **1992** ✢ ✢ ✢ ✢ ✢
p. 128–129 Club kids photos: Haim Ariav ✢ p. 130 Grunge workwear photo: Haim Ariav ✢ p. 131 Jenny Shimizu photo: Johnny Rozsa ✢ p. 132 Diane Brill at Thierry Mugler photo: Haim Ariav ✢ p. 133 Mr. Pearl photo: Josef Astor ✢ p. 134 Byron Lars photo: Randy Brooke ✢ Isaac Mizrahi backpack jacket photo: Valerie Shaff ✢ André Walker's wig scarf photo: Haim Ariav ✢ Thierry Mugler photo: Peter Davis ✢ Gianni Versace photo: David Hershkovits ✢ Sneaker and skateboard photos: Haim Ariav ✢ p. 135 Beeper pocket photo: Haim Ariav

✢ ✢ ✢ ✢ ✢ **1993** ✢ ✢ ✢ ✢ ✢
p. 136 Pot logo photo: Haim Ariav ✢ p. 137 Twin cutie pies photo: Marc Baptiste ✢ p. 138 Samoa and Kembra Pfahler photo: Richard Kern ✢ p. 139 Wigstock photo: Imke Lass ✢ p. 140 Isabel Toledo fashion photo: Valerie Shaff ✢ p. 141 Adeline André fashion photo: Judson Baker ✢ p. 142 Richie Rich photo: Dan Howell ✢ Mathu and Zaldy photo: Peter Davis ✢ Kate Moss

photo: Randy Brooke ✢ Piercings and tattoos photo: Peter Hamblin ✢ Diesel ad courtesy of Diesel ✢ p. 143 Label photo: Mark Contratto

✢ ✢ ✢ ✢ ✢ **1994** ✢ ✢ ✢ ✢ ✢
p. 145 Pussy power fashion photo: Haim Ariav ✢ p. 146 Celebutot photo: Wayne Maser ✢ p. 148 Barbie photo courtesy of Mattel © 1994 Mattel, Inc. ✢ Anna Sui runway photo: Raoul Gatchalian courtesy of Anna Sui ✢ Vivienne Westwood fetish chic photo: Randy Brooke ✢ Barbie as Bettie Page photo courtesy of George Lois ✢ p. 149 Tatiana von Furstenberg photo: Haim Ariav ✢ p. 150 Chloë Sevigny fashion photo: Haim Ariav ✢ p. 151 Vinyl Rules photo courtesy of the Vinyl Preservation Society ✢ Hair as art photo: Henny Garfunkel ✢ Sean "P. Diddy" Combs photo: Dan Howell ✢ Rita Ackerman's art as fashion photo: Kevin Hatt

✢ ✢ ✢ ✢ ✢ **1995** ✢ ✢ ✢ ✢ ✢
p. 152–153 Stefan Campbell "puppys" photos: John Scarisbrick ✢ p. 154 Harlem style photo: Melodie McDaniel ✢ p. 155 Chinatown style photo: Dietmar Busse ✢ p. 156–157 Geoffrey Beene fashion photos: Scott Heiser ✢ p. 158 Comme des Garçons runway photo: Randy Brooke ✢ Walter Van Beirendonck runway photos: Chris Rugge ✢ Tyson Beckford photo: Dah Len ✢ p. 159 Cyber swimmer photo: Mike Ruiz

✢ ✢ ✢ ✢ ✢ **1996** ✢ ✢ ✢ ✢ ✢
p. 160 Anna Sui fashion illustration: Amy Davis ✢ p. 161 Alek Wek photo: François Nars ✢ p. 162 Russian banjee photo: Cheryl Dunn ✢ p. 163 Cyber boy photo: Mike Ruiz ✢ p. 164–165 Angela Mothersill hair designs photo: Albert Watson ✢ p. 166 Quentin Crisp photo: Dietmar Busse ✢ p. 167 Isaac Mizrahi fashion show photo: Nick Waplington ✢ Roxanne Lowit photo: Roxanne Lowit ✢ Nail art photo: Julian Wass ✢ Donatella Versace photo: G.K. Reid ✢ Susan Cianciolo photo: Rosalie Knox ✢ Ricki Lake photo: Albert Watson

✢ ✢ ✢ ✢ ✢ **1997** ✢ ✢ ✢ ✢ ✢
p. 168 Little Miss Thing photo: John Scarisbrick ✢ p. 169 Dolly Parton photo: David LaChapelle ✢ p. 170 "Lady's Experience" (1997): Jean-Pierre Khazem ✢ p. 171 Philip Treacy photo: Corina Lecca ✢ p. 172 Ryan Findlay as Burt Reynolds photo: Jonathan Miller ✢ p. 173 Lil' Kim photo: Christian Witikin ✢ p. 174 Radical beauty looks photos: Mike Ruiz ✢ Style Fiends illustration: Amy Davis ✢ Hospital chic photo: Dan Howell ✢ p. 175 "New Day": Jean-Pierre Khazem

✢ ✢ ✢ ✢ ✢ **1998** ✢ ✢ ✢ ✢ ✢
p. 176 Isabella Blow photo: Roxanne Lowit ✢ p. 178–179 Futurism photo: Jo Ann Toy ✢ p. 180 Frosty beauty photo: John Mark Sorum ✢ p. 181 "Temptation": Jean-Pierre Khazem ✢ p. 182

Regal rasta photo: Michael Williams ❀ p. 183 cK©1997 Calvin Klein Cosmetics Corporation ❀ Alexander McQueen and Lauren Ezersky photo: Marc Joseph ❀ Pin-up photo: Matthias Clamer

❀❀❀❀❀❀❀❀❀❀
Please note: The folks at PAPER Publishing have tried really hard to reach all photographers and/or copyright owners of the images used in this book. If we've missed anybody, we apologize and are prepared to offer free fashion advice from Mr. Mickey or a one-year subscription to PAPER as compensation.

238

INDEX

THE TYPEFACE • THE HEADERS IN THIS BOOK ARE A VERY SPECIAL AND UNIQUE COMBINATION OF FONTS. THEY WERE CREATED IN 2000 BY ANDREA TINNES, AN INDEPENDENT GRAPHIC AND TYPE DESIGNER. THE HEADLINES ARE TINNES' FONT HAIRCRIMES, A SERIES OF MODULAR TYPEFACES SHE DESIGNED TO EXPLORE THE ORNA-MENTAL POTENTIAL OF THE ALPHABET. THE DATES IN THE BACK OF THE BOOK ARE A COMBINATION OF HAIRCRIMES AND VOLVOX, WHICH IS AN ORNAMENTAL SYSTEM OF FIVE FONTS SUPERIMPOSED ON EACH OTHER, RESULTING IN A STUNNING EFFECT. TINNES ALSO DESIGNED THIS UNIQUE FONT. WE ARE VERY GRATEFUL TO HER FOR ALLOWING US TO SHOWCASE HER WORK. WE ALSO WOULD LIKE TO ACKNOWLEDGE GAIL SWANLUND, A DESIGNER AT THE CALIFORNIA INSTITUTE OF THE ARTS, WHO HELPED US IN THIS TYPE PROJECT. HER ORIGINAL WORK IN THE CALARTS CATALOG INSPIRED US TO UTILIZE THESE GORGEOUS FONTS. WE ALSO THANK DESIGNER AGNIESZKA STACHOWICZ, WHO INTERPRETED AND EMBELLISHED TINNES' WORK; THE FONTS YOU SEE HERE ARE UNIQUE TO PUBLICATION IN THIS BOOK.

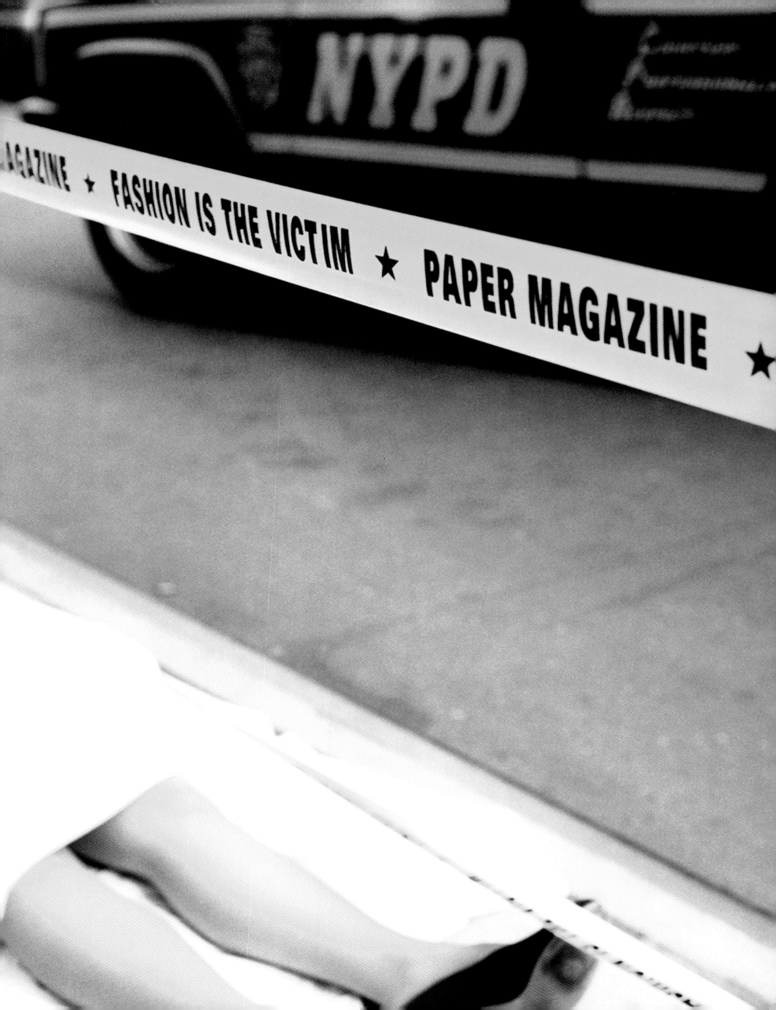

TO SUBSCRIBE TO PAPER MAGAZINE,

CALL 1.800.829.9160

OR GO TO WWW.PAPERMAG.COM

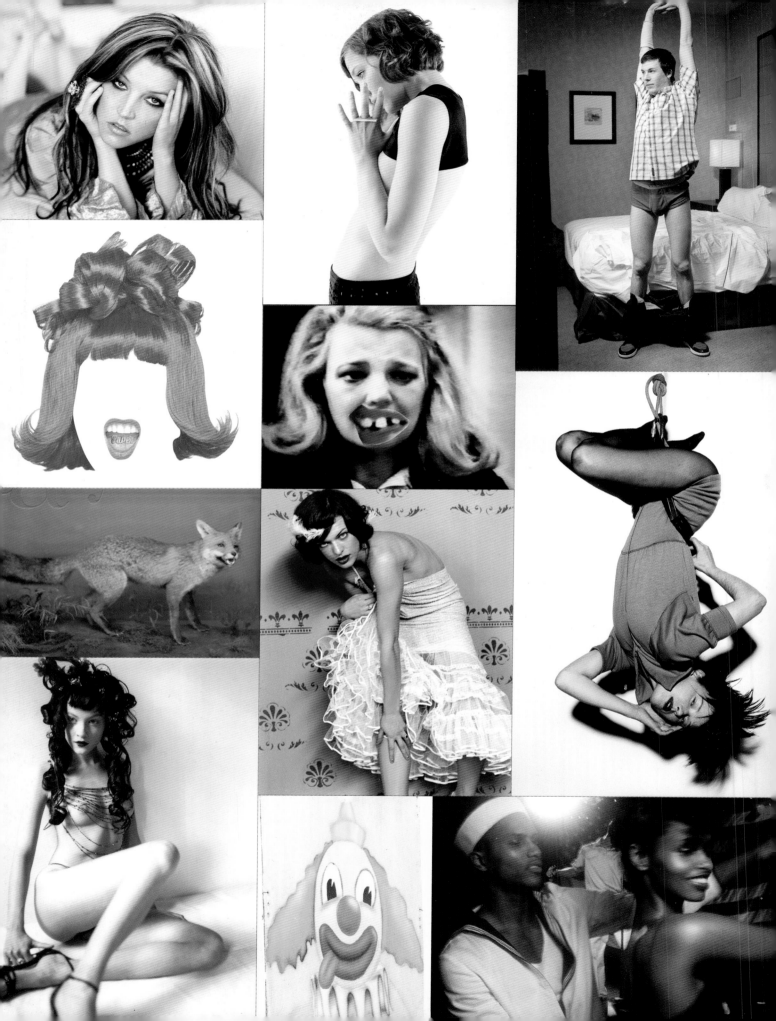